North Light
Dictionary of ART
TERMS

North Light Dictionary of ART TERMS

Margy Lee Elspass

North Light Publishers

Published by North Light, an imprint of
Writer's Digest Books, 9933 Alliance Road,
Cincinnati, Ohio 45242

Manufactured in U.S.A.
First Printing 1984

Library of Congress Cataloging in Publication Data

Elspass, Margy Lee, 1925-
 North Light dictionary of art terms.
 Bibliography: p
 1. Art—Dictionaries. I. Title.
 II. Title: Art terms.
N33.E5 1984 703'.21 84-22713
ISBN 0-89134-096-3

Dedication

Dedicated to The duCret School of the Arts
Plainfield, New Jersey

Acknowledgments

My most sincere thanks to:
Fritz Henning, editor, of North Light Publishers,
for giving me the benefit of his knowledge and
expertise

Robert S. Jackson of Seven Lakes, West End, NC
27376, who read the manuscript and contributed
greatly to the commercial entries

Anco Wood Specialties, Inc., 71-08 80th St., Glen-
dale, NY 11385, who granted permission to use
their photo illustrations of five of the easels in
this manuscript

Arthur Brown and Bro. Inc., 2 W. 46th St., NY, NY
10036, who granted permission to use the photo
illustration of their French easel

M. Grumbacher, Inc., 460 W. 34th St., NY, NY
10001, who sent information and answered ques-
tions concerning brushes

Winsor and Newton, 555 Winsor Dr., Secaucus,
NJ 07094, who sent information and answered my
many questions over many years' time

Preface

The *North Light Dictionary of Art Terms* is designed to supply artists, students, and others interested in the visual arts with a complete, convenient, inexpensive, nonspecialist reference for words and terms relating to the broad spectrum of art and studio procedures. The emphasis is on painting, drawing, and graphics. However, some terminology pertaining to sculpture, architecture, ceramics, textile design, photography, and handicrafts is covered. The commonality of these related creative endeavors makes the inclusion of these associated terms useful and fitting. Excluded are references dealing with the theatre, cinema, and dance.

In alphabetical order are short biographies of certain artists whose influence on a particular period, school, or type of art has proven significant. In chronological sequence, at the back of the book, is the listing of the vital facts of nearly five hundred important artists of the Western World.

The art and diagrams that profusely illustrate the text are to aid in the clarification of technical points and offer explanation beyond the written definitions. Of special interest is an endpaper fold-out identifying many frequently used artists' colors along with other supplemental material relating to aspects of color pertinent to all artists.

The purpose of the book is to supply everyone interested in the visual arts with accurate, succinct information covering a breadth of related material not otherwise readily available.

Contents

Subjects covered

Anatomy
Animation
Calligraphy
Classroom Terms
Colors
Commercial Arts
Fashion
Foreign Words and Phrases
Lettering
Movements
New Words and Phrases
Oriental Terms
Painting
Printing (Graphics)
Products
Schools
Sculpture
Studio Terms
Symbols
Techniques
Textile Designing
Wood Carving

A — Symbol on tube of paint indicating a standard degree of color permanence

AA — Symbol on tube of paint indicating the highest degree of color permanence

abbozzo — Sketch or rough drawing; first draft of a work of art; underpainting

abc art — *See* **minimal art**

abrasive — A substance that wears away or smooths a surface. *In graphic arts, see* **engraver's charcoal; jeweler's rouge; pumice powder; snake slip.** *In photography, see* **rottenstone**

absorbent ground — A ground or base on a surface to be painted that absorbs the liquid from the paint

abstract art — An art form in which the essence of a subject is stated in a brief or simplified manner, with emphasis on design and little or no attempt to represent forms or subject matter realistically. *See also* **design elements; nonrepresentational art**

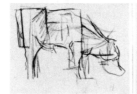 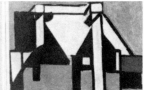

Abstract painting of a cow in progressive states by **Theo Van Doesburg**
Museum of Modern Art, New York

abstract expressionism — A style of non-geometric abstract art that started in the 1940s and became popular in the 1950s; paintings were usually large and forceful; among others, Wassily Kandinsky, Arshile Gorky, Jackson Pollock, Willem DeKooning, and Mark Rothko are classified in this style. *See also* **action painting; nonobjective art**

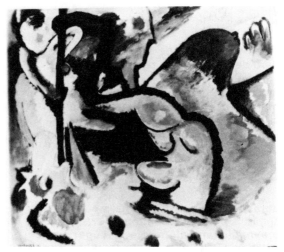

Abstract expression painting by **Wassily Kandinsky**

Abstraction-Creation Group — An international school of painters and sculptors of the 1930s who were dependent on geometric shapes and forms; Piet Mondrian was the major figure

academician — 1. An elected member of an academy; 2. One who follows the principles of the conservative academic tradition

academy (art) — 1. A learned group accepted as authoritative in its area of art; 2. A school in which art is taught

academy blue — Pigment; a mixture of viridian and ultramarine blue

academy board — A cardboard once used by

students in oil painting, replaced by canvas board

academy figure — A nude figure (life drawing or painting), about half life-size, used for instruction and not considered a work of art

acanthus — A plant with thorny leaves seen on capitals of Corinthian columns and elsewhere as a decorative motif.

accent — To emphasize by drawing attention to an area of a picture. This is usually accomplished by stressing in a limited area one or more of the design elements such as value or color contrasts, texture, etc. *See also* **design elements**

accent color — A small amount of contrasting color used against another color; for example, orange accent in a predominantly blue area

accidental color — Color that "happens" without conscious preliminary planning during the painting process

acetate — A strong, transparent, or semitransparent sheet of plastic, available in various thicknesses and used in covers for artwork, in color separation, in retouching, and in animation drawing. *See also* **cel; frisket; Frisk Film**

acetate color — Opaque, waterproof paint that does not crawl or peel when used on acetate, foil, glass, or other slippery surface

acetate ink — A special ink that can be used with pen or brush on slippery surfaces without a crawling effect

acetate, prefixed or prepared — A clear, treated plastic that can be painted on either side with watercolors, inks, or dyes without crawling or peeling of colors; used for overlays in graphic arts and in color separation of art or photography

acetic acid — In graphics, a liquid used to clean a plate just before the mordant is applied

acetone — A flammable, volatile solvent, mildly toxic, often used in the restoration and cleaning of old paintings

achromatic — Without color, as in white, black, and any gray made from the mixture of black and white

acid bath — In the etching process, an acid or acid mixtures in which a plate is immersed to be bitten or etched

acid-free — Said of art paper with a 7 pH (ideal); above 8.5 pH or below 6.5 pH is not considered acid-free

acid-resist substance — A stop-out substance used to block the action of acid. *See also* **stop-out**

Acra — Pigment; a violet color with a decided reddish-pink cast when reduced; permanent

Acra red — Pigment; a medium bright red; permanent

acrolith — A statue made of more than one material

acrylic flow improver — A medium used with acrylic paint to improve its flow without the loss of color strength

acrylic inks — A variety of toxic, flammable synthetic inks used in silk-screen process on acetate and acrylic sheets such as Lucite and Plexiglas

acrylic paints — Synthetic paints with a water base, fast-drying, lightproof, waterproof, nonfading, used on any nonoily surface; can be used opaquely or impastoed as with oils, or

thinned and applied transparently as with watercolors; thinned with water or special painting emulsions, cleaned up with soap and water

acrylic retarder — A medium added to acrylics to slow drying time

acrylic sheets — Crystal-clear sheets of plexiglass (trade marks, Lucite, Plexiglas), that can be carved, sawed, cemented, or molded

acrylic varnish — *See* **picture varnish**

acrylic varnish remover — A solution used to remove acrylic varnish

Action lines, cartoon by
Bud Sagendorf

action lines — In cartooning, extraneous lines used to suggest action

action painting — Imageless, spontaneous painting, marked by drips, splashes, and spatters; represented by Jackson Pollock, Mark Toby, Franz Kline, and others. *See also* **abstract expressionism**

action pose — Attitude or pose that suggests movement

Action painting
by **Franz Kline**

ad — Abbreviated form of *advertisement*

Ada school — Named for Ada, thought to be a sister of Charlemagne, who patronized a group of ivory sculptors and manuscript illuminators in late eighth and early ninth centuries

additive color mixing — The scientific method of adding colors in the form of light rays to create mixed hues of light important in color photography; in painting, the use of small points of color placed in close proximity and mixed by the eye, as in pointillism. *See also* **subtractive color mixing**

adhesive — A substance that bonds paper or other materials together, such as glue, mucilage, rubber cement, plastic cement

adhesive mounting spray — A fast-drying spray adhesive for mounting papers permanently or temporarily

adjacent colors

See **analogous colors**

adjustable triangle — A triangle that has one adjustable arm that can be clamped at different angles, with a protractor between the adjustable arm and the main area of the triangle

advancing colors — Colors that appear to move forward or closer to the viewer, usually red, yellow, and orange

Adjustable triangle

adventure strip — A realistically treated cartoon strip that deals with a continuing adventure story; usually syndicated in newspapers

advertisement (ad) — In publishing, a written and often illustrated means of attracting public attention, usually to a product or service. *See also* **medium**

advertising agency — A group of writers, artists, and marketing experts who create advertisements, sales campaigns, marketing surveys and tests, seminars, displays, package designs, audiovisuals, and similar promotions for clients

advertising director — Person responsible for producing advertisements

adz, adze — In sculpture and woodcarving, a cutting tool used to rough-shape wood

Aegean painting — Painting of Crete, Mycenae, and the Cyclades, 2600-1200 B.C.; colorful, stylized, but with a strong feeling for naturalism

aerial perspective — In painting, achievement of an effect of atmosphere and apparent distance by receding values and indistinctness of color

aerugo — *See* **patina**

aesthetic — Pertaining to the beautiful, re-fined, tasteful, and artistic

aestheticism — A doctrine whereby art exists solely for its own sake; the nineteenth-century aesthetic movement

aes ustum — *See* **patina**

African art — Ceremonial sculpture, masks, and crafts derived from African tribal cultures

afterimage — An optical image that continues after its source is removed; often tends toward the complementary color of the original image

agate — In printing, a small-size type, approxi-mately 5½-point

agate line — a unit of measurement for depth of a column of printed advertising, in which fourteen agate lines equal one column inch

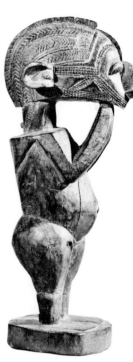

African Sculpture

agent — A business representative for an artist

agglutinant — An adhesive used as a binder in watercolor paints, pastels, and some inks

abcdefghijklmnopqrstuvwxyz
ABCDEFGHIJKLMNOPQRSTUVWXYZ

Agate type— 5½ point
Baskerville

"air" — A term used to indicate 1. atmosphere in a landscape or waterscape; 2. space in a painting around objects or portraits; 3. open, unprinted space in printed material

airbrush — A miniature precision spray gun at-tached to an air compressor, carbon dioxide tank, or other means of air pressure; used by commercial artists to create a smooth applica-tion of paint or gradations in value and color; frequently used in photo retouching and some-times in illustration and other types of painting

Airbrush

airbrush lithography — A lithography tech-nique in which the airbrush is used to draw di-rectly on the stone or plate

air bubbles — Paint bubbles filled with air found in paint that has been mixed or beaten too much or too fast; often leave holes in the painted surface after the paint has dried

air eraser — A tool similar to the airbrush; uses an abrasive in a fine, controlled spray to erase ink or paint; sometimes used to blend highlights and shadows in drawings or paintings

air gun — Same as airbrush

alabaster — A whitish semitranslucent gypsum that can be carved and cut into sculpture

à la colle — *See* **distemper**

à la poupée — In intaglio, a means of printing several colors at one time by applying each color to the plate separately with a pad of felt

album leaves — (oriental) A collection of small paintings in album form, usually six, eight, or ten

alcohol — A flammable, anhydrous (without water) solvent used mainly to thin lacquers and shellac

Alexandrian blue — Pigment. *See* **Egyptian blue;** close to cobalt blue

Alexandrian style — A soft and sentimental style developed by Hellenistic artists of the third to first centuries B.C. (Ptolemaic period)

alizarin blue — Pigment; a clear transparent lake generally used in printing inks and for semipermanent artwork; close to indigo on the color chart

alizarin brown — Pigment; a reddish transparent brown, permanent; close to burnt sienna on the color chart

alizarin carmine — An obsolete name for alizarin crimson

alizarin crimson — Pigment; a deep transparent red; mixes well with blue to create a true purple; permanent

alizarin crimson, golden — Pigment; a warmer, less bluish alizarin; some artists prefer it for skin tones; permanent

alizarin green — Pigment; a clear transparent lake generally used in printing inks and for semipermanent artwork

alizarin violet — Pigment; a clear transparent lake; not permanent; close to magenta on the color chart

alizarin yellow — Pigment; a brownish transparent yellow, semipermanent

alkyd colors — Artists' paints similar to oils but with a faster drying time, distributed by Winsor and Newton; can be used with any medium used with oil paints

alla prima painting — (Italian, *the first time*) Method of direct painting (usually in oil) often in one sitting, with minimal or no underpainting

Alla prima painting (detail) by **Frans Hals**

alligatoring — *See* **crackle**

allover pattern — 1. In textile design, usually a repeat or other pattern that completely covers the fabric; 2. in painting, an obvious design or repeating pattern covering a major portion of a picture

Almohad style — An art style introduced into Spain by the Almohads, a Moroccan Berber Moslem dynasty, in the twelfth and thirteenth centuries

alternation — Intervals of different sequence (patterns of line, form, color), happening in turns and creating a rhythm

alto-rilievo — (Italian *high relief*) In sculpture, a type of relief where the design projects almost entirely away from the surface

Amarna art — Egyptian, during the time of Akhenaten, a religious reformer (1375-1358 B.C.); a more natural than stylistic art, based on expressing the truth

amberlith — A transparent, amber-colored masking film used in making mechanicals and in the film processes of photolithography

American Gothic — A hard-edge, realistic type of painting associated with the American painter, Grant Wood; title of a popular painting by that artist

American Indian prints — Geometric patterns often in horizontal or vertical stripes*

American Ten, the — A group of American impressionists founded in 1898 by J. Alden Weir; the artists involved did not gain the kind of recognition achieved by their counterparts in France; prominent in this movement were William Merritt Chase, Childe Hassam, Ernest Lawson, and John Twactman

amorphous — Lacking a definite shape or form

A.N.A. — Associate member of the National Academy of Design

anaglyph — Sculpture or decoration (such as a cameo) in relief

analogous colors — Colors that are closely related, such as blue, blue green, and green; three or four colors that are adjacent (touch) on the color wheel

anatomy — The study of body structure, human or animal—muscles, bones, etc.; the visual appearance of the form

Anglo-Saxon art — An art style of the fifth to eleventh centuries in England, characterized by interlaced motifs. *See* **arabesque**

angular perspective — *See* **two-point perspective**

aniline colors — Colors made from coal tars; a disparaging term for synthetic dyes and pigments that are not sufficiently lightfast for artists' use

animate — To cause to appear lifelike and to have movement, as in animated cartoons

animated cartoons — In motion pictures, a series of successive still cartoons projected one after the other so rapidly that there is an appearance of movement

animation paper — Two- or three-ply paper available in rolls, used for animation drawings

ankh — The Egyptian Cross; the symbol of life; modern symbolism includes two meanings: everlasting life and love

ansate cross — Same as ankh

anthemion — A decorative design of honeysuckle or palm leaves

Ankh

19

anthropomorphic — Attributing human characteristics to nonhuman beings or things

anti-cerne — A white space in the form of a line between two areas of color in a picture; frequently used by the fauve artists; the opposite of a black line

antimony colors — Pigments; bright orange and vermilion, now generally replaced by cadmiums

antimony white — Similar to titanium white, but darkens from sulphur fumes; permanent

antimony yellow — Pigment; Naples yellow, name obsolete

antiques — 1. Plaster casts of classical sculptures used in drawing classes to study form; 2. ancient furniture and artifacts

antiquing — Using a glaze of burnt or raw umber over a work of art to create an appearance of age

Antwerp blue — Pigment; a reduced Prussian blue, transparent, not permanent

Antwerp red — Pigment; light earth red, permanent; between Venetian red and cadmium red light on the color chart

Antwerp school — Early sixteenth-century Flemish painters who were influenced by the Italian Renaissance; Quentin Massys was one of the prominent artists.

apex — The highest point or summit

apparel — In fashion and textile design, the clothing or attire designed for people

appliqué — In design, one material cut out and applied to another

aqua fortis — (Latin, *nitric acid*) In etching, the mordant or solution used to etch the plates, diluted for use with one to five parts water

aquagraph — A monoprint made by painting with a water medium on a metal, glass, or plastic plate and pulling one print from that plate; additional colors can be printed by aligning the paper to the plate design

aquarelle — (French) Transparent watercolor

aquarelle brush — A particular style of water-color brush, used flat for large areas and on the edge for fine lines

aquatint — An intaglio printing process in which tones can be etched, rather than just lines, and rich darks as well as transparent tints can be produced; often resembles a wash drawing

Aquatint and etching (detail) by **John Taylor Arms**

aquatint mezzotint — In etching, a plate is first bitten in a solid aquatint, then a design is worked on top of the aquatint with a scraper and burnisher, producing a result similar to a mezzotint

A.R.A. — (British) Associate of the Royal Academy of Art

arabesque — An interlaced ornamental design, floral and/or geometric

arc — A portion or section of a curved line

Arc-en-Ciel — A brand name for oil or soft pastels made without fillers

Arabesque

archaic — 1. Retaining the character of earlier art; 2. old-fashioned

Arches (D'Arches) — Trade name of a popular 100 percent rag watercolor paper made in France; available in weights of 72, 90, 140, 300, 400, and 550 pounds, as well as different textures—hot press (smooth), cold press (medium rough), and rough

architectural sketch paper — *See* "trash" paper

armature — In sculpture, a skeleton of wire or other durable material on which the artist builds his work in clay, plaster, etc.

armature wire — Wire used to build an armature, available in different diameters

Figure *armature*

Armory Show, the — In 1913, innovative and avant-garde artists from America and Europe held a show at the 69th Regiment Armory in New York City; the public derided the works, but nonetheless the impact on American art was lasting. "The Armory Show" has become an historical benchmark in America, separating earlier modes of art from "modern art"

Arnaudon's green — Pigment; a chromium oxide green, now obsolete

arrangement — A setup or composition of items used for a still life painting or drawing

art — Any artistic endeavor, such as painting, sculpture, singing, playing an instrument, or dancing. Also a craft, such as ceramics, jewelry, or wood carving

art appreciation — The understanding of and regard for the arts

Art Brut — (French, *art in the raw*) Jean Dubuffet (early 1900s) patterned his art after the primitive work of children and the insane, which he found to have directness and vitality

art buyer — The person who is a link between an agency and freelance artists; buys artwork for the agency

Art Deco — A geometric, sleek, elegant style of decorative art popular in the 1920s and 1930s

art director — One who directs or supervises the work of other artists

art engagé — (French, *art involved in life*) Art with a social or political significance

artgum — An eraser that crumbles as it erases, not scratching or discoloring artwork

artist's bridge — A tool used to balance the hand and keep it clear of the working surface while drawing or painting delicate passages. *See also* **mahlstick**

artist's proof — One of the first proofs from a limited edition of prints, for the artist's own copyright use; marked as artist's proof (A.P.) and not numbered; may draw a premium price. May have E.A. (*épreuve d' artiste*) instead of A.P.

Art Nouveau by **Aubrey Beardsley**

art nouveau — (French, *The New Art*) Art movement popular in the 1890s and early 1900s in Europe and America; a busy, decorative style characterized by flowing vines and flat shapes (as seen in Tiffany glass) and undulating line (seen in Toulouse-Lautrec posters); Aubrey Beardsley and Gustav Klimt are among the other noted artists associated with the movement, but its beginnings are attributed to William Morris. It is also known as *Jugendstil* and *Yellow Book style*

Art Students League — An art institute in New York City, founded in 1875; subjects taught are: drawing, painting, graphics, sculpture, illustration, anatomy, color, composition, design, portraiture, and mural painting

artwork — A general term applied to any artistic production

ASAP (*As Soon As Possible*) — Often found in a listing of specifications for the return of artwork

Ashcan School — a painting by **Everett Shinn**

ascender — The part of a lower case letter that projects above the main line, as in d, f, h, k, l, t

Ashcan school — An early twentieth-century American art movement started in opposition to established academic forms; the name was coined by a reporter when describing the group's realistic city-type subject matter; the founders, known as "The Eight," were Robert Henri, Maurice Prendergast, Arthur B. Davies, Ernest Lawson, John Sloan, Everett Shinn, George Luks, and William Glackens

asphaltum — 1. In etching, a liquid used on plates as a soft ground and on the backs of plates to protect them from the mordant; 2. in lithography, used to chemically process the drawing; 3. an old oil color, destructive to paintings

assemblage — A technique of combining together pieces of "this and that" to create a three-dimensional artwork

Asturian art — A ninth-century Gothic style with Moorish derivation used in Spanish churches in the Asturias region

asymmetry — An informal balance arrived at by the informal distribution of elements; balance similar to that of a steelyard scale: an arm is suspended off center and the object to be weighed is hung from the short arm, while a smaller weight is moved outward on the long arm until a balance is reached; may be compared also to a seesaw with one child weighing more than the other, where the heavier weight is moved closer to the center to achieve balance

atectonic — In sculpture, describes shapes or forms that tend to reach out into open space

atelier — (French, *artist's studio, workshop*)

atlantes — In sculpture, supporting columns carved in the form of heroic men. *See also* **caryatid**

atmospheric perspective — *See* **aerial perspective**

atomizer — A device for spraying a mist of thin liquid, such as a fixative, on artwork

attribution — Crediting a work of art to an artist, or denying attribution, by studying brush strokes, paint quality, clay application, or other identifiable mannerisms to make a determination

au premier coup painting — (French, *at first blow*). *See* **alla prima painting**

aureole — The halo, or nimbus, painted around the head of a holy person as seen in medieval and Renaissance art

aureolin yellow — Pigment; a cobalt yellow, bright, transparent, and durable; close to cadmium yellow light on the color chart

aurora yellow — Pigment; a bright yellow between a cadmium yellow light and a cadmium yellow medium, transparent and durable

autographic ink — A greasy ink used in lithography

autography — In graphic arts, the process by which a pen and greasy ink drawing is transferred from paper to stone; in lithography, reproduction of a print on autographic paper

automatic drawing — *See* **automatism**

automatism — A surrealist technique of closing the eyes and letting the hand draw without conscious direction; sometimes called *automatic drawing*

Autone prints — Trademark, in commercial art, for color- or metallic-based photoprints

autoportrait — (French, *self-portrait*)'

avant-garde — (French, *vanguard*) A term applied to art that is considered ahead of its time, innovative, and experimental

Avignon school — Late fifteenth- and early sixteenth-century school of painting centered around Avignon, France, influenced by Italian and Flemish styles

avocado — The olive-green color of the avocado fruit; may be light or dark in value

A.W.S. — Abbreviation for American Watercolor Society

axis — 1. A real or imaginary area in a picture that serves as a fulcrum in visually balancing the elements of the composition; 2. an imaginary line to which elements of a work of art are referred for measurement

axonometric projection — In mechanical drawing, includes isometric, dimetric, and trimetric projection; used to represent three-dimensional objects, not for an illusion of reality, but to show dimensions and other geometric information. *See also* **oblique projection**

Isometric drawings of a circle

azo yellow light — Pigment; a cool yellow, durable acrylic

azo yellow medium — Pigment; a medium yellow between cadmium yellow light and cadmium yellow medium, durable acrylic

azo yellow orange — Pigment; similar to cadmium yellow, deep, durable acrylic

azure blue — Pigment; a medium blue color coming from copper carbonate

azure cobalt — Pigment; a mixture of cobalt blue and viridian, permanent

azurite — Pigment; from a clear dark blue mineral, permanent, used in watercolors; now replaced by more easily obtainable blues

azzuro — Pigment; ultramarine blue, name obsolete

B — Symbol on tube of paint indicating a color of a less than permanent quality, but fairly durable

"baby" spot — 1. A spotlight of 500 watts or less; 2. a very small design or illustration

background — 1. The area farthest away in a landscape or seascape; 2. the area surrounding the subject matter in a picture

backing board — Any heavy cardboard or similar material used for mounting pictures or to protect the back of a stretched canvas. *See also* **chipboard**

backing-up — In printing, a term meaning to print on both sides of a sheet of paper, as the pages of a book

backlight — Light coming from behind a subject

Backstein Gothic — An architectural term used to describe the fourteenth-century German variant of Gothic structures wherein brick was used in place of stone

Back lighting as used in a painting by **Harold Von Schmidt**

backup — 1. Paper or cardboard glued to the back of artwork to prevent curled edges; 2. the printing on the second side of a printed page; 3. the process of filling in the back of a thin copper electroplate, making it solid

Bager blender

badger blender — A soft-hair artist's brush similar to a shaving brush, used dry, flattened, and spread out to blend areas of color; also called a *sweetener*

baguette molding — A simple strip of molding used for framing

balance — In composition, a visually favorable distribution of elements

ball-flower — In architectural decoration, three or four petals with a ball shape in the middle

balloon — 1. In cartooning, the writing inside a balloon shape; 2. in watercolor, an accidental puddle that has dried in a noticeable balloon shape

ball-point pen — A pen with an automatic ink supply that has a small round ball for a point

Balopticon — A projector that enlarges or reduces the image of a sketch or photograph while projecting it onto a drawing surface for the purpose of tracing or transferring artwork

balsa wood — A soft wood used for carving and crafts

bamboo brush — An oriental brush with a handle of bamboo. *See also* **calligraphy brush; fude; hake**

bamboo pen — A Japanese pen made from a piece of bamboo, used for drawing and calligraphy; a versatile instrument that can produce a range of fine to heavy lines

band — In design work, a running motif

banderole — In design work, a narrow, forked streamer, sometimes inscribed

banding wheel — A small turntable for banding pottery with colored glaze

Barbizon School — A group of French naturalist painters who left Paris and gathered in the village of Barbizon in the mid-1880s and sought a fresh approach to nature by painting on the site; led by Theodore Rousseau and Charles François Daubigny, other members were François Millet, Narcisse-Virgile Diaz, and Constant Troyon

barbola paste — A putty-like paste painted on a surface to create an embossed effect

baren — A round, smooth, flat pad used to lift an impression by hand from a wood or linoleum block; the traditional Japanese type is covered with bamboo, but barens are now available in wood, nylon, and other synthetics

baroque — 1. A style of European art dating from the latter part of the sixteenth to the early eighteenth centuries. Although centered in Rome, where the sculptural work of Bernini and the paintings of Cortona are dominant examples, the style also flourished in other areas. The Flemish painter Rubens is classified as high baroque. Sometimes derided for being flamboyant and overly decorative, baroque should not be confused with rococo, a style that overlapped and followed it; 2. Used as an adjective, baroque was, until the nineteenth century, synonymous with the absurd or irregular, but such meaning is no longer credited

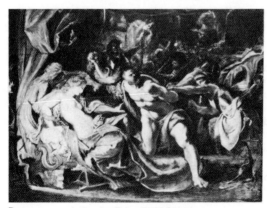

Baroque — painting by **Peter Paul Rubens**
The Art Institute of Chicago

bars — In commercial art, especially textile design, a set of parallel bars used to mask an area for a stripe to be made with an airbrush

barium yellow — A pale yellow similar to sulphur, permanent

baryta green — Pigment; manganese green derived from barium oxide; name obsolete

baryta white — An artificial barium sulphate used as a base for certain inert pigments; obsolete name for *blanc fixe*

Bateau-lavoir, Groupe du — (French, *the group of the floating wash house*) A group of international artists located in Montmartre, Paris from 1908 to the beginning of World War I; title derived from a tenement building occupied by Picasso; cubism was a leading pursuit; important names were Delaunay, Gris, Leger, and Modigliani

b and w — Abbreviation of black and white

basic forms — The four intrinsic three-dimensional forms in art: the cube, cone, cylinder, and sphere; separately or in combination, they can suggest the structure of almost anything, whether natural or man-made

bas relief — (French, *low* relief) A form of sculpture in which figures project only slightly from the background

bassetaille — (French, *cut low*) In jewelry-making, a process in which gold or silver is engraved with a design and carved in low relief; transparent colored enamels are applied, drying between coats, and a clear coat is made level with the rim, followed by enamel fixing

batik — A wax-resist process used in textile design; originated in Indonesia

Bauhaus — A German school of architecture, design, and applied arts founded in 1919 by Walter Gropius, specializing in relating art to industrial technology; some of the artists involved included Lyonel Feininger, Wassily Kandinsky, and Paul Klee

bead — A small dotted texture in a design

bead and leaf — A running molding design of a bead shape and a leaf pattern

bead and reel — A running molding pattern of a bead shape alternated with disk shapes

beading — The bubbling quality of paint when applied to a slick surface; most frequently occurs with water-base mediums

beam compass — A drawing compass with a long beam attachment which draws or cuts circles from 1½ to 15½ inches

beau brilliant paper — A 65-pound cover stock with a rough texture, available in a variety of colors

Beaux-Arts, Ecole des — (French, *Fine Arts, School of*) A school of fine arts located in Paris

bed — On a printing press, the surface that establishes the maximum usable sheet size

beeswax — Wax from honeycombs, used in encaustic painting, in etching grounds, in wax varnish, and as a resist in batik and other procedures

beige — A light brown color, considered a neutral

Bell's medium — An oil painting medium used since the nineteenth century, superseded by Owalin or other modern mixtures

Bauhaus seal by **Oskar Schlemmer**

Bead and leaf pattern

Benday screen — one of many patterns

bench hook — A device used to hold a wood or linoleum block in place while cutting

benday — In printing, a process using screens of different dot patterns to mechanically produce shading effects; named for its inventor, Benjamin Day (1838-1916). *See also* **shading sheets**

Bengal rose — Pigment; a sharp pink, gouache, fugitive

beni-ye, beni-zuri-ye — (Japanese, *pink picture*) A two-color print in pink and green

benzine — A toxic, flammable hydrocarbon used as a solvent, as a rubber cement thinner, and as a photo surface cleaner

beret — A round, soft, brimless tam sometimes worn by artists

Berlin blue — Pigment; also called Prussian blue; a term used mainly in France

bevel — 1. To cut an edge at an angle other than 90 degrees on mats, etc.; 2. to round off or slant an edge; 3. a ruler with an adjustable arm used to draw or cut edges

bi — A prefix indicating *two*

biacca — Artist-quality white lead pigment

biceps — 1. A front upper arm muscle that flexes the arm and forearm and turns the hand; 2. a large muscle of the upper leg

bichromatic — A term describing a work of art created with just two colors

bicutter — A tool that cuts two lines at the same time; adjustable from 1/8 to 3/4 inch

Biedermeier — A term coined from the fictional Philistine poet and applied to a style of art

and architecture of Germany and Austria during the period 1815 to 1845; a style geared to the middle class, similar to early Victorian art in Britain, and considered stolid, simple, and sentimental

Bienfang — A trade name for a variety of art papers

billboard — A large flat structure used to display artwork, posters, or advertisements, usually outdoors

bimetal plate — In engraving or printing, a plate made with two layers of metal, for example, copper over aluminum or copper over stainless steel

bin — A receptacle that holds artwork, often used in galleries for prints or other art that is for sale

binary colors — Colors made up of two hues, as orange, green, and purple

binder — the adhesive used to hold particles of pigment together in paint. In watercolor—gum arabic, a water-soluble glue; in oil—linseed oil; in tempera—egg yolk or whole egg; in pastels—gum arabic; in acrylics—a liquid plastic

biomorphic — A term applied to shapes that resemble the curves of plant and animal life; applied especially to the work of Hans Arp

bird's-eye — In textile design, a woven cloth pattern suggesting the shape of a bird's eye in the middle of a diamond

bird's-eye view — View as seen from above, as a bird would see, with a high horizon line

bisect — To cut into two equal parts

bismuth white — A less poisonous paint than white lead; it darkens from sulfur fumes; now obsolete

bistre — A brownish color used as a wash and in inks, made from the soot of burned wood; replaced by more permanent pigments

bite — In engraving, to etch or bite from a metal plate

bitumen — A native asphalt used in the preparation of asphaltum. *See also* **asphaltum**

black — 1. The absence of color; 2. black pigment:
> **acrylic colors:**
>> **carbon black, makes warm grays, permanent**
>> **ivory black, makes warm grays, permanent**
>> **Mars black, an artificial earth color, makes warmer grays than ivory, permanent**
> **alkyd colors:**
>> **ivory black, a bone black, permanent**
>> **lamp black, a carbon black, makes warm grays, permanent**
> **gouache colors:**
>> **ivory black, makes warm grays, permanent**
>> **jet black, makes cool grays, permanent**
>> **lamp black, grayer than jet, makes cool grays, permanent**
> **oil colors:**
>> **ivory black, cooler than lamp, a slow dryer but permanent**
>> **lamp black, a pure carbon, warmer than ivory, a slow dryer, permanent**
>> **Mars black, an artificial earth color on the brownish side, opaque, permanent**
> **watercolors:**
>> **ivory black, see gouache**
>> **lamp black, see gouache**

black and white — A term used for any rendering completed in black and white and the grays resulting from mixing black and white

black iron oxide or black oxide of iron — Pigment; Mars black, opaque and permanent

black lead — Graphite, commonly used in pencils

black letter — A typeface, commonly called *text*

black mirror — A piece of convex glass painted black and used to study values *and* composition by reducing details and eliminating color; also called *Claude Lorrain glass*

black sable — A lettering or fine varnish brush originally made from wood martin or stone martin, now from civet cat hair

bladder green — Now called sap green, a transparent earth green

blanc d'argent — (French, *silvery white*) Flake white, toxic

blanc fixe — (French, *fixed white*) A white base for watercolor and fresco painting; also called *constant white*

bland — Without impact or strength; a term applied to art that is too mild

blanket — The felt or foam rubber used between the paper and the roller on an etching press; a rubber-surfaced fabric used on the cylinder of an offset press

blank greeting card — A plain card, with envelope, that will accept many different art mediums; available in different sizes and colors

Blau Reiter — painting by **Franz Marc**
Walker Art Center, Minneapolis

Blaue Reiter, der — (German, *the Blue Rider*)
An avant-garde group of early twentieth-century painters who had a notable influence on modern art; members were founders Wassily Kandinsky and Franz Marc, and Paul Klee, August Macke, and others

Blaue Vier — (German, *the Blue Four*) Four artists, Paul Klee, Wassily Kandinsky, Lyonel Feininger, and Alexei von Jawlensky, who held exhibitions together in Germany, Mexico, and the United States in the 1920s

bleach-out — A bromide print that is underdeveloped and used as a basis for a line drawing, then bleached away

bleed — 1. Paint or ink that runs into an adjoining area or up through coats of paint; usually undesirable; 2. a fuzziness or spreading of the edges of a painted area; 3. in the graphic arts, to extend to the edge of a printed page, without a margin; accomplished by allowing an extra 1/8-inch bleed edge, to be trimmed

bleed marks — Lines at the corners of a piece of artwork to be reproduced, showing the area that will extend over an edge, usually 1/8-inch

bleed-proof — Said of dried paint or ink that will not spread when wet with water

blend — In artwork, to merge colors applied to a surface, usually with a brush

blended roller technique — *See* **rainbow printing**

blender — *See* **badger blender** and *fan brush*

bleu celeste — Pigment; cerulean blue

blind pressing — Making an embossed print with an uninked plate; also called *blind printing*. *See also* **embossed print**

block book — A book in which text and illustrations were printed as one unit, all in one impression; frequently used before the invention of movable type

blocking in — Laying in the initial statement of a picture by a broad indication of tone, color, and line

block letter — A typeface, commonly called *gothic*

THE GOTHIC FAMILY OF TYPE
the gothic family of type faces

Block letter typeface

block out — In graphics, to stop out an area with shellac, tusche, etc.; to use a block-out stencil

Tusche used to *block-out* sections on a lithography stone

Linocut by **Pablo Picasso**

block print — A print on paper or textile, each color requiring a separate block; the hand-carved wood or linoleum block may be stamped by hand or in a block printing press

block-printing ink — A thick ink applied to a wood or linoleum block; available in many colors in an oil-base or a water-soluble ink

blocks, duplicate — Two or more blocks that are exactly the same

bloom — In oil painting, an undesirable, dull, foggy, whitish effect on the surface of a varnished picture

blotting paper — In printing, an absorbent paper used to dry printed material

blowtorch — In metal sculpture, a hand-held gas-fueled burner that produces a flame hot enough to melt or fuse some metals

blowup — An enlargement

blue ashes — Pigment; Bremen blue, toxic

blue bice — Pigment; Bremen blue, toxic

blue black — Pigment; a variety of carbon black; another name for ivory black

Blue Four — *See* **Blaue Vier**

blue malachite — Pigment; azurite, a clear blue, obsolete

blue pencil, pale — Used to mark artwork, photographs, and photostats because it does not reproduce on line film, a film insensitive to blue, used in photographic printing processes

blueprint — A photographic reproduction in which white lines are on a blue background or blue lines on a white background

Blue Rider — *See* **Blaue Reiter**

blue verditer — Pigment; Bremen blue, toxic, obsolete

board — In artwork: 1. a drawing or painting surface with a stiff backing. *See* **Bristol board; canvas board; illustration board; Masonite**

boasting — In stone carving, the rough shaping of the design

boasting chisel — In sculpture, a flat chisel used to rough shape the stone

Bocour blue or **green** — Trade name for phthalocyanine blue or green

body — In painting, the viscosity or density of pigment or ink

body color — Opaque color in paint, often achieved by the addition of gouache or opaque white to transparent color

body matter — In typography, the text or body text

body type — The typeface that is used for the text in a book, usually up to 12-point. Most common body type sizes are in the 8- to 12-point range. The body type of this book is 10-point

bogus drawing paper — A stiff sheet of paper used with markers, pastels, gouache, etc.

bohemian — Originally an inhabitant of Bohemia (Czech.), now a nonconforming person, indifferent to convention

Bohemian earth — Pigment; green earth, transparent, permanent, name obsolete

boiled oil — *See* **linseed oil**

bokusaiga — A Japanese ink painting using the traditional black and color

bokuseki — (Japanese, *traces of ink*) Zen calligraphy

bold — Strong, obvious, direct; for example, a bold, black line

Gothic
Gothic Bold

boldface type — A heavy dark typeface that stands out in comparison to standard or light type

bole — Gold size; a dull red ground laid to provide a smooth, nonabrasive base for gold leaf

Bolognese school — Group of artists in and around Bologna, Italy in the twelfth to seventeenth centuries

bolus ground — A ground or base for canvas, prepared with a dark brown or reddish earth (bole); eventually shows through and affects the painting

bon à tirer — (French, *good to pull*) A press proof of an etching, lithograph, or other print that is approved and so labeled by the artist, and serves as the standard for the edition of the print

bond paper — A good-quality paper used for drawing and sketching

bone black — Pigment; a brownish black made from charred bones; artists' grade called *ivory black*

bone emulsion — A product added to plaster or moist clay to make it self-hardening

boneless style — *See* **mo-ku**

bone structure — The body frame, the way the bones affect the surface appearance

book jacket — A cover or wrapper used to protect as well as to advertise a book; also called a *dust jacket*

booklet — A pamphlet or small book usually with a paper cover

border print — 1. In illustration, a design on all four sides of a picture; 2. in textile design, a design on only one edge, such as on the bottom of a skirt or the top of a drapery

bordering wax — Wax used around the edges of a large plate as a molded border so that the plate can be etched without immersion; also called *walling wax*

boss — In sculpture, any projecting mass that will later be carved or cut

boucharde — A mallet used by sculptors, with short, pyramidal points on both hammering ends to bruise and break up stone and soften it, in the early stages of stone carving; also called a *bushhammer*

Bougival white — Bismuth white

Bourges process — The use of transparent acetate sheets for color separation in the printing process where each overlay sheet is produced by the artist; a relatively inexpensive means of achieving color in printed art

box frame — A frame in which the picture is set in a box behind the glass

bozzetto — (Italian, *small sketch*) In sculpture, a small, rough model used as a guide; also called a *maquette*

bracketing — 1. In lettering, the rounding off of the corners where the serif connects to the stem; 2. in photography, shooting the same picture with the same lighting, using different exposure settings

Braquette

braquette — An inexpensive, frameless frame in which clips are held on the top and bottom of a piece of glass-covered artwork with spring tension and nylon cord; adjustable to different sizes

brayer — A hand roller designed for inking printing blocks and plates; also sometimes used by artists in painting large areas

braze — 1. In metal sculpture, to solder with hard solders such as an alloy of copper and zinc, zinc and silver, or nickel and silver; 2. to cover a metal with brass

brazilwood lake — Pigment; a blood-red lake, now obsolete due to improved, synthetic colors

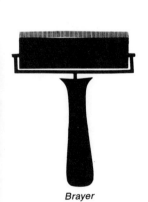

Brayer

breathing — The expansion and contraction,

according to weather conditions, of papers and canvas

breathing space — The empty area surrounding a form; *See also* **negative space**

Bremen blue — Pigment; a semiopaque, poisonous blue available in many shades, now replaced by nonpoisonous ultramarine blue

Bremen green — Pigment; a pale green variant of Bremen blue

brick repeat — A textile repeat pattern fashioned after a brick wall

bridge — *See* **artist's bridge**

briefing — Instructions to an artist from a client

bright — A short, flat brush with a long handle, used mainly for oil, acrylic, and alkyd painting

Bright

bright red — Pigment; in watercolor, a blend of chlorinated para red and arylamide yellow, transparent and permanent

brilliant yellow — Pigment; a bright orangish yellow, permanent; also known as *Naples yellow*

bristle — *See* **brush, bristle**

bristol board — A durable drawing surface used for all types of general artwork and lettering; can be used on both sides; available in a smooth plate finish or medium vellum

broad manner — A style of engraving in which the lines are broad and bold; also, a term sometimes used to describe a bold manner of painting

broadsheet or **broadside** — A large folded advertisement

brocade — In textile design, an interwoven jacquard design of raised flowers or figures with an embossed appearance achieved by contrasting the background of twill or satin with gold or silver threads or by using different surfaces and colors

brocatelle — In textile design, a stiff cloth with embossed, twilled figures woven onto a plain ground, producing a high relief effect; similar to damask, it was originally made to imitate Italian leather

brochure — A booklet or bound pamphlet

broken color — Two or more colors so placed in a painting as to produce the optical effect of another color, without being mixed on the palette

bromide print — In commercial art, a photographic print

bronze — An alloy, principally of copper and tin, used for sculpture

bronze blue — Pigment; Prussian blue, intense, transparent, name obsolete

bronze powders — Powders made in different metallic shades and used decoratively; will tarnish and turn dark

brown madder — Pigment; same as alizarin brown, transparent, durable; close to Mars violet on the color chart

Brücke, die — (German, *the Bridge*) Name given to a turn-of-the-century group of German expressionist artists who introduced the influence of Van Gogh, Gauguin, and others into Germany; founding artists were Erich Heckel, Ernst Kirchner, and Karl Schmidt-Rottluff

Die Brucke — **Ernst Kirchner**
self portrait

Brunswick blue — Pigment; a variety of Prussian blue, not used in artists' colors

46

Brunswick green — Pigment; a chrome green made from chrome yellow and Brunswick blue, name obsolete

brush — The tool with which an artist paints; made of many different materials, in many styles and sizes

brush, acrylic — A nylon-bristle brush compatible with acrylic and polymer paints

brush, bristle — Oil painting brushes made from hog bristles, which have a unique taper, or curve. *See* **bright; egbert; filbert; flat; round**

brush cleaner — A compound used to clean oil, acrylic, varnish, etc. from art brushes; also a receptacle or holder for brush cleaning; *See* **brush washer; Master's brush cleaner**

brush, hair — A brush made of animal hair, such as fitch, badger, ox, and squirrel (called camel hair), with the highest quality called red sable (kolinsky)

brush quiver — A container, with a carrying strap, to hold and carry brushes

brush script — 1. Calligraphy with a brush; 2. a script typeface

Examples of *brush* type

brush washer — A metal cup specifically designed to use in cleaning watercolor brushes

brushwork — The distinctive manner in which an artist applies paint with his brush

buckle — Waves, or bulges that appear in paper or canvas, usually from too much moisture and uneven drying

Buddhist school — A religious art propagated in Japan by Buddhist priests

bug — *See* **logo**

bump up — To make an enlargement

burgundy — A dark red color imitating burgundy wine

Burgundy, school of — 1390-1420; Flemish court artists under Philip the Bold of Burgundy. The school practiced Flemish realism superimposed on the naturalism that was dominant in the Italian schools; from this grew the International Gothic style; among the most noted members were the Van Eyck brothers

burgundy violet — Pigment; manganese violet

A burin or graver

burin — A graver; a tool of different sizes and styles, used to engrave wood or metal plates

burl — A knot or growth that may be found in a tree; in a woodblock it is hard to carve, but sometimes can be utilized effectively in a design

burlap — A coarsely woven cloth made from jute, hemp, flax, etc., and used for crafts and painting

burn — 1. In lithography, the result of too much nitric acid in a gum etch; 2. a term used in photographic platemaking for plate or film exposure

burnisher — A tool used to smooth, flatten, or polish, available in different sizes and materials

burnt carmine — Pigment; a deep dark red, fugitive

burnt green earth — Pigment; a dark brown, transparent and permanent

burnt ochre — Pigment; a brick-red ochre, permanent

burnt plate oil — An extender for etching ink

burnt sienna — Pigment; a natural earth color (raw sienna) that has been roasted; burnt orange or burnt red in color

burnt umber — Pigment; a natural earth color of a dark warm brown

burr — A rough edge on a cut in metal

bushhammer — *See* **boucharde**

bust — In sculpture, a portrait that includes the head, neck, shoulders, and breast

bust peg — In sculpture, the wooden support upon which a bust is modeled

busy — Said of areas of a picture that are confusing or overactive

butcher's tray — A white enameled tray used as a palette for watercolors or acrylics

butting — Placing two items close together without overlapping

butt joint — In design, a place where two motifs meet in a visible or invisible straight line without overlapping

Byzantine art — The term refers to a particular style rather than the area of the Byzantine Empire—paintings and mosaics have been found in Europe, Asia, and parts of Africa. Encompassing the period A.D. 330 to the fifteenth century, the art is religious in nature—early Byzantine art was called Early Christian art. The style creates floating figures with large eyes, bright-colored mosaics on gold or toned backgrounds; the effect tends to be flat and decorative, featuring frescoes and relief carvings

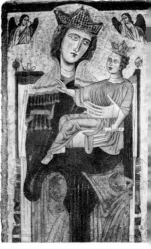

Byzantine art of twelfth century by unknown artist

Byzantium purple — Pigment; a bluish purple used in ancient times, now obsolete

C — Symbol on tube of paint indicating a fugitive color

© √ Copyright symbol indicating the exclusive right granted by law to sell, distribute, or reproduce the piece of artwork

cabinet projection — A system of projection similar to isometric, where the lines of an object are drawn parallel to three axes, one horizontal, one vertical, and one 45 degrees to the horizontal

cadmium green — Pigment; a mixture of cadmium yellow and viridian, permanent

cadmium orange — Pigment; bright orange, opaque and permanent

cadmium red — Pigment; light—similar to vermilion, bright orangish red; opaque and permanent; medium—a bright medium red; opaque and permanent; deep—a dark red; opaque and permanent

cadmium scarlet — Pigment; an orangish red, permanent; between cadmium orange and cadmium red light

cadmium yellow — Pigment; a bright yellow close to lemon yellow, permanent; light/pale— a bright, light yellow, opaque and permanent; medium—a medium goldish yellow, opaque and permanent; deep—a dark goldish yellow, opaque and permanent

Caledonian brown — Pigment; an earth color similar to burnt sienna but inferior; now obsolete

Caledonian white — Pigment; a white lead, now obsolete

calendar painting — Term applied to painting that may be pleasant to look at, have pleasing subject matter, but seldom has lasting value as art

calender printing — In textile design, same as direct printing

calendered paper — A smooth-surfaced paper

calico — In textile design, a tiny allover floral print, originally with a bright yellow, dark red, or black background, but now includes all colors

calipers, pair of — An instrument with two adjustable arms used to measure thickness or distance between two points

Calligra-cote — Trade name for a protective spray for calligraphy; used with waterbase inks, markers, or watercolor

calligram — A calligraphic notation, picture, or conveyance

calligraphy — 1. The art of fine handwriting; 2. a typeface that resembles such writing; 3. any calligraphic-type line work used in drawing or painting

Calligraphic Itali

Everyday Italic

Calligraphy by **Gary J. Munch**

calligraphy brush — A specially balanced oriental brush made from weasel, raccoon, and horse hairs, used for lettering; only the tip is submerged in ink. *See also* **bamboo pen**

camaieu, en (French, *as a cameo*) — Painted in tones of only one color, usually for decoration

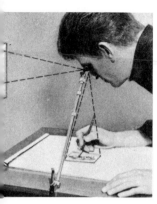

Camera lucida

camel-hair brush — Any of a number of soft-hair watercolor brushes made of squirrel, badger, goat, fitch (skunk), etc. (True camel hair is unsuited for brushes)

cameo — A small carving in relief, usually of a gemstone

camera — The basic instrument of photography

camera lucida — (Latin, *light chamber*) An optical instrument that uses a prism to enlarge or reduce an image, which is projected for tracing; sometimes referred to by artists as a *luci*. *See also* **opaque projector**

cameraman — In platemaking, one who photographs art or mechanicals

cancellation proof — A proof made from a canceled plate or stone to show that no more prints can be pulled; usually a large X is drawn on the plate before the final proof

candid shot — Unposed photograph

canvas — A fabric (cotton, linen, jute, etc.), prepared as a surface for painting; also a term for the finished painting

canvas board — Canvas laminated onto cardboard

canvas carrier — A frame-shaped metal device made to carry two to four wet canvases without touching

canvasette — *See* **canvas paper**

canvas paper — A paper with a canvas-like surface, used for sketches or practice work

canvas pins — Double-point pins used to separate two wet canvases when carrying or storing them

canvas preparation — 1. Coating a canvas with gesso or some other primer; 2. on an already primed canvas, painting a tone or underpainting

canvas scraper — A tool with a curved blade, used to scrape oils or acrylics from a canvas

canvas separator clips — Spring-controlled clips used as canvas pins

canvas stretcher strips — *See* **stretcher strips**

cap — A border frame without a liner or mat

capitals/caps — Uppercase letters

cappage brown — Pigment; similar to umber but inferior, permanent, now obsolete

caption — A brief explanation of a picture reproduced in a book or magazine

caput mortuum — Pigment; a burned red oxide similar to Indian red only deeper and a little more bluish, permanent, name obsolete

Caravaggisti — The followers of Caravaggio, a prominent Italian painter (1573-1610)

Caravaggio, Michelangelo Merisi da — 1573-1610, Italian, considered a tenebrist for his low-key paintings. An accomplished artist who is noted for his precise details and chiaroscuro painting.

National Gallery, London

Caravaggio — "Supper at Emmaus"

carbon black — Pigment; a pure black, permanent, but not used by artists because it streaks

carbon paper — Transfer paper coated with carbon

carbon pencil — *See* **Wolf's carbon pencils**

Carborundum — Trade name for an abrasive used in graphics; used as a surface in collagraphs to produce gray masses; available in powder form and as a coated cloth

car card — A small poster advertisement displayed in buses, subways, and streetcars

cardboard — A stiff paper board used for mounting pictures, backing, etc. *See also* **chipboard**

cardboard cut — A design cut into cardboard, used in a printing technique

cardboard relief — A collage made up of pieces of cardboard for relief block printing

caricature — A distortion of physical characteristics to create a humorous or satirical likeness

carmine — Pigment; a fugitive red lake; close to Thalo red rose on the color chart

Caricature by **Emery Clarke**

Carolingian art — Art of a period from the mid-eighth to the early tenth century, beginning with the reign of Charlemagne; modeled after the style of Rome during the reigns of Constantine and Theodosius, and after Byzantine art of the sixth and seventh centuries; characterized by elaborate illumination of manuscripts and decoration with gold and gems. *See also* **Ada school**

carpenter's pencil — A flat, graphite pencil in sizes 2B to 6B, used for sketching

carpus — In anatomy, a bone of the wrist

carrying case — A reinforced fiberboard case used to carry art materials

carthame — Pigment; safflower, a fugitive lake, now obsolete

carthame pink — Pigment; a bright pink, moderately permanent, gouache

cartilage — In anatomy, a tough, fibrous connective tissue

cartoon — 1. A satirical drawing or caricature; a comic strip; 2. a drawing for a mural or large painting used as a full-size guide to the final painting

cartouche — 1. An ornamental scroll-like design sometimes used in printing and hand lettering; 2. studio usage refers to all types of scroll outlines and irregular shapes; 3. a signature in picture form from the Egyptian era

A sixteenth century *cartouche*

cartridge paper — A British or Canadian term referring to an inexpensive paper of almost any quality, weight, or finish; used mainly for sketches; originally similar to ammunition paper

carve — To cut into wood, stone, or other hard material; to incise

caryatid — In sculpture, a supporting column carved in the form of a woman. *See* **atlantes**

Casali's green — Pigment; a variation of viridian green, name obsolete

casein — A binder made from casein glue, a milk derivative; combined with pigments, it resembles opaque watercolor and is used on paper or board, for light impasto, for underpainting, wall decoration, etc., but is too inflexible for canvas; dries quickly with a waterproof surface and may be varnished

casein engraving — A technique in which a piece of Masonite board is built up to about 1/16-inch thickness in multiple layers of casein; an engraving is made on this hardened surface, and a sealer used to provide a good printing surface

Cassel earth — Pigment; an earth color similar to Vandyke brown, fugitive; close to burnt umber on the color chart

Cassel green — Pigment; manganese green, now obsolete

Cassel yellow — Pigment; Turner's lead yellow, now obsolete

Cassatt, Mary — 1844-1926, American- born but spent much of her life in Paris, where she was associated with the impressionists; a friend of Degas; she is noted for her paintings and prints of mothers and children.

Mary Cassatt, lithograph (detail) The Brooklyn Museum

cast — 1. To form in a mold; 2. a reproduction of classic or other sculpture used as subject in drawing classes

casting off — Computing the amount of space a column of type will occupy when set in a desired typeface of a given size and line measure

cast shadow — A shadow cast upon a surface, such as a shadow from a tree upon the grass

catching up — In lithography, the collection of ink or scum on a nonimage area of a plate

catch light — The tiny light dot painted into the eye to give it more form and sparkle

cat's tongue — A long-haired, flat painter's brush, shaped like a filbert but with a thinner, rounded tip; also spelled *kat's tongue*

cavalier projection — A type of oblique projection

cave painting — A painting on the walls of caves during the Stone Age, dating from about 40,000 to 3,000 B.C.

Cave paintings

cavo-rilievo — (Italian, *hollow-relief*) In sculpture, relief carving in which the highest part is level with the surface and the rest is below level; also called *intaglio*

cel — In animated cartooning, the plastic sheet on which an animation drawing is traced and painted before being photographed: from Celluloid, a trademark for the material of motion picture film

celadon green — Pigment; green earth, name obsolete

celery green — A light yellow-green mixture

celestial blue — Pigment; a variety of Prussian blue, not permanent

cellocut — In graphic arts, a plastic plate (acetate, Lucite, or Plexiglas); also a plastic varnish used to build up or texture a design

cellophane — A thin, transparent acetate film available in crystal clear and colors

celluclay — A papier-mâché in powdered form, to be mixed with water

cement — A general term for *adhesives*; a special mixture of Portland cement is sometimes used as a base for mural paintings. *See* **rubber cement**

cenacolo — A painting of the Last Supper

center of interest — The main area of interest in a picture

center spread — The two facing pages in the center of a newspaper or magazine

center of vision — In perspective, the viewer's eye position in relation to the picture plane and the horizon line. *See* **station point**

Cercle et Carré — (French, *Circle and Square*) A group of painters founded in 1929 by Michel Seuphor and Torrés-Garcia. Mondrian was the major figure in the group

cerise — (French, *cherry*) A purplish cherry red color

cerography — Painting in which wax is employed as a binder. Also called *encaustic painting*

cerulean blue — Pigment; bright sky blue, opaque and permanent

ceruse — Pigment; white lead, now obsolete

cervical — In anatomy, of or pertaining to the neck or cervix. *See also* **vertebrae**

Cézanne, Paul — 1839-1906, a French postimpressionist whose use of color and structured compositions had a profound influence on aesthetic principles of several twentieth-century movements.

Chagall, Marc — 1887-1981, a Russian who spent much of his career in France, he is classified as an expressionist whose work combines fantasy with Russian folklore. An illustrator, painter, designer, and printmaker, he is well known for his whimsical and decorative paintings.

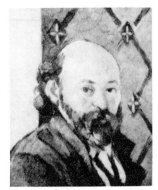

Paul Cézanne, self portrait
National Gallery, London

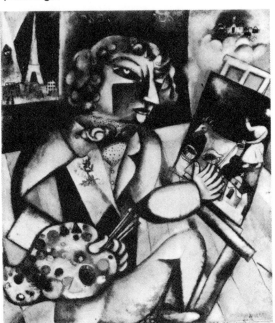

Marc Chagall, self portrait

chalcography — Copper engraving for printing

chalk — A powdery substance derived from limestone, compressed with a binder into sticks for easy handling; chalks range from common chalkboard chalks to pastels. *See also* **layout chalk**

chalk manner — *See* **crayon manner**

chalk roll — A tool that is a type of roulette, used in crayon- or chalk-manner engraving. *See also* **roulette**

chalky — Said of a paint that has too much white pigment; white and pasty-looking, without enough color quality

chamois — 1. A soft, pliable skin used to blend and shade pastels and charcoals, and to wipe plates in graphics; 2. an obsolete name for yellow ochre

champlevé — Carving on metal to form a design with raised lines, and wells or cell areas in which enamel is laid; after which the piece is fired, filed, and polished; resembles cloisonné

character — 1. In lettering and type, a letter, punctuation mark, or other graphic symbol; 2. also refers to the personality of the style or face of lettering in relationship to surrounding elements, atmosphere, and mood

charcoal — A black porous carbon made from charred wood; vines, and twigs make the best charcoal for drawing. *See also* **engraver's charcoal**

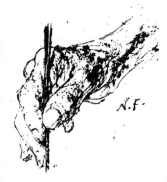

Charcoal drawing by **Nicolai Fechin**

charcoal black — Pigment made from charcoal, seldom used by artists

charcoal brown — Pigment; a dark grayish brown

charcoal, compressed — Ground charcoal powder compressed into sticks; harder than vine charcoal and not as easily manipulated; also known as *Siberian charcoal*

charcoal gray — Pigment; a dark blackish gray

charcoal, hard — *See* **charcoal, compressed**

charcoal holder — A handle used to hold charcoal, crayons, or pastels

charcoal paper — A paper with a "tooth" used for charcoal, pastel drawings, and other dry mediums

charcoal pencil — A pencil with charcoal as the inner rod or marking material

charcoal vine — Thin sticks of charcoal about 6 inches long, available in soft, medium, and hard grades; also called *willow stick*

charge the brush — A term generally used in watercolor work, meaning to fill the brush with color or ink

Char-Kole — Trade name for a hard, compressed charcoal made in squared-off sticks

chartreuse — A bright yellow-green mixture; close to cinnabar green on the color chart

chase — 1. To ornament metal by chasing. *See* **chasing; 2. In letterpress printing, a frame made from metal, used to lock up type and plates so they will retain their position while in the press**

Chasing

chaser — One who is skilled in the art of chasing. *See* **chasing**

chasing — A process in metalwork and sculpture in which chasing tools or punches are tapped with a hammer to create an indented design; also a name for the surface finishing of a metal cast

chasing tools — Tools used in chasing that create squares, circles, lines, etc., when struck with a special hammer; also used on metal in repoussé and copper tooling

check — 1. A split or crack in wood; 2. in textile design, a small square repeated in a print

checkerboard — In textile design, a repeat pattern using every other square, as on a checkerboard

cheesecloth — A soft gauze-like cloth used to wipe plates in graphics

cherub — In design, a winged, nude baby angel

chest — Thorax, the area between the arms, below the neck and above the diaphragm

chestnut brown — Pigment; umber, a permanent earth color, name obsolete

chevron — A *V* pattern repeated vertically

chiaroscuro — (Italian, *light/dark*) Strong emphasis on the change from light to dark in drawing or painting

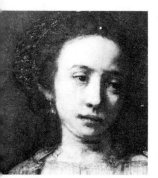

Chiaroscuro — detail of a painting by **Rembrandt**

chih hua — (Chinese) A painting made by using fingers and fingernails in place of brushes

chimera — In design, a fire-breathing monster with the head of a lion, body of a goat, and tail of a serpent

China bristle — Bristle hair from China for manufacturing brushes

china-marking pencil — A pencil that has grease crayon substance as the rod; used for marking on glass, ceramics, china and other slick surfaces

Chinese blue — Pigment; a variety of Prussian blue

Chinese orange — Pigment; a burnt orange, permanent, gouache; close to burnt sienna

Chinese red — Pigment; a bright orangish red

Chinese white — Pigment; a zinc white used in watercolors, gouache, and commercial art, opaque

Chinese yellow — Pigment; King's yellow; also a bright yellow ochre

chinkinbori — (Japanese) A lacquer technique using gold dust sprinkled on black lacquer

chinoiserie — (French, *Chinese things*) European style of decoration that was inspired by Chinese art, beginning in the sixteenth century

chipboard — Newsboard, a heavy, stiff cardboard, used for mounting, backing, or as a cutting board base

chip carving — Carving by cutting wedge shapes and triangular shapes from a wood surface

chiro-xylograph — A woodblock in which a space is left empty so that text can be put in by hand

chisel — A cutting tool with a sharp, beveled edge used for carving

chisel brush — A brush with hairs shaped like a chisel, useful in sign writing

chisel draft — In sculpture, marks on the edge of a stone or other solid material that are used as a cutting guide

chisel point — 1. A manner of shaping a pencil point as a chisel; 2. a lettering brush

chop mark — A signature or identifying mark impressed on paper, often used by commercial printers and workshops

An artist's *chop;* the Chinese characters mean water/men.

chroma — The intensity, strength, or saturation of color, distinguishing the chromatic colors from black and white

chromatic colors — All colors are chromatic; black, white, and the mixture of black and white to create grays are achromatic

chrome green — Pigment; a mixture of Prussian blue and chrome yellow

chrome orange — Pigment; a soft orange lake, opaque, durable; close to cadmium orange on the color chart

chrome red — Pigment; a bright red, toxic, fugitive, replaced by cadmium red

chrome yellow — Pigment; bright yellow, toxic, fugitive, replaced by cadmium yellow

chromium oxide — Pigment; a green earth, permanent

chromolithography — Color lithography

chromo-luminarism — *See* **neo-impressionism**

chromium oxide green — Pigment; a cool earth green, opaque, permanent

chrysocolla — Pigment; native green copper silicate, now obsolete

Chungking bristle — The finest bristle used for brushes, from the province of Chungking, China

Cinquefoil design

cinnabar — Pigment; a native vermilion

cinnabar green — Pigment; a combination of chrome yellow, Prussian blue, and raw sienna, durable

cinquefoil — (French, *five-leaved*) A motif using five leaves in a pattern

circle — A curved line, all parts of which are equidistant from the center

circle cutter — An adjustable tool used to cut exact circles

circulars — Leaflets, handbills, or the like that are distributed free to the public

circumference — The boundary line or border of a circle; the distance or length around a circle

cire perdue — (French, *wax lost*) *See* **lost wax process**

citron yellow — Pigment; any pale greenish-yellow, also zinc yellow

classic — Having permanent quality in accordance with established principles of excellence; pertaining to ancient Greek and Roman civilizations

classical art — Pertaining to the art of the ancient Greeks and Romans

classical lettering — Roman lettering

Claude Lorrain glass or **Claude glass** — *See* **black mirror**

clavicle — In anatomy, a bone that links the sternum and the scapula; collarbone

clean color — A pure color, not reduced

cleaning agent — In printmaking, ammonia, whiting, salt, and vinegar are used to remove fingerprints from metal plates

cleaning pad — A cloth bag containing a powder that absorbs dirt, used to clean drawings

clean lines — Lines in artwork that are stated simply but superbly

cleavage — Flaking off of paint as it cracks and separates from its ground

cliché verre — (French, *exposure of glass*) A graphic art in which clear glass is covered with opaque pigment, a design is scratched into the coating with a stylus, and the glass is exposed on photosensitive paper

clip file — A collection of pictures arranged for reference according to subject or artist; also known as *swipe file, scrap file, the morgue, research file, and reference file*

Clip-it — Trade name for a specially designed spring clip used to mount stretched canvas in a wood frame

cloisonné — A form of enamel decoration in which metal lines separate the colors

cloisonnisme — A style of painting of the 1880s marked by gray lines between areas of color; developed by Emile Bernard and Paul Gauguin; resembles the metallic separating lines in cloisonné

close up — *See* **kern**

close-up — 1. A very close view of a subject; 2. a section of a subject enlarged

closure — The ability of the mind to complete a pattern or picture where only suggestion exists

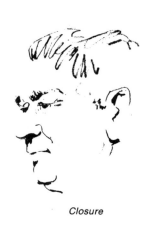

Closure

coal-tar colors — Synthetic organic colors derived from coal tar

coated — Covered with a layer of paint

cobalt blue — Pigment; a bright clear blue, permanent and nearly transparent

cobalt drier — *See* **drier**

cobalt green — Pigment; a bright bluish green, opaque, permanent

cobalt turquoise — Pigment; a compound of aluminum, cobalt, and chromium oxides, durable; a bluish green

cobalt ultramarine — Pigment; a transparent blue, permanent

cobalt violet — Pigment; semiopaque, with a reddish or bluish undertone; the artificial product is nontoxic and permanent

cobalt yellow — Pigment; a bright transparent yellow, permanent

coccyx — A small bone at the base of the spinal column

cockled — A term applied to paper that is rippled or slightly wrinkled

cockle finish — An irregular surface on paper

coelin — Pigment; cerulean blue, permanent, name obsolete

Coeruleum — Trade name in England for cerulean blue

coil pottery — A method in which rolled clay (about pencil thick) is coiled into a desired shape, filled in, and smoothed off

coke black — Pigment; vine black, an inferior carbon black

colcothar — Pigment; a red oxide, now obsolete

cold — An expression used to describe artwork that has no feeling or emotion; or a palette or painting where cool colors are dominant

cold-pressed oil — Vegetable oil extracted from seeds and nuts by pressing them without heat. *See also* **linseed oil**

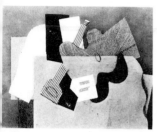

Collage by **Georges Braque**

cold-pressed paper — A handmade watercolor paper with a medium to rough texture, made as chemically pure as possible

collage — (French, *pasting*) Bits and pieces of paper, fabric, nuts and bolts, or any objects or materials are pasted on the picture's surface to serve as the design; may be combined with paint

collage intaglio — An intaglio printmaking process in which the block is built up as a collage. *See also* **intaglio**

collage relief paint — In printmaking, a relief print made from a block built up like a collage. *See also* **relief printing**

collagraph — A print made by the collage intaglio method

collagraph plate — In graphics, a piece of heavy cardboard, Masonite, or wood with a collage glued to the surface, used in printing a collagraph or collage relief print, depending on which is inked, the depressions or the surface. *See also* **intaglio; relief printing**

collarbone — *See* **clavicle**

collate — To collect or assemble in proper order, sheets, signatures, insertions, or similar material for publications, such as magazines and books

collaterals — In publishing art, auxiliary pieces of artwork that accompany and support the main body of art; usually used in reference to small separate pieces that are combined into one layout on a printed page

Cologne earth — Pigment; Cassel earth, umber, name obsolete

colonial prints — Designs of textiles and papers taken from American colonial times

colophon — (Greek, *finishing touch*) An inscription giving information about a publication or artist, usually placed at the end of a book or on the mat of a picture

colophony — A rosin used in the process of relining paintings on canvas

color — A general term for the qualities of hue, intensity, and value observed in pigment or light. *See also* **chroma; color wheel; primary colors; secondary colors; tertiary colors**

coloration — In textile design, a term for color variation

colored print — A print that has been handpainted or handcolored. *See also* **color print**

colorfast — Having color that does not run or fade

color fatigue — Tiring of certain color receptors in the eye, causing inaccurate color perception

color-field painting — An abstract art of the late 1960s using color applied to the picture surface in a flat or uniform style; seen in the work of Barnett Newman

color happening — Unplanned color effect that occurs accidentally in painting

color indication chart — In animated cartooning, a pencil tracing of a scene with all the colors numbered according to a precise formula

colorist — 1. A painter who is known mainly for his mastery of color; 2. in textile design, one who colors in the design

color modulation — A means of creating volume, from its cool dark side to its warm light side in chromatic nuances, by overlapping warm patches of color over cool patches of

color. Where the colors overlap, solidity is created. This is different from direct dark to light modeling. Cézanne is noted for his color modulation

Color Orchestration — *See* **Orphism**

color painting — The term loosely applied to a style of painting using flat applications of color. Creating form is not intended

color pencils — Drawing pencils of different colors; some are made to be blended on the paper with a wet brush

color print — Print on which each color is printed from a separate block or plate

color proof — Printer's or engraver's proof; shows the colors as closely as possible to their final printed form

color scale — Colors in a series of steps at regular intervals, based on hue, value, or chroma

color scheme — The choice of colors used in a work of art, such as monochromatic, analogous, complementary, or mixed

color separation — 1. A photographic process used in photolithography that separates colors through the use of filters; the standard four-color process reduces each full-color picture to four separate plates—magenta, yellow, cyan, and black, but more than four colors can be used; when printed one over the other, a reasonably accurate reproduction of the original is achieved; 2. by hand, color separation is usually accomplished by using acetate or ruby-lith overlays keyed to the base art; or colors can be indicated on tissue overlays from which a camera process creates separate negatives that are used to make the required printing plates

color slide — A photographic transparency; artists often send color slides, rather than their work, to be viewed for prospective shows or sale

color swatch — 1. In textile design, small squares of painted color at the side of a design, indicating the color separations in the design; 2. examples of the colors to be matched in printing

color symbolism — The use of color to express an emotional, political, religious, or other meaning

color temperature — *See* **cool colors; warm colors; temperature**

color triad — Three colors spaced an equal distance apart on the color wheel, such as red, yellow, and blue; or orange, green, and violet. *See also* **color wheel**

color variation — In textile design, a different-colored version of the original design

color wheel — A divided or sectioned circle with colors in a spectrum effect. *See also* **color triads; complementary colors; Ives color wheel; Munsell theory; Newton's color wheel; Ostwald system; Prang color wheel; primary colors, secondary colors; tetrads; tertiary colors. (See color chart at end of book)**

combination plate — In printing artwork, the combination of line and halftone of the same color on one plate

comic strip — A series of drawings in strips or panels, which may or may not be humorous

commercial art — Art that is created to serve a specific business purpose, such as selling a product; advertising illustration, textile designing, packaging, lettering, and fashion illustration are some of the facets of commercial art

Compass

Composite shapes

commission — An authorization to create a work of art for a stated price

companion pieces — Textiles, wallpapers, and fabrics made to match or to be companions through related design

compass — A drawing instrument used to draw circles or arcs

compass cutter — A drawing compass, but with a blade to cut circles

complementary color — Colors directly opposite each other on the color wheel, such as yellow-purple, red-green, and blue-orange are complementary pairs.

compose — 1. To put together, assemble, create; 2. to set type. *See also* **design elements**

composite shape — A group of two or more objects or shapes (sometimes including shadows) that form an easily recognizable shape or unit

composition — 1. Arrangement of forms, lines, values, and other pictorial elements into a picture design; 2. production or arrangement of type for printing. *See also* **design elements**

composition brayer — A soft gelatin roller used in graphics

compositor — A person or machine that composes or sets type

comprehensive — A finished layout, usually made to show to a client; includes indications of illustrations, type, spacing, etc., to suggest the appearance of the completed printed piece

compressed charcoal — *See* **charcoal, compressed**

concept — An idea; something conceived in the mind

concept, picture — The visual idea (picture) that takes form through a creative process, sparked by any stimulus, conscious or subconscious

cone — A form in which the base is circular and the sides taper upward to a common point (apex)

cone of vision — In mechanical perspective, the visual field, in a cone shape of about 45 degrees to 60 degrees, in which a person views the points in a picture

considered line — A planned, thought-out line used to show texture, form, etc.

consistency — The thickness or softness of a given medium, its apparent viscosity

constant white — Pigment; blanc fixe, a base for watercolor and fresco painting

construction paper — An inexpensive paper that is made in many colors, often used in school for children's artwork

constructivism — An abstract movement in sculpture, begun in Russia about 1917, that used metal, wood, plaster, tin, and other industrial materials to build three-dimensional sculptures, paintings, and graphics; a form of art designed to bridge the gap between art and everyday life; also called *Tatlinism*, after Vadamir Tatlin (1885-1953), a champion of the art form

contact points — Points at which lines or objects meet

contact screen — Halftone screen

conté crayon — Trade name of a unique French drawing crayon that is made in square sticks or in pencil form, is grease-free and available in several colors; the reddish crayon is called a *sanguine*; Conte also manufactures a line of pencils, pastels and chalks

contemporary art — Art of our era or times

content — The meaning or aesthetic significance an art object imparts to the viewer

continuity — In cartooning, the running story behind a comic strip, animated cartoon, or related themes in illustrations, murals, etc.

continuous line technique — A technique based on the "golden mean." Using any variation of the golden mean rectangle, an angular line is drawn from a major point to the picture's edge. At this intersection, another angular, horizontal, or vertical line is drawn. Continue in this manner. A picture is then incorporated into the line formation. Often the lines are left visible

continuous-tone illustration — In commercial art, any picture or photograph that has not been screened and that contains gradient tones in either black and white or color

contour — The outer limit of a figure, form, or object; an outline

Contour drawing

contour drawing — A line drawing using one continuing line or as few lines as possible to render a given subject while the artist keeps his eyes on the subject, not on the paper

contour style — *See* **koule**

contrast — The difference in high and low values used for emphasis in a picture

convergence — The tendency of two or more lines or shapes to approach each other or come to a common point

conversation piece — 1. A type of group portrait popular in the eighteenth century; 2. said of an artwork that may or may not be a quality work, but is unusual enough to attract attention and cause conversation among the viewers

cool colors — Colors in which blue, green, or violet predominate

coordinates — In textile design, two or three patterns that go together, such as a plaid and a floral design in the same color scheme

copal painting medium — A medium made from resin, pure oil, and rectified turpentine, used with oil paints

copal varnish — A quality varnish sometimes used as a finish coat on an oil painting after it is thoroughly dry (six to twelve months)

copper blue — Pigment; Bremen blue, ultramarine blue, toxic, obsolete

copper color — Pigment; a color that resembles copper

copper glass — Pigment; *See* **Egyptian blue**

copper green — Pigment; Bremen green, bluish green, toxic, obsolete

copper plate — An engraving plate made from copper

copper tooling — Creating a design or picture on copper by means of pressing a tool into the surface either from the front or back; sulphur is then applied to make different values

copper wheel engraving — The process of engraving a design on glass with various copper wheels and abrasives. The copper wheels are fitted on a small lathe and the object to be engraved is held against the spinning wheel

Coptic art — Early Christian art, mainly in Egypt during the fifth to eighth centuries

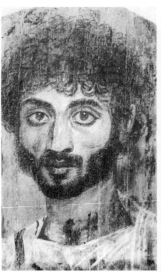

Coptic art

copy — 1. A duplication or imitation; 2. any text or illustration to be reproduced

copyboard — 1. The area of a process camera that holds the material to be photographed; 2. any board or surface on which art or other material is placed to be photographed

copy counter — An instrument that is rolled over copy to be measured and registers length in agates, picas, inches, and/or centimeters

copying process — The use of a photographic emulsion that is sensitive to light, or a form of radiation to produce an image

copy negative — In commercial work, a negative made of the original artwork

coquille board — A textured illustration board available in several different stipple finishes, used to make halftone effects through line reproduction

cork black — Pigment; vine black or Spanish black; name obsolete

cornsilk — Pigment; a pale yellow mixture

cornucopia — (Latin, *horn of plenty*) In design, a cone-shaped horn overflowing with fruit, vegetables, and flowers; a symbol of prosperity or plenty

correction tape — A white, lightweight, opaque tape used mainly in commercial art for masking and making corrections

correction white — An opaque white paint used in commercial art to make corrections or to block out an area of artwork.

corrosion — A gradual wearing away by a chemical process, especially of metals; oxidation of iron-producing rust

corundum — An extremely hard mineral abrasive used to smooth or grind

Coquille board

cotton canvas — Heavy-duty cotton, usually already primed, used as a painting surface

counterchange — In textile design, a figure-ground reversal; the background color or value is the reverse of that of the main subject; may be referred to as *interchange*

Counterchange

counter-etch — To resensitize a lithographic or other printing plate so that it will accept crayon or tusche

counterproof — 1. After a plate of woodblock has been printed, and while the proof is still wet, a clean sheet of paper is placed on the wet proof and run through the press, making an offset or reverse image called a counterproof; 2. when a pastel or chalk drawing is put through a press face-to-face on a damp paper, a reverse impression is pulled from which a new study is developed

country painting — Decorative design, with teardrop brush strokes predominating, painted on country craft articles. *See also* **tole painting**

country print — In textile design, a rural floral or patchwork pattern

coverage — In textile design, the amount of design within a given space

cover paper — A heavy-duty colored paper used for covers of brochures, catalogs, cards, etc. *See also* **cover stock**

cover sheet — *See* **flap**

cover stock — A type of smooth or textured paper produced in single or double weight, in white and colors, and used for covers, advertising, greeting cards, etc.

C.P. — *See* **cold-pressed paper**

crackle — A network of fine cracks on a painting caused by the paint becoming brittle and cracking; often due to unequal drying times of paint layers; sometimes called *alligatoring* because of the pattern formed

Crackle-it — Trade name for a fast-shrinking glaze used over decals or on glass, mirrors, etc., to create a crackle finish or texture

cradle — The wood stripping on the back of a painting panel that helps to stiffen it. *See also* **rocker**

Craftint — Trade name for certain types of chemically screened papers, the patterns of which are activated when developer is applied; also a line of paints and other art supplies

craftsmanship — The skill with which one uses tools and materials

cranium — The skull

craquelure — (French, *crackle*). *See* **crackle**

crawling — Term given to a tendency of paint, inks, or dyes to spread outward on application in a crawling fashion

crayons — Drawing sticks of colored wax

crayon manner or **chalk manner** — An etching or engraving process in which a multipointed tool creates the effect of a crayoned or chalked area on a plate, for intaglio printing

Cray-Pas — Trade name for oil stick colors that combine qualities of crayons and pastels, do not need to be fixed, and can be used with turpentine to create a special effect

creative — Having the ability to use imagination, to express ideas, and to present them in an individual and effective manner, especially through the arts

creep — 1. The tendency of ink or paint to move by itself on the surface of a paper or support; 2. moving forward of the blanket during the printing process

creeping bite — Etching performed in stages by gradually submerging the plate into the acid

Cremnitz white — *See* **white**

crepe paper — A paper with a crepe texture, available in many colors, used for decorations and crafts

crest — In design, a crown or coat of arms. *See also* **heraldic**

crevé — In etching, the collapse of a whole area of a plate where lines are close together and the plate is left in the acid too long

criblée — Covered with dots punched on an engraving plate to create an image; also a technique of surface decoration with dots; also called *dotted manner; maniére criblée; schrottblatt*

crimson — A deep red hue; close to cadmium red deep on the color chart

crimson lake — Pigment; a transparent lake color similar to alizarin crimson, permanent

critic, art — One who expresses his personal judgment of works of art; usually also a writer on art

critique — A constructive discourse covering a work or works of art, pointing out areas that are well done as well as things that might be improved

crop marks — Marks or indications on artwork or photographs to be reproduced that give instructions where to crop or cut

Croppers

croppers — Two *L* shaped pieces of mat board held around a picture to judge how a composition can most effectively be cropped

cropping — Cutting a picture down or trimming it from its original dimensions to a specific size

croquis — (French, *sketch*) Sketch and notes that will be used for a full art rendering at a later date; often used in fashion drawing

cross — A motif with two intersecting lines, often symbolic

crosshatch — A means of creating a tonal effect by repeated and parallel horizontal, vertical, or diagonal lines

Cross hatch — drawing by **Joseph Clement Cole**

cross-joint ruling pen — A ruling pen with a cross joint that allows one blade to be moved without changing the thickness setting, for easy cleaning

crossmarks — *See* **registration marks**

cross section — A rendering that shows an inside section of an object by cutting through it, usually at right angles

cross-sectional paper — A finely milled graph paper on which the square-inch lines are accented

crow quill pen — A small dip pen with a fine steel nib, used for sketching or drawing, where thin lines are needed

cruciform — In the shape of a cross

crux ansata — *See* **ankh**

C-scroll — A design in the shape of the letter *C*

cube — A solid form consisting of six equal square sides

cubism — An abstract art movement of the early twentieth century, initiated by Pablo Picasso and Georges Braque; in painting, a means of representing volume in a two-dimensional plane without resorting to the illusion of depth as usually developed within the picture space; in sculpture, in Africa, Oceania, and Alaska, cubistic form was used at much earlier dates

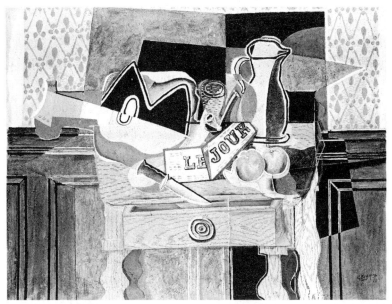

Cubism — **Georges Braque** The National Gallery, Washington, D.C.

Cupid — In design, a chubby, nude infant; derived from the god of love in Roman mythology

Cupid's bow — The middle hollow above the upper lip

cursive — Flowing, as in lettering or type that imitates handwriting; also used to describe flowing design

curve — *See* **French curve**

Curve ruler

curve ruler — A piece of rubber or plastic that can be bent into various curves as an aid in scribing lines

curvilinear — Having curved lines

cushion — *See* **engraver's pad**

cushion blanket — In intaglio printing, the middle blanket on the press that pushes the paper into the hollows of the plate

cut — Originally meaning *woodcut*, used loosely to describe any type of plate for printing and the print thus made

cutaway — A drawing or other artwork where the outside of an object is cut away to reveal the interior. *See also* **cross section**

cutter — A flat bristle brush with its edge cut on an angle, used by sign painters. *See also* **mat cutter; paper cutter**

cutter, paper — *See* **paper cutter**

cutting — In textile design, a small sample of fabric showing a design and its colors

cyanine blue — Pigment; a mixture of Prussian blue and cobalt blue, permanent

Cycladic art — Art of the islands of the Aegean Sea called the Cyclades, about 2600-1100 B.C.; consisted mainly of pottery and sculpture

cylinder — A pipelike form; a rotating part of a printing press

cylinder printing — *See* **direct printing**

Cyprus green — Pigment; almost a blue turquoise, moderately permanent, gouache

Cyprus umber — Pigment; Turkey umber, raw umber, name obsolete

D'Arches — *See* **Arches**

dabber — In graphic arts, a pad of leather or cloth used to apply ink to a plate of type

dada — (French, *hobby horse, a word picked at random from a dictionary*) An antiestablishment art movement during World War I expressing outrage at the conditions of the world and cynicism and rebellion toward traditional art forms; major artists were Hans Arp, Man Ray, Max Ernst, and Marcel Duchamp (who produced a porcelain urinal and sent it to a New York art show); considered a forerunner of surrealism

Dagger stripper

dagger — A dagger-shaped brush used by sign painters for striping

Dali, Salvador — a prominent surrealist who was born in Spain. In 1940 Dali came to the United States, where his provocative style and personal demeanor made him newsworthy. Many of his paintings have a dreamlike quality and are realistically rendered.

damar varnish — A final varnish for oil and tempera paintings, used when the picture is completely dry (about six to twelve months for oils); colorless; available in spray or liquid form; European spelling, *dammar*

damask — In textile design, a firm cloth with an elaborate raised pattern of fruit and flowers, made by directions of thread against a plain background

Salvador Dali, "The Persistence of Memory" (detail)

damping the paper — 1. In watercolor, putting water on paper with a brush or sponge; 2. in graphics, placing paper in a tray of water for a period of time (depending on the kind of paper), then putting it between two blotting papers to absorb the moisture before printing

damp paper — Paper that is drying, but still cool to the touch (not completely dry); said about watercolor paper

damp press — In graphics, a means of dampening paper, using a box lined with oilcloth, rubber, or zinc

dance of death — In the Middle Ages, a recurring *subject* of pictures, depicting skeletal figures accompanying human figures to their deaths.

danse macabre — (French, *dance of death*) *See* **dance of death**

Davy's gray — Pigment; a warm gray used in watercolor, permanent

dead area — 1. An area not desired in a picture and dropped out by use of retouch white; 2. in a painting, an area that has little appeal and weakens the composition

deadline — The final time or date when artwork is due

dead metal — 1. Excess metal in areas not to be printed from a relief printing plate; 2. discarded type that will be melted down for reuse

debossment — The act of pushing into or cutting below the image surface

decal — A design or picture that is transferred from paper to another surface

decalcomania — 1. The process of transferring specially prepared printing from its paper

to another surface; 2. a technique of blot drawing used by the surrealists for inspiration in painting

deckle edge — The decorative ragged edge on quality watercolor paper and on many paper stocks used for printing (one edge deckled on each sheet)

décollage — A reverse collage made by tearing away parts of paper layers and revealing colors or images that are part of the final artwork

decor — The decorative style employed in an interior; may sometimes pertain to an area or period of time, such as Spanish, Louis XIV, Pennsylvania Dutch, etc.

decorative — Ornamental, fashionable or beautiful objects used in interiors; embellishing a surface, as furniture or pottery

decorative overload — Too much surface decoration in an artwork

decorator colors — An overused word for describing special colors promoted by commercial designers, coordinated for the use of professional decorators in interior design

découpage — (French, *cut out*) A decorative technique in which cut-out pictures or designs are pasted onto a firm surface and then varnished

deep etch — The preparation of a printing plate for a long print run

del. — (Latin, abbreviation for *delineavit, he drew it*) On an engraving, the artist who drew the original for the print

deltoid muscle — A thick muscle covering the shoulder joint, triangular in shape; raises and rotates the arm

demi-teinte — (French, *half-tone*) or mezzotint

density — Thickness, used in relation to paint thickness or amount of opacity

derby red — Pigment; a bright chrome red, fugitive, toxic, obsolete

descender — The part of a lowercase letter that descends below the line, as in p, q, g

descriptive art — Art that is realistic or representative of actual things

desensitize — In lithography, to render areas insensitive to grease on a stone or plate with acidified gum etch

design — 1. To plan the grouping or arrangement of the elements in a composition; 2. in flat design, the motif or pattern. *See also* **design elements**

design elements — Line, shape, size, value, color, direction, and texture

designer — One who creates or designs art or applied art

designer's colors — gouache; high-quality opaque watercolor

De Stijl — A Dutch art movement, 1917-1928, also known as neo-plasticism, employing rectangles and primary colors; the major artist was Piet Mondrian; a magazine of the same name was published by the group, featuring articles on pure abstraction

details — All the little particulars evident in a work of art

devil's mask — (Chinese) Two animals, birds, or other motifs made into a design forming a third and larger animal design

diagonal — Oblique line or pattern in a composition

diameter — A straight line passing through the center of a circle or sphere; the length of such a line

diamond black — Pigment; carbon black, name obsolete

diamond point — A diamond-tipped needle used to directly incise a plate. *See* **drypoint**

diamond repeat — In textile design, a repeat pattern in the shape of diamonds or lozenges

diaper — 1. In textile design, small squares or diamond shapes connecting to form a network, as a block or diamond repeat pattern; 2. an identifiable fold pattern in drapery

Diamond repeat

diffused light — Light that is distributed or spread, rather than focused

diffusion — In painting, a spreading, blending, or blurring

dimensions — In art, the measures of spatial extent—height, width, and length

diminution — In visual perspective, the effect of things appearing smaller as they recede

Dingler's green — Pigment; a variety of chromium oxide green, a dark green close to Phthalo green on the color chart, name obsolete

dioxazine purple — A synthetic true purple, durable, acrylic

dipper — *See* **palette cup**

diptych — A pair of carved or painted panels, hinged together like a book

Fourteenth century ivory *diptych*

direction — In art, the pattern of movement the eyes follow through a picture; the "eye path" that is controlled by careful manipulation of the elements of design

directoire style — Late eighteenth-century French style in decorative arts that was a simplified combination of Louis XVI neoclassicism and the Empire style

direct printing — Calender, roller, or cylinder printing where the paper is in direct contact with the printing plate; in textile design, it is the same method as newspaper printing, but each color has a separate roller, some machines taking up to sixteen colors

direct transfer — In lithography, transfer of an image directly to the stone from an inked object

discord — Lack of harmony in a composition

display — A branch of commercial art given to the design of exhibits

display face — *See* **display type**

display letters — Large letters in various fonts made in plastic, cardboard, wood, aluminum, etc., used for indoor and outdoor advertising and exhibits

display type — A large typeface for headlines, to attract attention

disposable palette — A pad of oil-proof paper in the general shape of a palette; after use, the top sheet can be torn off and thrown away

disposable watercolor cups — Small indented cups used in a specially made aluminum tray for holding or mixing colors

dissymmetric — Not symmetrical. *See* **symmetrical**

distemper — A matte-finish paint process using powdered pigment mixed with water-base glue size for large areas such as walls and stage sets; popular around 1900; poster and

showcard colors, but not tempera paints, are offshoots of this process; term mostly British

distort — To deform, elongate, angularize, misshape, twist, or exaggerate

divided interest — The effect of two or more points of equal interest in a composition

dividers — Drafting instrument used for dividing lines and transferring measurements

divine proportion — *See* **golden mean/golden section**

divisionism — A term for pointillism or optical mixing. *See also* **pointillism**

Distortion

doctor — 1. In lithography, a greasy fluid used to strengthen the work; 2. a painting knife or scraper used to remove paint from a surface; 3. in general artwork, to repair or correct any mistake

documentary — In textile design, an original fabric and design, as very old cloth from China from which a present design is copied

dominant — In art, having paramount importance in a picture or design

dominant color — The main color; the predominating color in a composition

dominant tint — *See* **mother color**

doodle — To draw or scribble with little or no conscious thought about the result

Dorland's wax medium — Trade name of a concentrated wax used for encaustic painting and for preserving sculpture, carvings, and paintings

dorsal — *See* **vertebrae**

dotism — Slang for pointillism

dotted manner — *See* **criblé**

double elephant — *See* **watercolor paper sizes**

double image — In drawing or painting, a subject that can be two different things, such as a tree that is a hand or a cloud that is an eye

double load — To fill a brush with one value or color and then tip the brush with a second value or color

double run — Running a plate through the press twice to create a heavier impression

double spread — Illustration or copy occupying two facing pages of a publication

double truck — A newspaper printing term meaning two facing pages dealing with the same story or material; a double spread. *See also* **truck**

dovetail joint — 1. An interlocking joint; 2. in textile design, a point where a portion of a repeat fits into a part of the next design without touching it

double primed (D.P.) — Said of canvas having two coats of priming, such as gesso

drafting film — A polyester film used for drafting in ink

drafting tape — A crepe paper pressure-sensitive tape used to secure a drawing to the drawing board, mat, etc.; similar to, but not as sticky as *masking tape*; is easily removed without damage to drawing

draftsman/draughtsman — One with excellent drawing ability; one who renders architectural, mechanical, or engineering drawings

drag — To pull a paint brush across an area of a painting so it drags and catches, leaving an uneven texture. *See also* **dry brush**

dragon's blood — 1. A red resin used as an etching resist in photoengraving; 2. a blood-red transparent resin once used in Europe, now obsolete

drawing — An art technique using pencil, pen, brush, charcoal, crayon, pastel, or stylus; an entity in itself, or may be used as a preliminary for a rendering in another medium

drawing board — A rectangular panel, usually wood, used as a base for drawing

drawing bridge — A wooden support for the artist's hand and to keep it off the surface of the picture; often used while working over a wet paint area, or on a litho stone

drawing table — A table used for artwork, adjustable in height and slant

draw through — Drawing the back, unseen side of a subject

draw tool — In graphic arts, a tool with a hooked blade used to "hand cut" a plate

Draw tool

dressing — 1. In tole painting, the medium that is commonly called *goop*; 2. the ornamental top strokes applied to folk art

dried lacquer work — *See* **kanshitsu**

drier — A prepared liquid (a siccative) added to paint to speed the drying process; cobalt drier is used in artists' materials, Japan drier in sign painting and industrial paints

drizzle — In painting, to drip paint or let it run into a pattern

Dr. Martin's flex-opaque — Trade name for a medium used with opaque paint to prevent it from crawling on smooth surfaces

Dr. Martin's watercolors — Trade name of a concentrated color in liquid form, used mostly in design work; available in many colors

drollery —.Comic or humorous content in a picture, such as cats cooking supper

droodle — A picture without meaning until a caption is added

drop black — Pigment; a carbon black made from burnt vegetable and animal matter

drop-out — A portion of original art that is not sufficiently dense to reproduce when making a half-tone plate

dropout marker — Light blue pen or pencil that will not reproduce when photographed with normal reproduction film; used for instructions on copy and mechanicals

dropping out — In platemaking and printmaking, cutting, digging, scraping, opaquing, or otherwise eliminating lines, tones or colors

Dry brush

dry brush — With ink, watercolors, or other mediums, a method of painting with very little color or moisture on the brush, creating a "skipped" or "missed" effect

dry-brush blend — A flat dry-brush stroke that blends two values or colors

dry-cleaning pad — A small pad containing a powder that absorbs dirt, used to clean drawings

dry-in — Name given to oil paint that gets dull as part of the picture dries-in and loses its shine; retouch varnish is used to restore the luster to the level of the newly added paint

drying oil — In graphics, an oil such as linseed or tung oil, which changes to a solid as a result of the action of oxygen

dry lithography — A lithographic printing method using a chemical coating that repels ink

dry mounting — A method of attaching a print, drawing, or photograph to a cardboard backing by placing a sheet of dry mounting tissue between the artwork and the cardboard and then applying heat for adhesion

dry-mounting press — A machine that adheres drawings, photos, and other papers to cardboard, using heat and pressure

dry-mounting tissue — Tissue with a thermosetting heat seal adhesive used between a paper and a cardboard surface for dry mounting

dry offset — A process in which ink is transferred from a relief to a printing blanket, and from there to the paper

dry pigments — Pigments in a dry powder form, ready for grinding

drypoint — A graphic art in which a needle scratches directly onto the plate and the burr is allowed to remain, producing a soft effect in printing but limiting the number of prints obtainable

dry-relief offset — A type of offset printing in which photomechanically made plates print without dampeners or water; also called *high etch*

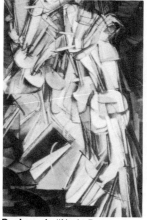

Duchamp, Marcel — 1887-1968, a French painter and sculptor. He shocked the art world at the 1913 Armory Show when he exhibited his *Nude Decending a Staircase,* a cubistic, futuristic work. He was part of the Dada movement and often used found objects to stand as works of art.

Duchamp's "Nude Descending a Staircase"

duck canvas — A durable cotton canvas ranging in weight from 5 to 24 ounces per square yard, used mainly as a painting support and available in different weaves

duotone — The process of using two halftone cuts of the same black and white illustration; the screened plates are angled slightly so the printed dots do not overlap; one plate is usually printed in black, the other in a second color, such as red or blue

duplex paper — A paper made with a different finish or color on each side

duplicating process — A process for making a number of copies from an original, with images being formed by transference from plates, type, or stencils onto white or colored paper

durable — A term used for class *A* pigments

dust bag — Ground-up rosin in a cloth bag, used in making aquatints

dust box — A box in which rosin is applied to a plate for an aquatint

dusting brush — A brush used to clean artwork

dust jacket — *See* **book jacket**

Dutch mordant — A mordant used for the etching of fine lines. *See also* **mordant**

Dutch pink — Pigment; in addition to a tint of red, a yellow lake, fugitive; also called English pink, brown pink, and stil-de-grain

Dutch white — Pigment; a white lead, toxic, darkens with age

dyes — Pigments that dissolve completely, are transparent, and have no bulk

dyes, batik — Highly concentrated dyes used to color cloth. *See also* **batik**

dyestuff, natural — Natural coloring matter taken from plants and animals

dye transfer — A photographic process used in making color prints, now seldom used

dynamic symmetry — A theory of design linked to the formula of the golden section; at one time many artists followed it as an aid to achieving the perfect composition, but the system is now rarely used. *See also* **golden mean/ golden section**

Dynamic symmetry, or root-2 projection, is based on extending a square according to the arc of the square's diagonal.

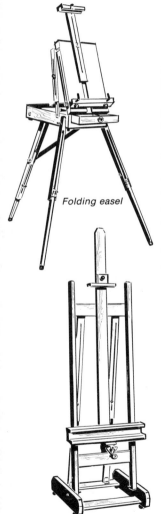

Folding easel

Studio easel

E.A. — (French, *epreuve d' artiste*) Artist's proof

Early Christian art — *See* **Byzantine art; Coptic art**

earth colors — Pigments, such as yellow ochre, burnt sienna, the umbers, made from minerals such as iron, manganese, copper, etc.; yellow ochre, for instance, is refined clay colored by iron oxide and chrome yellow; such colors have been used since prehistoric times

easel — A free-standing structure used to hold a canvas while painting

> **French easel** — A folding, adjustable easel originally made in France, having an attached box for supplies and a place to hold a canvas or paper
>
> **portable studio easel** — A sturdy and adjustable easel, but lighter than a studio easel; folds for convenience in storage
>
> **sketching easel** — A lightweight, adjustable wood or aluminum easel; folds for convenience in carrying or storage
>
> **studio easel** — A sturdy easel in design and structure; adjustable and often has casters for easy movability
>
> **table easel** — An easel that is set up on a table; folds for convenience
>
> **watercolor easel** — An adjustable, folding, portable easel that may be used outdoors, mainly for watercolor painting

easel painting — A painting executed on a support held on an easel, rather than directly on a wall or ceiling; usually refers to studio painting rather than painting on location outdoors

Easy wipe — Trade name of a chemical compound that is mixed into graphic ink to keep it fluid for easy manipulation

ébauche — A monochrome lay-in over a drawing, later to be painted in full color; an underpainting

ebony — Pigment; a brownish black color

ebony pencil — Sketching and layout pencil, very dark black, and having a rod of a larger diameter than a standard pencil

echo — In composition, a repeat of an element such as a shape, texture, or color

echoppe — (French, *graver*) An etching and engraving needle ground to an oblique face

ectype — A copy or replica of an original artwork

ecru — A golden tan, considered a neutral color

edges, hard — Sharp lines and forms that do not blend into adjacent areas

edges, soft — Limits having no definite line but allowing a value or color to blend and blur into the adjacent areas

edition — The number of prints, such as lithographs or etchings, pulled from the original stone or plate; each print identified by the artist according to the total number and the sequence in which they were pulled; the fifth print in an edition of twenty would be stated in the margin in pencil as 5/20; an edition can be of any number, but seldom more than 100

egbert — A long-haired, round-tipped brush with a long handle

Egg and dart

egg and dart — A running design, alternating the shape of an egg and a dart

eggshell — An off-white or neutral color

eggshell finish — Finish on a paper that resembles the surface texture of an eggshell

egg tempera — *See* **tempera**

Egyptian art — A stylized, flat, decorative art developed and practiced in ancient Egypt

Egyptian blue — Pigment; an artificial blue used in Egypt about 3000 B.C., now replaced by a mixture of cobalt blue, cerulean blue, and viridian, or of cerulean blue, a small amount of white, and phthalocyanine green; also called Alexandrian blue, coeruleum, copper glass, Italian blue, Pompeian blue, Pozzuoli blue, and Vestorian blue

Egyptian cross — *See* **ankh**

Egyptian green — Pigment; a greenish Egyptian blue, obsolete

Eight, the — *See* **Ashcan school**

eikon — *See* **icon**

Egyptian art, circa 1400 B.C.

electric eraser — A revolving, rubber-tipped eraser driven by a small electric motor

electron painting — A graphic art developed by Caroline Durieux in which radioactive isotopes are used for the image-making process

electroplating — An electrochemical process by which a thin layer of metal is deposited on another metal's surface

electrotype (*electro*) — A facsimile printing plate made from an original plate by means of electroplating

electrum — A natural gold and silver alloy, used for casting and in sculpture; also, an alloy of nickel, copper, and zinc, sometimes called *German silver*

elements — *See* **design elements**

elephant — *See* **watercolor paper sizes**

ellipse — A curved, elongated, oval shape

ellipsograph — A tool that draws mathematically true ellipses, using a pencil, pen, scriber, or cutting knife

elliptic graver — A special graver for wood engraving, having curved sides that can produce thick and thin lines; sometimes called a *spitsticker*

em — A unit of type measurement; the width of the type is equal to the point size; for instance, a 6-point em is 6 points wide

embellish — To ornament or add decoration

emblem — A design that is a symbol or insignia, such as a heraldic crest used on seals, stationery, clothing, etc.

emboss — To create a relief or raised design

Emblem —
The British coat of arms

embossed print — A relief print made by pressing into the paper with an intaglio plate; also called a *gypsographic print* and *inkless intaglio. See also* **white-on-white; blind pressing**

embroidered design — A design made with needlework; may be handmade or machine-made

embu — A dull area in an otherwise glossy picture, usually caused by the paint sinking into the canvas

emerald chromium oxide — Pigment; viridian green, name obsolete

emerald green — Pigment; a brilliant green, toxic and fugitive; obsolete

emeraude green — Pigment; a confusing name for viridian green; although *emeraude* means emerald, it is not emerald green; transparent

emery — A polishing and grinding agent for metals made from corundum

emotional color — Color used for its emotional impact rather than for realistic representation

empaquetage — *See* **wrapping**

emulsion — A suspension of small drops or globules of one liquid in a second liquid with which they do not mix; a condition found in egg tempera

en — A type measurement term meaning one half of an em. *See* **em**

enamel — A vitreous glaze applied to metal or ceramics, then fired in a kiln. *See also* **champlevé; cloisonné**

enamel paint — Paint that dries hard and shiny, suggesting the quality of baked enamel

enamel paper — Paper with a fine clay finish

enamel white — Pigment; *blanc fixe,* a base for watercolors and frescoes

Second century *encaustic* painting on wood panel

encaustic painting — A method of painting with hot wax mixed with pigment, difficult to control but extremely durable; some examples exist that were done in the first century B.C.; also called *cerography*

English finish — A paper finish that is between machine finish and supercalendered finish

English pink — Pigment; *see* **Dutch pink**

English red — Pigment; a light red iron oxide; close to Venetian red on the color chart, permanent

English varnish — *See* **megilp**

English vermilion — Pigment; a bright red close to cadmium red light on the color chart

English watercolor technique — A technique using transparent washes, alone or as a means of building up color through glazing

engrave — To incise, carve, or cut into a hard surface

Partially completed *engraving*

engraver's charcoal — Charcoal in block form, used to polish plates in graphics

engraver's pad — A leather-covered pad filled with sand, used to support a plate during the engraving process; also called a *cushion*

engrossing — Decorating with calligraphy and border designs on certificates, citations, etc.

en kin — (Japanese, *what is far and what is near*) Perspective

eraser — A device for cleaning off finger marks or pencil marks, or correcting a drawing; there are many kinds, such as pink pearl, kneaded, artgum, and felt erasers. *See also* **air eraser; electric eraser**

erasing shield — A metal or plastic shield with various-shaped slots, used along with electric erasers and manual stick erasers to avoid errors in erasing

espagnolette — A bust of a smiling young woman, originally in bronze

essence — A compound mixed into paints to create a sparkle

esquisse — (French, *outline*) A preliminary sketch and notes, for a painting or sculpture with more detail than a croquis

etching — An intaglio process of creating a design on the surface of a metal or other plate with a needle, and using a mordant to bite out the design; the resulting print is called *an etching*

Etching (detail) Anders Zorn

etching ground — A thin, usually darkened acid-resisting coat applied to a plate, on which the design is incised

etching ink — A special thick ink made for etching, available in different colors

etching needle — A tempered piece of steel, sometimes in a wooden handle, used to incise a design on a plate for etching

etching paper — Paper specifically made for etching, lithographs, and block printing, avail-

able in hot- (smooth-) pressed or semismooth finish

etching press — A printing press designed especially for printing intaglio plates

Etruscan art — Art from early Etruria, a part of Italy; the culture dates from the seventh century B.C. to about the first century B.C.

euchrome — Pigment; burnt umber; name obsolete

exc. — (Latin, abbreviation for *excudit, he executed it*) Used on a print as credit for the one who printed it, as differentiated from the one who engraved it

expressionism — A twentieth-century art movement that turned away from the representation of nature and to the expression of emotional intensity; forerunners were Vincent Van Gogh and the Fauves; other such artists were Georges Ronault, James Ensor, Marc Chagall, and Emil Nolde

Expressionism — "The Cry" (detail) lithograph by **Edvard Munch**

extender — A substance added to an inert pigment in order to increase its bulk or reduce its color strength

extensors — Muscles in the lower arm that move the fingers

eyedropper — An implement useful for transferring or measuring water or other liquids, one drop at a time

eye level — The horizon line, in mechanical perspective, where two parallel lines meet at the vanishing point

eye path — The movement pattern the eyes follow when studying a picture

eye trap — An element that attracts attention to a particular area of a picture, sometimes a void

F

facade — The main face or front of a building, usually given special treatment, as the facade of a cathedral

face — A front surface; the front part of a human head. *See also* **typeface**

fan brush — A bristle, sable, or synthetic brush made in the shape of a fan with a long handle; used to blend colors or to create texture in a painting, especially in trees and shrubs; more sparsely bristled than a badger blender

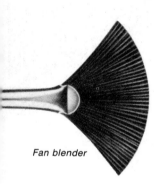

Fan blender

fantastic realism — Very realistic rendering in fantasy art

fantasy — A product of the imagination; an artwork produced from the imagination

fast frame — *See* **braquette**

fat over lean — In oil painting, the practice of painting "lean" or with less oil at first, with top layers painted "fat" or with more oil, to allow changes in the lower layers (expansion, contraction) without cracking the surface

Fauvés, les — (French, *the wild beasts*) The first major aesthetic movement of the twentieth century, it was led by Henri Matisse in France in 1905-06; the outstanding characteristic of the Fauvés was their use of pure, bright, explosive color (often squeezed straight from the tube for directness and emotional effect)

rather than tone; other important artists in the movement were André Derain, Maurice Vlaminck, Georges Roualt, Raoul Dufy, and Georges Braque

Fauve — **André Derain**

fawn brown — Pigment; a combination of dark ochre with either raw or burnt umber, also called *velvet brown;* names obsolete

feather — To blend an edge so that it fades off or softens; to overlap values and colors in the manner of the overlapping feathers on a bird

feathering — In etching, to stir or move around the bubbles of the acid with a feather, brush, or pipe cleaner

features — The parts of the face: nose, mouth, eyes, etc.

federal blue — A grayed blue color used in Early American decor

felt finish — Term describing paper that imitates felt

felt side — Said of the smoother side of paper, the top side in papermaking

felt-tip markers — Pens or cartridges with soft, felt-like, fine to broad tips, used for sketching, drawing, and layouts; permanent or watercolor, in a wide range of colors

femur — The thighbone, located between the pelvis and knee

fence — In sculpture, the piece of metal or clay used as a separation in a piece mold of plaster

ferric chloride — In etching, a liquid used on both copper and zinc printing plates as a mordant

ferrule — The metal part of a brush that holds the hairs or bristles

Ferrarese school — Mid-fifteenth-century Italian and Flemish artists around Ferrara, Italy, who painted in the Gothic and Renaissance styles; leading artists were Piero della Francesca, Pisanello, Jacopo Bellini, and later Dosso Dossi

festoon — A decorative motif made up of flowers or fruit and leaves held together or interlaced with ribbons

fiberglass eraser — A fiberglass brush in a holder, used to remove ink and other marks difficult to eradicate from paper

fiberglass paper — Paper made of fiberglass, used for many mediums; lies flat, though wet, without buckling; Strathmore Aquarius is a trade name for a part cotton and part fiberglass paper; Scintella is a trade name for a fiberglass paper with a texture in which the fiber is raised, giving the paper a definite shine or "twinkle"

fibula — The smaller bone in the lower leg occupying the outside and posterior part of the leg

field — The overall illumination in a picture; for example, if the majority of elements appear bright, the field is bright; if grayed, the field is grayed

field of vision — Everything that is visible without moving the eyes. *See also* **cone of vision**

figurative — 1. Representational; 2. a painting depicting a human figure(s), more real than abstract

figure-ground reversal — In design, the background and the main subject reverse colors and/or values; same as **counterchange**

filbert — A flat artist's brush with an oval-shaped point

Filberts

filigree — Delicate, ornamental openwork of fine wire; lacelike ornamentation mainly used in jewelry

fill — 1. In textile design, the crosswise (horizontal) yarns, woof, or weft; 2. the small designs that are added to fill in around a major motif

filler — An inert pigment added to a paint or pigment to extend it or cheapen it

film stripper — In platemaking for photolithography, the person who handles the films and negatives for plating; fits, positions, and assembles the negative film elements

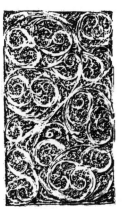

Filigree

fine art — Art primarily produced for the artist's satisfaction rather than for direct commercial purposes; does not necessarily denote quality

fine manner — A means of engraving with a fine crosshatching that can approach a wash effect

finish — Treatment of the surface of a painting or photograph, such as glossy or matte, or of paper, such as smooth, kid, etc.

finished artwork — Artwork ready to go to the printer or exhibition

finished, highly — Having a very glossy finish; said also of a work of art with exact and complete details

fire — 1. In artwork, a characteristic of colors that are vivid or exciting, or of a piece of artwork that is exciting; 2. to bake in a kiln

fire-engine red — Colloquial for any bright red

firmer — In wood carving, a chisel that is flat-bladed and double-beveled

Chiseled edge fitch brush

fish-scale motif — A pattern resembling fish scales

fitch — A long, flat sign-painting or lettering brush with a chiseled edge; fitch, or polecat, hair is also used in some "camel hair" brushes

fixative — A permanent waterproof spray used to protect artwork such as pencil drawing, charcoal, pastels, etc., from smearing

fixed palette — A limited number of colors to be used for a particular painting

flake white — Pigment; *see* white

flaking — Separating of small particles of paint from a painting

flame black — Pigment; a brownish carbon black, inferior to lampblack

flame red — Pigment; an orange red similar to cadmium red light, gouache, permanent

flap — A cover for artwork; often made of transparent paper or acetate; also called a *cover sheet*

flat — 1. Term describing the finish of a picture as lusterless; 2. term for an application of paint that has no variations in value or color and no brush marks showing; 3. a brush with oblong hairs and a long handle, available in bristle, sable, and synthetic; 4. in printing, the assembled composite of films ready for platemaking

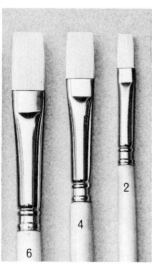
Flats

flat sketching pencil — A flat pencil used for sketching and layouts, available in 2B, 4B, and 6B; sometimes referred to as a carpenter's pencil

flat wash — An even color or value of wash over an area in a picture

flavine lake — Pigment; yellow quercitron lake, fugitive

Flemish white — Pigment; a lead white, toxic

flesh tint — Pigment; a prepared Caucasian flesh color, permanent; since flesh tones vary considerably, most professionals prefer to mix their own flesh colors

flesh tone — Any color imitating flesh, be it white, black, brown, red, or yellow; usually a mixture of two or three colors

flexible ruler — *See* **curve ruler**

Flextex — Trade name for a compound of marble dust and opaque white acrylic, used to produce a texture

flimsy — The transparent overlay paper used on a piece of artwork for protection and notations

flint paper — A highly coated paper with a glossy finish, used for packaging and displays, available in many colors and white

flip board — Usually a gesso-coated cardboard or Masonite, used in graphics to turn over or flip a print

flock — A soft-textured, pulverized product of wool, cotton, rayon, etc., that is glued or sprayed onto cloth or paper, creating a velvety effect, either solid or in a pattern

flong — A term referring to strong tissue paper pasted to thick blotting paper, used in making stereotype printing plates

floodlight — A portable light used for lighting effects when painting portraits or still life, and for photography

Calligraphic *flourishes* by
Charles Pearce

flop — To reverse or turn over a design or photograph from left to right or vice versa

Florentine brown — Pigment; a brownish Vandyke red; toxic; darkens

Florentine lake — Pigment; crimson lake, obsolete

flourishes — Fancy or decorative embellishments on calligraphy or lettering

flour paste — Wheat flour and water mixed together to form a paste

flow — 1. The ability of a printing ink to spread; 2. the movement of the eyes through a picture

fluorescent pigments — Brilliant, synthetic, luminous paints that glow or have a fluorescent effect in daylight and in the dark under black light; familiar as Day-Glo Colors, a trade name

flush — Up tight to a line or edge, next to or touching without overlapping

flush left or **flush right** — Lined up at the left or the right of a column without indention

flux — In metal sculpture, a substance applied to metal to make the solder flow and stick

foamcore board — Board with a plastic foam center faced with white paper on both sides; lightweight and sturdy, used, among other things, for mounting or backing pictures

focal point — The center of interest in a picture

foil — 1. Any visual means in a picture employed indirectly to enhance or support another area, often accomplished through contrast of color, value, texture, etc.; 2. thin leaf of metal used in jewelry making, sign painting,

etc.; 3. a small arc or lobe used in threes and fours, as in Gothic tracery. *See also* **trefoil; quatrefoil**

foliated — Decorated with leaves or with foils

folk art — Art and handicrafts produced by untrained people, usually of a traditional decorative style, such as tole painting, hand carved toys, handcrafted ironwork, embroidery, calligraphy, scrimshaw, etc.

font — In type, a complete selection of one size and face including numbers and punctuation marks; a standard typewriter has a font of type

Fontainebleau school — A group of Italian and French painters working at Fontainebleau, France, in the mid-sixteenth century. *See* **Mannerism**

foreground — The area in a picture that seems to be closest to the observer

foreshorten — To shorten forms in a drawing as they recede from the foreground in order to maintain the proportions that appear natural to the viewer

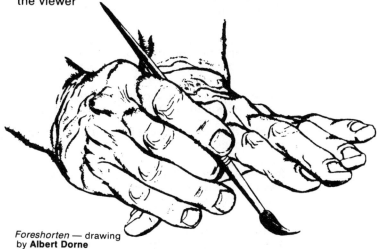

Foreshorten — drawing
by **Albert Dorne**

form — The three-dimensional shape and structure of an object

formal balance — Bisymmetry; equal weight or importance on both sides of the center

formalism — The tendency toward symmetrical balance; a devolution from naturalism toward the stylized

format — Layout or makeup of a book, paper, magazine, etc.; its appearance in size, shape, type, and design

foul bite — In etching, the accidental biting of an area, causing unplanned inking

foundation white — Pigment; a variety of flake white used for priming or foundation coats

found materials — Pieces of sand, glass, cans, lids, etc.; used in collage, assemblages, and sculpture

fountain — In printing, a reservoir on a press for the ink supply

fountain Sumi ink brush — A fountain brush (sable) with a barrel for the ink; takes refills

fractured planes — In pictorial composition, planes that have been "chopped up" and re-aligned; also referred to as *split planes*

frame — A border of molding surrounding a picture to enhance it and to facilitate hanging it

Frankfort black — Pigment; a carbon product, name obsolete

free — Applied to art, a loose and not exact treatment in drawing or painting; a broad manner, not clipped or tight

free-form — Irregular in shape; usually used to describe forms that depart from the rectangular and flow in curvilinear freedom

freehand drawing — Drawing without the use of mechanical aids

free-lance artist — One who does artwork for several different employers, not on salary or on a specific day-to-day basis

French blue — Pigment; French ultramarine blue, permanent

French bristle — A silky, thin bristle, usually white, used for brushes

French chalk — *See* **talc**

French curve — A thin template, usually made of clear plastic, used to draw curves; available in many sizes and shapes

French easel — *See* **easel**

French ultramarine blue — Pigment; an artificial ultramarine blue, transparent and permanent

French Veronese green — Pigment; viridian, name obsolete

French watercolor — A coined name for watercolors that are runny or dribbly in handling

French white — Pigment; a flake white, zinc white, or silver white; toxic, permanent

fresco — A type of mural painting using lime-proof pigments painted on a fresh lime plaster, becoming a permanent part of the wall; many masterpieces were done in fresco; no longer commonly used

fret — *See* **Greek key pattern**

frieze — A horizontal band high on an external wall, often decorated with relief sculpture, or a band below the ceiling on an internal wall

Detail of fifth century *frieze*

113

frisket — A transparent paper or other material with adhesive backing, used as a stencil, or to protect areas of artwork from a wash or airbrush treatment

Frisk Film — Trade name of a self-adhesive vinyl frisket; often used for airbrush work

frog perspective — *See* **sotto in sú**

frontality — Presentation of the straight-on view of an object or scene, as in Egyptian and other early painting

frontispiece — An illustration that appears at the front of a book, near the title page

frothing etch — In lithography, a strong etch that appears to "boil" on the stone

frottage — (French, *rubbing*) The technique of taking an impression of wood, stone, or any other texture, by placing paper over the object and rubbing with a pencil, crayon, chalk, or charcoal over the surface; Max Ernst used this type of work in some of his collages; similar to the rubbings from tombstones, sculpture, etc.

Frottage taken from a tombstone

frottis — Term for a glaze or thin layer of paint

fuchsia — A reddish purple mixture

fude — An oriental brush 8 or 9 inches long with a bamboo handle, made of various combinations of squirrel, horsehair, weasel, rabbit, wolf, and raccoon; soft, round and makes a hairline point

fugitive pigment — Said of color that is not stable but changes chemically under different circumstances, usually fading

full-color rendition — Using a wide range or full spectrum of colors

full drop — In design, a repeat motif directly below the first motif

full length — In painting or drawing, from the top of the head to the feet (of a figure)

futurism — An artistic movement founded in Italy in 1909 as a glorification of machinery, speed, and violence; followed the color approach of neo-impressionists; important artists were Boccioni, Balla, Carrá, and Severini

Futurism — Painting by **Giacomo Balla** Buffalo Fine Arts Academy

fylfot — A design made up of the Greek letter gamma, called a gammadion, one of which is the swastika. *See* **gamma** and **gammadion**

gag line — A colloquial term for a caption

Gahn's blue — Pigment; cobalt ultramarine, permanent, name obsolete

gallery — A room or rooms where artworks are exhibited

gallery tone — The golden brown tone acquired by many old masters' paintings due to age, poor varnish, dirt, and the use of bituminous pigments

Galliolino — Pigment; a Naples lead yellow, obsolete

gallstone — Pigment; a variety of Dutch pink, obsolete

gamboge — Pigment used in watercolor; a transparent yellow close to cadmium yellow medium on the color chart, permanence questionable

gamboge, New — A trade name for a color close to cadmium yellow, transparent and permanent

gamma — A Greek letter resembling an upside-down *L*, sometimes used in design

gammadion — A design made up of four gammas, an example of which is the swastika or fylfot

"gang of Batignolles" — Nickname for a group led by Claude Monet who met at the Café Guerbois in Batignolles, a district in Paris; the group included artists, writers, musicians, and critics

gang run — A printing operation in which several different jobs, all of the same color, are printed at the same time to reduce cost

gang up — To put a number of items together for the printing or platemaking processes

garance — Pigment; madder lake, obsolete

gargoyle — A carved, grotesque human or animal figure projecting from the roof of a building; most popular in the Middle Ages, it was originally used as a rain conductor, the water spouting from the mouth

gas black — Pigment; carbon black, name obsolete

gauffer/goffer — A tool used to emboss a surface with decoration

gauffrage — An embossing process, using a tool called a gauffer, for decorating various surfaces

Gauguin, Paul — 1848-1903, born in Paris, a French postimpressionist, he is best known for his use of broad planes and symbolic color depicting the life of the South Seas.

Paul Gauguin, self portrait

gear — For artists, the general term includes paints, brushes, rags, easel, and all studio equipment

gel — 1. A transparent oil color medium, packaged in tube form, used to alter the viscosity and elastic quality of paint for ease of handling, drying time, and certain effects; 2. a thick, colorless acrylic medium that adds gloss to acrylic paints

gelatin — A protein product, colorless, transparent, used as an adhesive or for sizing

gelatin roller — In graphics, a firm but flexible roller used for inking and used by some artists in painting; also called a *brayer*

gellert green — Pigment; a variety of cobalt green (bluish green)

genre painting — A type of painting that portrays a phase of everyday life, such as the interior of a room, a child at play, or a person cooking; most of Jan Vermeer's work is genre painting

Piet Mondrian, geometric abstraction

geometric abstraction — The use of geometric shapes—lines, squares, triangles, rectangles, circles—to design a composition; Piet Mondrian is a leader of this style

geranium — Pigment; a dark cherry red close to cadmium vermilion on the color chart, moderately permanent, gouache

geranium lake pale — Pigment; a bright pink lake close to cadmium vermilion, fugitive, gouache

German black — Pigment; drop black, a carbon product, name obsolete

gesso — A white primer used as a base for painting canvas, wood, Masonite, etc.; can be textured or sanded smooth

gesso engraving — Process in which gesso is built up to a 1/16-inch thickness in multiple layers and an engraving is made on this hardened surface; a sealer is used to provide a good printing surface

gesture — The movement or action of a body or part of a body (arm, chin, leg, etc.) as a means of expressing an attitude

gestural drawing — A way of drawing action or movement, generally of a figure or object in motion; drawn rather quickly to express the feeling of movement, not as a detailed work of art

ghost — 1. In lithography, the remnant of a previous drawing reappearing on a wet stone. 2. The remnant of a previous painting appearing through a painting done over it. *See also* **pentimento**

giallorino, giallolino — Pigment; a lead yellow, obsolete

gilded — Covered with gold leaf or gold paint, as on a picture frame

gimmicky — Having a contrived appearance, as in paintings where sponge technique, splatter technique, dripping, salt additives, etc. are overdone

gingerbread — A lot of unnecessary decoration or ornamental details, especially in architecture

glair — A glaze or size made from the white of an egg, used in gilding and in egg tempera

glassine — A thin, transparent cover paper used over artwork or as sleeves for photo negatives

glass stain — A transparent paint in a full range of colors, used on glass, ceramics, or metal, to imitate stained glass

Sixteenth century *gesture* drawing by **Jacopo Pontormo**

Gingerbread

glaze — 1. A transparent layer of paint mixed with a medium, applied over a dry area, allowing the underpainting to show through; 2. in ceramics, a fired-on finish for pottery

glisten — A stage in the drying of a watercolor when the paper reflects light with a slight shine or luster, best seen at about a 45-degree angle to the paper

glitter — Small metallic particles that sparkle, used for decoration on signs, posters, etc.

glory — *See* **aureole**

gloss finish — A shiny finish on an artwork

gloss medium — An acrylic medium that is used to increase the gloss in pigments, and can be used as a final varnish on acrylics

glossy — A photograph printed on shiny paper

gluteus — Any of three large muscles of the buttocks: gluteus maximus—the muscle forming the prominence of the buttocks
 gluteus medius — the muscle that adducts and rotates the thigh
 gluteus minimus — the muscle that adducts and extends the thigh

glycerine — A heavy, colorless, and odorless oil used in making watercolor paints, or added to watercolor paints and gouache to delay drying time

Gmelin's blue — Pigment; artificial ultramarine, name obsolete

golden mean/golden section — An idealized proportion based on the division of a line so that the ratio of the shorter section to the longer is equal to that of the longer section to the whole; based on a mathematical theory of Euclid

Golden mean—One way to locate the ideal placement of a picture's center of interest: Start with baseline AB of any length. Drop a perpendicular line from A to point C so that AC is one-half AB. From C scribe an arc the measure of AC to point X on triangle ABC. From B swing an arc the measure of BX. The perpendicular from B to intersection of arc at Y is the height of desired rectangle. Complete rectangle ABYZ. Point M on line AB establishes the golden ratio. An arc from A, the length of AM, will place N. M and N are the coordinates for the golden section at G.

gold ink — An ink made of gold-colored metallic particles in suspension; used with pen or air brush; requires frequent agitation to keep particles from settling

gold leaf — Extremely thin beaten gold for gilding; standard is 23½ carats, but available in a number of weights and quantities

gold ochre — Pigment; transparent, permanent

goldpoint — A technique in which gold wire is used to draw on specially prepared paper. *See also* **silverpoint**

Goldrite — Trade name for a gold transfer paper; lines written or drawn on it with a ballpoint pen transfer in gold to almost any surface such as wood, metal, paper, leather, glass, or plastic

gold size — *See* **bole**

goobungie — *See* **pick-up**

goop — In tole painting, the medium used to thin the paint

Gorky, Arshile — 1904-1948, an American abstract expressionist; he was an influence on deKooning and Pollock.

Arshile Gorky, "Garden in Sochi"

Gothic — Milan Cathedral, fourteenth century

Gothic — Pertaining to European art and architecture, between the twelfth and fifteenth centuries; the building style emphasized pointed arches, cross-ribbed vaults, and flying buttresses; the scope was monumental in scale, with much ornamentation; Gothic painting emphasized human qualities striving for classical ideals

Gothic type — Also known as *spire gothic, sans serif,* and *block letter*; gothic type today is a plain sans serif face

gouache — French for opaque watercolor, permanent. Designer's colors and casein are gouache, also the mixture of opaque white with transparent watercolors can be used. Sometimes referred to as tempera

gouge — A kind of chisel used on wood, linoleum, etc.

G R — Grams per meter, stated about certain papers; 100 gr., 250 gr., etc.

gradation — In composition, a gradual transition from one form or element to another, usually with slight changes in value

graded wash — A wash with variation in color or value from dark to light or light to dark

gradine — In sculpture, a toothed chisel used to remove large pieces from marble or stone

graffiti — (Italian, *graffiare, to scratch*) Originally a drawing on an ancient wall, in modern times has come to mean crude drawing or writing disfiguring walls, doors, or any available public space

graffito — *See* **sgraffito**

grain — Refers to the texture of paper, as fine or rough

graining — In lithography, a slight roughening of the stone to give it a tooth to catch the grease crayon

grandee paper — An 80-pound cover stock in a medium texture, 20 × 26 inches, available in a variety of colors and white

grand manner — A term applied to the lofty style and noble themes advocated in the Academies; Michelangelo, Poussin, and Reynolds, among others, are said to be painters in the grand manner

granos de trigo — Dots of ivory resembling grains of wheat, used as design

granosis — In sculpture, toning or dulling the glare of stone by using an application of color mixed with wax

granular board — A sand- or marble-textured board prepared by the artist and used for pastels, etc.

grape black — Pigment; vine black, a carbon product

graphic arts — 1. Any form of art producing original prints, such as aquatint, drypoint,

etching, lithography, silkscreen, woodcut, etc.; 2. any form of art for commercial reproduction, including mechanicals, typography, layout, etc.

graphics — In a broad sense any representation by printing, drawing, and painting

graphic symbols — "Press style" symbols such as dots, lines, stars, borders, etc., used to decorate type for advertising and other printed material

graphite pencils — Drawing pencils in which the center rod is graphite; H to 9H are graduated degrees of hard (light); HB and F are between hard and soft; and 2B to 6B are graduated degrees of softness (dark)

graphite transfer paper — A thin paper coated with graphite, used for transferring a drawing

graph paper — Paper with a printed grid, available in various sizes and grids, used by designers, architects, engineers, teachers, publishers, etc.

graver — *See* **burin**

gravity folds — Folds in cloth that follow the least resistance or "fall" of the cloth

gravure, photogravure — A commercial intaglio printing process using plates or cylinders, known for its quality in halftone and color reproduction

gray, grey — Commonly the mixture of white and black; can also be produced by mixing complementary colors

grease pencil — A lithographic pencil; a pencil with a waxy, grease-like base

Grecian purple — Pigment; Tyrian purple, an inferior purple used by the Greeks and Romans; obsolete

Greco, El Theotocopulos Domenikos — 1541-1614, born in Crete, settled in Spain where he was known as *the Greek*. His style is often mystical and full of exaggerated proportions. His work had a great influence on all who followed.

Greek cross — A cross with four equal arms, vertical and horizontal, as in the plus sign

Greek fold — Folded cloth in an angular shape with rounded ends

Greek key pattern — A running design popular in Greek and Roman decoration, also called *Greek fret* and *Roman key*

greeking — Rough lettering or type indication to suggest the appearance of type in a layout

green bice — Pigment;green earth, name obsolete

green earth — Pigment; transparent earth green, permanent, made in yellowish (Cyrian), bluish (Verona), and dull blue (Tyrolean)

green ultramarine — Pigment; a semitransparent, permanent greenish blue, not widely used

green verditer — Pigment; Bremen green, toxic, obsolete

grenadine — A bright to medium cherry color, permanent, close to cadmium vermilion, gouache

grid — A graph pattern of proportional divisions with many uses, including enlarging or reducing a composition

griffin — In design, a mythical beast, half eagle and half lion

grinding stone — In lithography, a pumice stone used with a mixture of sealing wax and alum solution to smooth the stone

El Greco, "Cardinal Guevara" (detail)

Greek key pattern

Grotesque decoration

grisaille — (French, *gray*) 1. A Renaissance technique of underpainting with grays; transparent or semitransparent colors were then glazed on; 2. contemporary usage has come to mean a monochrome painting rendered in grays, often in imitation of bas-relief

grotesque — Decorative art that combines fanciful human and animal forms

ground — 1. A base coating of paint or gesso applied to a panel, canvas, paper, or board on which a picture is painted or scratched; 2. in textile design, the first screen or the base color of a design, often white; 3. an acid-resistant coating for plates used in etching

ground color — Base or background color

grounding — In sculpture, the polishing of marble with a fine abrasive

ground line — In linear perspective, the line on which the object (often a building) rests, parallel with the horizon line

ground plane — In linear perspective, the horizontal plane on which the viewer stands, theoretically extending to the horizon

guide — Template

Guignet's green — Pigment; viridian, name obsolete

guillotine — A heavy cutting knife on a paper-cutting machine

gum arabic — A natural gum material from the acacia tree used in solution with watercolors and other art products to increase gloss and transparency, now nearly unobtainable; synthetic or cellulose substitutes, referred to as "gum," are usually used

gum eraser — A firm but soft crumbly eraser used to clean artwork

gumming up — In lithography, brushing a solution of gum (arabic) and water over the stone to seal off and desensitize a nonpainting area

Gumtine — Trade name for a substitute for turpentine

gum water — A gum solution used with watercolors to increase gloss and transparency and improve flow and wetting; a binder of watercolors

gutter — The inner margin (white paper) of a printed page and the empty space between two facing pages

gwa — (Japanese) A drawing or a picture

gwafu — (Japanese) A book of sketches

gwajó — (Japanese) An album of folding prints

gypsographic print — *See* **embossed print**

Haarlem blue — Pigment; Antwerp blue, a reduced Prussian blue, name obsolete

Haarlem checks — Named for Haarlem, The Netherlands; a textile design, originally red and white, or blue and white checks; now other colors are also used

Hague school — Dutch realist artists who painted at the Hague during the last half of the nineteenth century

hair — *See* **brush, hair**

hairline — A very thin line

hairline register — A very close register; in printing a register within plus or minus one-half row of dots

hairline spacing — Very fine, tight spacing of type or elements in a layout

hake — An oriental flat brush made of sheep or goat hair, used for washes (pronounced *hokey*)

half-drop — In textile design, a repeat motif that is dropped halfway down from the first motif

halftone — 1. In painting, a value between the lightest and the darkest tone of a color; 2. in printmaking, a gray or tint made by breaking an area up by use of dots or lines; 3. in com-

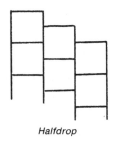

Halfdrop

mercial printing, a photo or gray or tint produced by photographing the original through a crosshatch screen, the dot size being determined by the number of crosshatch lines to the inch; 4. in commercial art, a benday screen of dots on acetate, used on a layout to create grays and textures, known by various trade names, such as Zipatone

Enlarged *halftone* screen of photo

halo, halation — 1. A glowing or halo effect usually about the head of religious figures; 2. in graphic arts, the same type of effect around headlines, products, etc.

hammer — In stone carving, a tool used to pound on a chisel or other tool to cut or remove stone

hamstring muscles — Three muscles on the back of the thigh that flex the leg, adduct and extend the thigh

hand-blocked — Printed by hand with the use of a block plate

hand burnishing — In printmaking, a method of rubbing a plate, often achieved with a wooden spoon

hand coloring — *See* **pochoir**

handi-bender — A wire-bending jig used to bend coat hangers or other wire into many desired shapes for crafts

handmade paper artwork — 1. A one-of-a-kind print executed on handmade paper; 2. a procedure in which paper pulp is worked into a design during the process of making the paper

hand-primed — As opposed to mechanically primed canvas, the primer is brushed or rolled on by hand rather than by machine

hand screen printing — *See* **silkscreen**

hand-tacking iron — An electrically heated iron used to tack or fix, in the dry-mounting process, without a press

hand wiping — Wiping of inked plates with the edge and palm of the hand

Hansa yellow — Pigment; a pale yellow, both transparent and semitransparent, permanent; close to cadmium yellow pale

happy accident — A pleasing but unplanned visual effect in painting

hard goods — In advertising art, subjects for drawing or painting, such as pots and pans, appliances, furniture, etc.

hardline art — Rendering of hard goods. *See* **hard goods**

hard realism — A realism with an exact and flat painting style; Grant Wood (1892-1942) painted in this manner

haricot — In design, a kidney bean shape

harmony — The pleasing combination of elements; order, agreement, balance

hatch, hatching — Lines superimposed upon lines to create texture and value. *See* **crosshatch**

Hatchett's brown — Pigment; a brownish Vandyke red, name obsolete

Hawaiian prints — In textile design, brightly colored, large floral or abstract prints

haze — An atmospheric condition that clouds an area

H D — Handmade

head animator — The person responsible for an animated cartooning operation

heartwood — In woodcarving, the harder and darker part of the tree near the center, "the heart"

heat transfer printing — In textile design, the procedure of transferring a design to fabric, using heat and pressure

heavy — Said about any element in a composition if it is strong and compelling

heel (of a brush) — The portion of hair on a brush where the brush and ferrule meet

hell box — A printer's receptacle for discarded type

Henri, Robert — 1865-1929, an American painter and teacher, one of the founders of the Ashcan school. He was author of "The Art Spirit," a popular manuscript dealing with the philosophy of picture making.

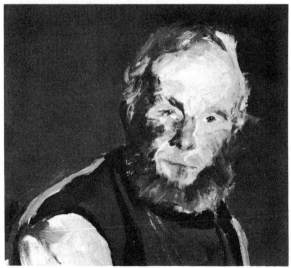

Robert Henri, self-portrait (detail)

heraldic — Pertaining to a design or emblem symbolizing or identifying a family or a profession, especially a coat of arms

Heraldic

Herringbone

Hexagon repeat

herm — A rectangular block or slab of stone having a head carved at the top, used as a dedication to a god, or as a grave marker

herringbone — In textile design, a broken twill weave with a chevron pattern

hexagon repeat — In design, a six-sided repeat pattern

hex sign — A flat design used by the Pennsylvania Dutch, said to ward off evil spirits. *See* **Pennsylvania Dutch patterns**

hickey — In graphics, an undesirable mark or imperfection in printing, caused by dirt in the ink or on the press

hide glue — An adhesive made from the hides of animals—rabbit, calf, and others

hiding power — The degree of opacity of a coat of paint; how it covers an area, whether lightly or completely

hieroglyphics — Pertaining to picture characters (signs or symbols) in Egyptian and other early writings; any emblematic markings

high etch — *See* **dry-relief offset**

high-key painting — The use of upper values on the value scale in a composition, creating a light, sometimes pale picture

highlight — A spot of the highest or lightest light or value on a subject or in a painting

highliner — A square-tipped, long or extra long lettering brush, the best being red sable

highlining — In lettering, an edge on letters like a highlight

high surface — A smooth surface on paper

HMP — Handmade paper; the pattern is more random, therefore will not tear as easily as mold-made paper

Hogarth's line — *See* **line of beauty**

hog hair — *See* **bristle**

Hokusai (Katsushika Hokusai) — 1760-1849, a Japanese master printmaker famous for the *Great Wave* and *View of Mt. Fuji,* among others. His sketchbooks are an invaluable source of Japanese life and custom.

Hokusai, "Sumo Wrestler," woodcut (detail)

holding line — A line on a mechanical, usually in black, to be printed unless otherwise indicated; not a key line

holiday colors — Colors that are traditionally correlated with certain holidays

holly green — Pigment; green earth, name obsolete

home furnishing designs — In textile design, any design for home decoration, such as upholstery, bed linens, rugs, carpets

Homer, Winslow — 1836-1910, an American illustrator, graphic artist, and painter. He recorded the Civil War but is best known for his rural, small-town genre paintings, and later for pictures of men and the sea.

"The Fox Hunt" by **Winslow Homer**

honeycomb — In design, a small raised geometric network resembling the honeycomb of bees; also called *waffle*

Hooker's green — Pigment; a mixture of gamboge and Prussian blue in two shades, one with a yellowish undertone and one more bluish, neither permanent; the mixture of phthalocyanine blue and cobalt yellow is permanent and transparent

Horace Vernet green — Pigment; a type of Bremen green, toxic, now obsolete

horizon line — In perspective, a straight horizontal line at the line of sight. *See* **line of sight**

horizontal — Parallel to the horizon; horizontal composition is one in which the dimensions are more wide than high

horsehair brush — An oriental painting brush with stiff hairs, originally made from horsehair

hot pink — A bright pink color

hot pressed paper (H.P.) — Smooth, dense paper used for drawing and opaque watercolor painting

hound's tooth — In textile design, an interrupted check pattern similar to a four-pointed star, used for suiting and upholstery

Houndstooth

H.P. — *See* **hot pressed paper**

Hudson River painters — A nineteenth-century group of American romantic landscape artists who painted mainly in the Hudson River valley and the Catskill Mountains, but some roamed as far west as the Sierras; famous painters of the early group included Cole, Doughty, Durand, among others; the second group were called the Luminists and included such artists as Church and Bierstadt. *See* **Luminism**

Hudson River School — **Asher B. Durand**

hue — The name of a color, such as red, blue, green

humanism — A Renaissance doctrine centered on the potential of mankind, with some rejection of supernaturalism; in art, brought a tendency toward secular themes

humerus — The arm bone reaching from the shoulder to the elbow

hyalography — Engraving on glass with diamond or emery cutting tools, or with an etching solution

hydrochloric acid — In etching, a colorless acid best used on zinc plates

hygroscopic — Capable of absorbing moisture from the air; said of paper that changes character and size with humidity

Hypro paper fabric — Trade name of a paper that is textured on one side and smooth on the other; versatile and available in many sizes, even in rolls for murals; moistened with water, it will form, drape, and sculpt

135

Icon (Russian)

Illumination — Initial letter from a tenth century manuscript.

icon, ikon, eikon — A religious image, particularly of the Eastern orthodox churches; a sacred likeness or representation, often painted on wood

ideogram — A sign or symbol representing an object or idea

illumination — The art of decorating manuscripts with fanciful letters, pictures, and designs; the earliest known example was found in the *Book of the Dead* in Egypt

illusionism — *See* **trompe l'oeil**

illustration — A picture that tells a story or is used to support and accompany a written text

illustration board — A good-quality paper mounted to a stiff backing board; available in two thicknesses and two textures, hot pressed and cold pressed; used in a variety of types of artwork

image — 1. A representation of a person or thing, translated in an artwork; 2. abstractly, a form or semblance of creative thought, which may also be translated in an artwork

imbrication — A pattern in which the motifs overlap like the shingles on a roof

imp. — (Latin, abbreviation for *impressit, he printed it*) Same as exc. *See* **exc.**

impasto — A thick application of paint on a painting

imperial — *See* **watercolor paper sizes**

imperial green — Pigment; a form of emerald green, toxic, name obsolete

imposition — In printing, the positioning of pages on the press so they will be in proper sequence when printed and folded

impression — An imprint made by means of pressure

Impasto — detail of paint quality by **Van Gogh**

impressionism — An art movement beginning in France in the 1870s, founded by an individualistic group of artists including, among others, Claude Monet, Auguste Renoir, Alfred Sisley and Camille Pissarro; all concerned themselves mainly with the components of light and the immediate visual impression of a scene using unconnected colors that were to be mixed by the eye; bright colors and bold brushwork were often used to achieve these impressions. *See also* **pointillism, postimpressionism**

improvise — To create spontaneously without a definite plan

inc. — (Latin, *incidit, he cut it*) Found on a print as credit for the engraver or etcher when different from the artist

India ink — A dark black liquid ink, available in what is called waterproof or nonwaterproof formulas

Indian blue — Pigment; a deep transparent blue, Fugitive, an obsolete name for indigo

Indian red — Pigment; a reddish earth color with bluish undertone; opaque and permanent

Indian yellow — Pigment; a synthetic yellow similar to a warm cadmium yellow medium, transparent and permanent

India oil stone — A stone used to sharpen knives, burins, and scrapers

indigo — Pigment; no longer available from the natural plant; in oil, a mixture of ivory black, Prussian blue, and ultramarine; in watercolor, a mixture of alizarin crimson, lamp black, and phthalocyanine blue; durable

indo orange red — Pigment; similar to scarlet vermilion, durable, acrylic

informal balance — In an artwork, equilibrium in the distribution of elements without bilateral symmetry

ink — Pigment in liquid or paste form. *See* **India ink; Sumi ink; printer's ink; etching ink**

inkers — Artists who do portions of ink drawings for animated cartoons or comic strips

inking roller — *See* **brayer**

inking slab — Any heavy flat surfaced material on which ink can be placed (butcher's tray, glass, marble, Masonite), to roll ink onto a brayer

inkless intaglio — *See* **embossed print**

inlay — To decorate by making slots in a surface and "laying in" small pieces of precious metals, ivory, or other material. *See* **intarsia**

Innes, George — 1825-1894, an American romantic landscape painter who developed without formal training. His early paintings were influenced by the Barbizon school, but his later works were done in a more intimate manner of unpicturesque subjects.

insert frame — *See* **liner**

in situ — (Latin, *in position*)On the spot; said of a painting when painted on location

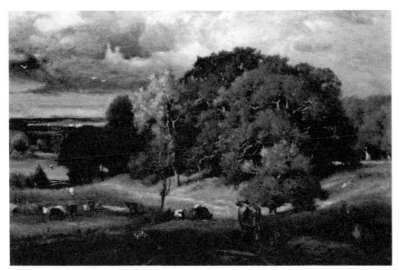

George Innes, "Autumn Oaks"

instant lettering — *See* **press type; pressure-sensitive letters**

instant mount sheets — Double-faced adhesive sheets (20 × 25 inches), used where heat, glue, or wax may damage artwork

intaglio — 1. In sculpture, hollow or concave relief. *See* **cavo rilievo;** 2. in printmaking, design or lettering cut below the surface of a plate, with ink left only in the depressions, as in etching, drypoint, aquatint, photogravure, and line engraving

intaglio relief plate — A plate that has been inked on the surface rather than in the lines

intarsia — Inlay work, usually wood inlaid with contrasting wood, but may be ivory, mother of pearl, or other material. *See also* **marquetry**

intense blue — Pigment; phthalocyanine blue, similar to Prussian

intensify — To make bright or strong; to strengthen in some way

intensity, color — The brightness or saturation of a color, the chroma

interchange — See **counterchange**

interference colors — Pastels made with two different colors in one stick

interlacing — In textile design, a pattern made up of lines or bands that are interwoven, or painted so they look interwoven

intermediate colors — See **tertiary colors**

international reply coupon — A form purchased at the post office and enclosed with artwork sent to a foreign country; used to cover return postage

interpret — In art, to represent or illustrate in light of the artist's belief; not necessarily a literal copy of real things

intervals — In art, the spaces between elements of a composition that set up a rhythm

in the round — See **sculpture in the round**

intimism — A style of painting, concerned with intimate domestic settings; major artists were Pierre Bonnard and Edouard Vuillard

intuitive painting — Painting from a subjective, or personal, frame of reference

inv. — (Latin, abbreviation for *invenit, he invented it*) Credit given on a print to the one who designed it

investment casting — See **lost wax**

iridescence — Delicate tints of rainbow colors caused by diffraction of light

iris green — Pigment; sap green, name obsolete

iron blue — Pigment;Prussian blue, an intense transparent color, name obsolete

iron brown — Pigment; Prussian brown, iron hydroxide, name obsolete

iron gall ink — An ink made from tannin or gallotannic acid, which comes from oak galls; used in the Dark Ages

irregular curve — *See* **French curve**

isometric projection — A form of axonometric projection used in mechanical drawing which has equality of foreshortening of the three planes of an object, with the height, width, and depth drawn on the same scale; horizontal lines are usually all drawn at 30 degrees to base, and verticals perpendicular to base; distortion is evident; first used by East Indian and Persian artists

Isometric scale

Italian blue — Pigment. *See* **Egyptian blue**

Italian earth — Pigment; an old name for sienna

italic — Name of an alphabet of type that is slanted or leans upward to the right; most type fonts have an italic, as well as a Roman alphabet

Ives color wheel — The red, yellow, blue color wheel introduced by Herbert Ives, an American (1882-1953); red was called achlor, yellow was zanth, and blue turquoise was cyan

ivory — Pigment; an off-white color, usually with a yellow undertone; a medium for carving, from animal tusks. *See* **scrimshaw**

ivory black — *See* **black**

jacaranta brown — Pigment; umber, name obsolete

Jacquard — In textile design, a raised, figured pattern woven into cloth like tapestry, damask, brocatelle, etc.; invented by J.M. Jacquard, an eighteenth- and early nineteenth-century French weaver

Japan colors — A sign painter's quick drying paint, available in many colors in tubes or cans

Japan drier — *See* **drier**

japanning — An imitation of oriental lacquer. *See* **lacquer, oriental**

japan paper — Paper made with an irregular mottled surface, used for greeting cards

Japonisme — The influence of Japanese art and decoration, especially in France, 1854-1910; a number of French artists were influenced by the simplicity of oriental design, among whom were Monet, Whistler, Tissot, Degas, Bracquemond, and Jacquemart

jaune brillant — Pigment; a reddish variety of Naples yellow made from cadmium yellow, flake white, and vermilion, toxic but durable

jaune d'antimoine — Pigment; Naples yellow

jeweler's rouge — A compound used to buff and polish metals

jigger — *See* **levigator**

join — A coming together of two separate pieces of canvas or paper to form a joint; many of the old masters joined additional portions to their canvases

Jugendstil — The German term for art nouveau after the Munich publication *Jugend*, meaning youth. *See* **art nouveau**

juicy — Said of paint that is thick, succulent, and workable; also said about a painting that is free and loose in handling

Juicy painting (detail) by **Alfred Chadbourn**

jumping the gutter — Designing a double-page spread so that elements of the layout cross from one page to the next

jungle print — In textile design, a pattern of animals and foliage that are found in the jungle

justify — In typesetting, to space out letters and words so that each line is exactly the same measure and both margins form perpendicular lines

jute — A coarse natural fiber used for making burlap and a cheap canvas that does not last well

juvenile print — In textile design, a pattern for children, such as Donald Duck, Bambi, and other cute animals and stylized characters

juxtaposition — In painting, the close placement of adjoining colors or forms; side by side

kakemono — (Japanese, *hanging scroll*) A vertical scroll displayed periodically, often following seasonal changes or as a dedication to a friend's visit, a birth, or the like. *See also* **makimono**

Drypoint by **Kandinsky**

Kandinsky, Wassily — 1866-1944, Russian, associated with the Blue Rider group and the Bauhaus. His work is nonobjective, based on a spatial feeling rather than the depiction of objects realistically. Many theoretical writings on art are credited to his name.

Kano school — (Japanese), founded in the sixteenth century by Kanō Masanobu; known for its boldness, the life of the brush stroke, and the play of values in the ink paintings. *See also* **Sumi-e**

Kano — Tannyu

kanshitsu — (Japanese) Sculptural forms produced by the use of lacquer-saturated cloths placed on an armature

kara-zuri — (Japanese) Blind embossing. *See also* **embossed print**

Kassler yellow — Pigment; Turner's lead yellow, now obsolete

kat's tongue — *See* **cat's tongue**

kelly green — Pigment; a bright green

kerf — In woodcarving, the path cut by a saw blade

kermes — Pigment; crimson lake, obsolete

kern — In typesetting, to adjust the letter spacing of type such as TA, VC, AY, to improve appearance and legibility

TA VC
Normal spacing

TA VC
Kerned

kernel black — Pigment; vine black, a carbon product made by burning kernels

kerosene — A thin oil distilled from petroleum, used to clean oil brushes and sometimes as a substitute for turpentine in painting

key — 1. The dominant tone or value of a picture—high (light), medium or low (dark); 2. a wooden or plastic form used in the holes of stretcher strips to tighten the canvas

key block, key plate, keystone — In multicolor printing, the block, plate, or stone that has the complete drawing on it, the other color blocks, plates, or stones being made from this key

key lines — In commercial art, the outline, usually in red, indicating the placement, size, and shape of elements such as photographs and drawings on the mechanical; not printed, but a guide for the platemaker

khaki — A light brown/tan mixture, considered a neutral

kid finished — Describes a medium-textured drawing paper, also called *vellum*

killed matter — 1. Metal type or plates that are discarded and will be melted down; 2. any copy that Is not to be used

kill fee — The part of the original agreed-upon price an artist receives for a work of art that was assigned, but canceled through no fault of the artist

kinetic art — Popular in the 1950-1960s and continuing into the present, includes any artwork that moves or has moving parts, such as mobiles and motorized sculpture; some of the earlier artists involved were Bury, Calder, Chadwick, and Wynter

king's blue — Pigment; cobalt blue, name obsolete

king's yellow — Pigment; a bright yellow, opaque, toxic, and fugitive, name obsolete

kiss impression — In printing, a very light impression, just enough to show the image

kitchen prints — In textile design, motifs pertaining to fruit, vegetables, pots and pans, baskets, etc.

Klee, Paul — 1879-1940, Swiss, a printmaker, painter, and teacher associated with the Blue Rider group and the Bauhaus. His work appears childlike, using simple lines, geometric shapes, and striking color.

kneaded eraser — A pliable, nonabrasive eraser that can be shaped to a point; used for cleaning artwork, picking out highlights, and softening pencil lines

knife — *See* **mat knife, painting knife, palette knife, and X-Acto knife**

Paul Klee, self portrait,
woodcut

knit — In textile design, to form a fabric of interlooping yarn by the use of needles

kolinsky — *See* **sable**

Korin school — Japanese school of painting emphasizing decoration; the artist Korin was a superb painter in lacquer

kou le — (Chinese, *contour style*) A style of painting in which light outlines are drawn to establish a basic structure, darker lines are used to reinforce them, and finally color is added if desired; *pai-miao* is the name given to the drawing or painting; *shuan kon* is a form of kou le with a double outline

Kremnitz/Krems white — *See* **white**

labored — Overworked; said of artwork that has lost a feeling of spontaneity

lacework — 1. A flat, filigree design, chainlike or similar to strapwork. *See also* **strapwork;** 2. **calligraphy-type strokes in a painting**

lacquer, modern — Coating made of cellulose materials, made for ease in spraying to create a fast-drying, shiny, tough, hard film, used mostly in industrial work

lacquer inks — Used for commercial silk-screen work, available in many colors, can be thinned to transparency with a special base; one type of lacquer ink can be used on aluminum foil; toxic and flammable

lacquer, oriental — Name given to a coating used in Asia to create artwork, usually platters, bowls, boxes, etc., coated with multiple applications and built up to a hard, tough, permanent surface, sometimes thick enough to be carved; the artwork is also called *lacquer*

laid paper — Paper with a pattern of equally spaced parallel lines made by a screen on which the paper is formed, giving a ribbed effect to the surface

lake colors — Colors made by precipitating a dye upon a pigment; transparent and usually not permanent

laminated — 1. Formed into a bond in layers, as in plywood; also applies to papers, paper-

board, etc.; 2. Said of a transparent film permanently applied to artwork, book jackets, etc., to preserve and protect the surface

lampblack — Pigment; pure carbon black, permanent

landscape — A view of scenery—fields, trees, rocks, sky, etc.—as the subject of a picture or design

landscape shape — A term occasionally used in reference to a horizontally shaped piece of paper canvas or other support

lapis lazuli — Pigment; a true ultramarine blue made from the semiprecious stone; practically obsolete

latissimus dorsi — A large back muscle that originates in the lower thoracic and lumbar region and extends up the side under each arm, adducting, extending, and rotating the arm

lattice — An open framework of crossed strips, or a design resembling such a framework

lay figure — A wooden manikin with movable parts; can assume almost any desired position, to substitute for a life model

Lay figure

lay in — To apply a rough application of paint, pastel, or other medium to a section of a picture at a preliminary stage

layout — A rough or general planning of a page, advertisement, brochure, etc., showing positioning of type and illustrations

layout chalk — Chalk used for layouts, made in different colors and in different values of grays

layout paper — A bond or offset text, vellum-finished, able to accept paint, chalk, pencil, etc., and usually translucent

layout pencils — Soft, smooth, usually black pencils, used for layouts and sketching (ebony, negro, and flat carpenter's pencils)

lazuline blue — Pigment; native ultramarine, practically obsolete

lead/leading — Originally a strip of lead separating lines of type, still used to designate the space between lines; example: ten on twelve (10/12) means a ten-point typeface cast on a twelve-point body, allowing two extra points between lines, referred to as "leaded two points"

lead adhesive — A pressure-sensitive adhesive brushed on lead tape so that it can be applied to glass, metal, etc.

lead casting — A form of sculpture using lead

lead holder — A mechanical, handle-type tool that holds lead (graphite) for drawing

lead pointer — Pencil sharpener

lead tape — A pliable, soft, lead stripping used to create a stained-glass window effect

lead white — *See* **white**

leaf — Metal that has been rolled or beaten to a very thin sheet, used in gilding; available in gold, silver, palladium, and aluminum

leaf green — Pigment; chrome green, fugitive, name obsolete

leaflet — A printed circular, handbill or flier, usually consisting of a single sheet of paper

lean — Said of oil colors that are thin or low in oil content, giving a matte finish. A lean quality can be achieved by squeezing the oil paint onto a blotter to absorb some of the medium

leather brayer — In lithography, a roller covered with soft leather

L'Ecole de Paris — (French, the *School of Paris*) A term that implies "contemporary art." It started about 1900 when Paris was the world art center

leek green — Pigment; chrome green, fugitive, name obsolete

Leipzig yellow — Pigment; chrome yellow, fugitive, name obsolete

Leithner blue — Pigment; a form of cobalt blue, name obsolete

lemon yellow — Pigment; barium yellow; a pale, cool yellow; permanent

Leonardo da Vinci — 1452-1519, Italian, a Florentine painter, sculptor, architect, and designer. Among his best-known paintings are *The Last Supper* and the *Mona Lisa*. His notebooks and sketches show the scope of his remarkably agile mind.

Leonardo, self portrait

Leroy lettering pen — Trade name for a tool for mechanical hand lettering often used by architects and other draftsmen

Letraline tape — Trade name of an opaque tape (glossy or matte) used in commercial art; available in 10 widths and in different colors

letterhead — The heading on business stationery, giving the name, address, etc., and often carrying a unique logo design

lettering — Letters drawn by hand as opposed to type or other mechanical forms

lettering brush — Brushes used by a hand letterer, such as a quill, chisel brush, liner, striper, single-stroke brush, or cutter

lettering pen — A pen used for hand lettering. *See* **Leroy lettering pen; Speedball pen**

lettering quill — A quill brush for lettering, available in a long, flat, squarecut brush that produces sharp, clean work, and a pointed quill, used for outlining, shading, and highlining. *See also* **quill**

letterpress — Commercial relief printing used mostly for newspapers, books, and magazines

letter spacing — Adjusting the spaces between letters so they appear proper and consistent, legibility and ease of reading being the prime considerations

levigator — In lithography, a circular tool used to grind the stone; also referred to as a *jigger*

Leyden blue — Pigment; a form of cobalt blue, name obsolete

liberty print — An early American design, usually limited to one or two color variations on a white or natural background

life (of a brush) — 1. The spring or bounce of a brush, making it easy or hard to use; 2. the length of time that a brush will last—a month, five years, a lifetime

life drawing — Drawing of the human figure; usually refers to drawing from a nude model

life mask — An impression of the face of a living person, usually made of plaster

life size — Of the same size as the person or animal used as a model

lift — In watercolor, a term for taking out unwanted pigment, using dry brush, a sponge, tissue, paper towel, finger, or cloth

lift-ground etching — Using aquatint as a base, positive images of lines or brush strokes

are etched into the plate, which is then inked with a lift-ground solution (e.g., 50% saturated sugar dissolved in 50% India ink); also called *sugar bite*

lifting — In gouache and some other mediums, the mixing of an undercoat with a second coat; prevented by using a fixative on the first coat

ligature — In typography, two or more letters joined together in one body, such as fl, fi, etc.

light and dark — Having to do with values of color and grays

light and shadow — The change from pronounced light to pronounced dark. *See* **chiaroscuro**

light box — A translucent glass-topped box with a light under it, used for tracing

light face — The lightest and thinnest form of a typeface

lightfast — Resistant to fading on long exposure to sunlight

light "from within" — A painting showing atmosphere or an airy feeling. This quality is evident in some of J.M.W. Turner's work

light green oxide — Pigment; a light yellowish green, extremely permanent, acrylic

light, medium, dark — Terms used to denote values and to "key" a picture. *See* **key**

light red — Pigment; an earth red, between burnt sienna and Venetian, permanent

light-sensitive plate — Plate that is treated with a light-sensitive coating, used in photogravure and photolithography printing procedures

Helvetica
Helvetica
Helvetica

10 point type in light face, regular and semi bold

light source — The location that the light appears to be coming from in a picture, as indicated by cast shadows, highlights, etc.

lime blue — Pigment; Bremen blue, toxic, obsolete

lime white — Pigment; whiting, used as a filler in inexpensive paints

limited edition — In graphic arts, a limited number of prints, determined by the artist, that are pulled from a plate and numbered, after which the plate is destroyed

limited palette — A selected number of colors on the palette, which by mixing can often suggest a full range; for example; alizarin crimson, cadmium yellow, and cobalt blue

limner — An artist who paints miniatures

linage — The size of an advertisement; the depth in agate lines, 14 lines to an inch; example: a 2-inch ad is 28 lines deep.

line — 1. A continuous mark as made by a pencil, pen, or brush in an artwork, as distinguished from shade, color, mass; 2. a set of marks, shapes, colors, or other elements that lead the viewer's eye through a work of art; 3. the "line" in textile design is the presently salable designs pertaining to a given subject, as the designs for bed linens and related products

line and wash — A line drawing combined with a wash of ink or watercolor

linear — Of or pertaining to lines; said of an artwork that is dominated by lines

linear perspective — Mechanical, geometric perspective, a means of giving the illusion of distance in three-dimensional space on a two-dimensional surface by the location of lines

line art — In commercial art, black and white drawings, type, etc., achieving grays or variations in values by line hatching and not requiring halftones; may be called *linecopy*

line block — *See* **linecut**

line conversion — The process of photographing continuous tone photos with line film in which the values are all reduced to either black or white

linecopy — *See* **line art**

Line drawing

linecut — A printing plate photoengraved from a line drawing, executed in only black and white or one color and white; flat screens are used to produce a gray tone with black and white solids (no variable screen); other names are *line engraving, line block, line etching,* and *line plate*

line drawing — *See* **line art**

line engraving — *See* **linecut**

line etching — *See* **linecut**

line film — Film used to create extreme contrasts of white and black by dropping out grays; used in graphic and commercial arts

line leading — *See* **lead/leading**

line matter — *See* **line art**

line movement — The arrangement of elements in a picture so that the viewer's eye is directed from one area or object to another

Line conversion
Photo of Robert Fawcett reproduced in line

linen canvas — Linen cloth used as a support for painting; may be primed or unprimed, in different textures and qualities

linenfold — A decorative Gothic fold in cloth, straight in line with soft and hard ends. *See* **Gothic fold**

Linen tester

linen tester — A small, powerful magnifying glass originally designed to count threads in linen; now also used to examine the dot structure in plates, printed materials, and negatives

line of beauty — Called Hogarth's line after the English painter William Hogarth (1697-1764), it takes the form of a graceful *S* curve in a composition

line of sight — In linear perspective, the line extending from the viewer's eyes to the picture plane, in the exact center of the cone of vision; also called the *line of vision*

line of vision — *See* **line of sight**

line plate — *See* **linecut**

liner — 1. A brush used by sign painters to create straight lines and sharp edges; available in different shapes and in pointed quill and square liner quill sizes. *See also* **dagger**; 2. a strip of wood, linen, hemp, velvet, etc., that lines the inside of a frame immediately next to the picture

lines, kissing — Obvious touching lines in a composition. Often undesirable

line spacing — Adjusting the space between lines in copy for better layout or fit

line, weighted — A line that is heavy in either value or thickness

linocut — A linoleum cut

linoleum — A durable floor covering material used for linoleum cuts

linoleum block — A piece of wood with battleship linoleum mounted to the surface, cut and inked to make a block print called a *linoleum cut* or *linocut*

linoleum cut/linocut — A relief print similar to a woodcut. *See* **linoleum block**

linotype — A machine that sets type by keyboard, to be cast by the line in hot metal. The procedure, which dates from the 1870s, is being replaced by various computer typesetting systems

linoxyn — The dried linseed oil skin of an oil painting

linseed oil — An oil made from flax seed, used as a medium with oil paints and as a drying oil in pigments

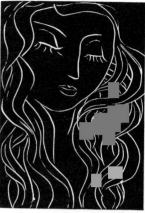

Linecut by **Henri Matisse**

> **boiled linseed oil** — Processed with heat or driers; not used by artists
> **cold pressed oil** — No heat involved; oil from the crushed seed is left to stand until the impurities have settled out, and is then filtered
> **raw linseed oil** — Seeds are heated before being pressed; used only in lower quality paints
> **refined linseed oil** — Steam pressed, refined, and bleached; less expensive than cold pressed oil; most often used in grinding paints
> **stand oil** — The molecular structure has been changed by polymerization; a heavy oil, dries slowly but creates a tough, flexible film
> **sun-thickened oil** — Of honey-like consistency, is thicker and quicker drying than cold pressed oil or refined oil; has been partly oxidized, thickened, and bleached by exposure to the sun

liquid eraser — Used on drafting film to completely erase an area

liquid mask — A liquid frisket used to block out areas on paintings in watercolor, gouache, commercial art, etc.; can be removed by rubbing with the fingers; a few trade names are: Maskoid, Moon Mask, Miskit, and Luma Liquid Mask

liquid resin ground — In aquatint, a saturated solution of resin mixed in denatured alcohol

liquin — A medium used to thin oils and alkyd; speeds drying time

lithographic crayon or pencil — A black grease crayon or pencil with which the drawing is made for the lithographic process; also used to write on glass, china, stone, or where a dense black line is desired; may be used on rough-textured paper to create halftone effects with line

lithographic ink — A printing ink available in colors, used in reproducing lithographs; not to be confused with the tusche in lithography used for drawing and painting on the stone

lithographic points — Needles or points used for scratching in the crayon areas on a lithograph stone to create white-line effects

lithograph stone — A flat slab of limestone, prepared with a grain to be used for lithography

Drawing on a *lithograph* stone

lithography — A process that involves drawing with a grease crayon on limestone or a metal or plastic plate, which is wet with water and then inked with a roller; the oily printing ink adheres to the oily drawing and resists the blank areas, making it possible to pull prints with a litho press; since its invention in 1798 it has been a popular process with such artists as Daumier, Degas, Toulouse-Lautrec, Picasso, and Miró

Inking a litho stone

lithography, offset — A term applied to printing by offset press in which the image is transferred to the plate by a photographic process; not to be confused with the lithographic process

lithography press — The printing press used to pull prints in lithography

lithography, transfer — A process in lithography that allows an image to be transferred from paper to the stone

lithol red — A bright cherry red used in inks and commercial products, not permanent

livering — The turning of oil paint to a rubbery mass in the tube, caused by impurities in the pigment

live stills — A term coined by Zoltan Szabo, a contemporary artist, to describe small, living, motionless landscape subjects, such as a small tree and its surroundings

loaded — Fully charged; said of a brush filled with paint

local color — The actual color of a subject

loft — An upper floor, usually unpartitioned, in a house, warehouse, or factory, often used by an artist as a studio

logo/logotype — An identifying symbol, signature, or trade name for commercial use; also called a *bug*

long shot — A view of a subject or scene from a distance

loose painting — Painting characterized by free, broad handling of areas and brushwork, lost-and-found contours, broken or loose lines, or patches of color

lost and found — A painting quality in which lines and/or contours dissolve, fade, or blend into others and then reappear at intervals

lost-wax process — A procedure for casting metal sculpture and jewelry, used from the fifth century A.D. to the present time; also called *cire perdue* and *investment casting*

lotus — A flower design originating from the lotus flower, a kind of tropical water lily; a Buddhist symbol

lowercase letters — The uncapitalized letters of a font

low key painting — Using the darker section of the value scale, likely to be subtle, subdued, or moody

lozenge — A diamond shape

luci/lucida — *See* **camera lucida**

Lucite — Trade name for a clear acrylic sheet with many uses. *See* **acrylic sheets**

Lucite roller — In graphics, a roller used for pressure rolling

Lukasbrüder — Order of St. Luke. *See* **Nazarenes**

lumbar — In anatomy, the region between the thoracic vertebrae and the sacrum. *See also* **vertebrae**

luminism — A style of painting characterized by concern with the effects of light; applied to the nineteenth-century impressionists, but also used to refer to the late Hudson River school of painters and their fascination with light and atmospheric effects in landscape

luminous — Appearing to give off a glow from under the surface, as from under a glaze on a painted work; also describes a paint that glows in the dark

lunette — A half-moon shaped panel decorated with artwork

luster — A deep glow, often metallic or iridescent

Lutschism — *See* **Rayonnism**

lyrical — A poetical term used to describe art that is graceful and flowing

lyrical abstraction — In the early 1970s, an outgrowth of abstract expressionism, featuring large picture sizes and muted color harmonies; the term is sometimes applied to the work of Mark Rothko (1903-1970) who is also classified as an abstract expressionist

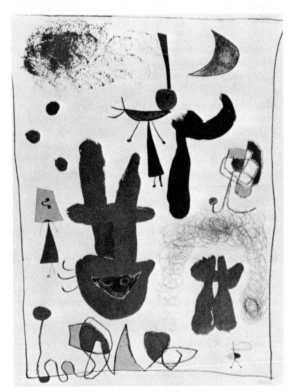

Abstraction by **Joan Miro** (color lithograph)

macaroni — An uncomplimentary colloquial term for a stringy design or pattern

macchia — (Italian, *spot* or *stain*) A style of painting or sketching in spots or patches of color in an impressionistic manner

Macchiaioli — A group of nineteenth-century Florentine landscape artists who painted with patches of color and called their work *macchie*

mace-head — A tool used in mezzotint to produce graininess or burr where desired; also called a *mattoir*

machine composition — Setting of type by machine, usually hot metal type

machine finish — A finish on paper made by calendering or polishing by mechanical means

machine screen printing — *See* **screen printing**

macle — A hollow lozenge or diamond shape

maculature — In intaglio printmaking, pulling a second print without reinking, to remove surface ink or color

madder brown — Pigment; alizarin brown, transparent, permanent

madder lake — Pigment; a transparent color similar to alizarin crimson, moderately durable

Madonna — Usually refers to a representation of the Virgin Mary

magenta — Pigment; a purple with a red undertone, moderately permanent

Magic Markers — Trade name for a type of felt-tip markers. *See* **felt-tip markers**

magic realism — A type of painting of the twentieth century where almost photographic realism is achieved. Sometimes the realism is combined with the fantastic through strangely related subject material and mysterious light-source treatment; creating metaphysical effects reminiscent of de Chirico and others

magnifier — A converging lens that enlarges an area or object; used mostly in commercial arts

mahlstick (or maulstick) — A stick about 30 inches long, of wood or telescoping aluminum, used as a rest to balance the hand and arm when drawing or painting. *See also* **artist's bridge**

mailing tube — A sturdy, visually pipe-shaped cardboard tube, also used for storage of maps and artwork

maize — Pigment; a corn yellow

makeover — In graphic printing, any plate which is reworked or remade

make ready — 1. In printmaking, to level relief printing plates on the bed of the press, so a good impression is possible; 2. In commercial printing, all work done on printing presses prior to starting the print run, including setting the plates, adjusting the ink fountains, grippers, etc.

makimono — A Japanese horizontal scroll painting that is unrolled with the left hand and

rolled up with the right hand; after the viewing, the scroll is rewound so it can again be viewed from right to left. *See also* **kakemono**

Malevich, Kassimir — 1878-1935, Russian; his early work was fauve, then cubistic and finally he founded Suprematism, a nonobjective geometric movement.

Charles Malevich — Suprematist painting

Maltese Cross

mallet — A wooden hammer used in sculpture, leatherwork, and woodcarving

Maltese cross — An eight-pointed cross, named for its use as an emblem by the medieval Knights of Malta

mandala — A Hindu or Buddhist symbol of the universe, based on a square within a circle

Manet, Edouard — 1832-83, French; a fine technician who was much influenced by his study of Velasquez and other Spanish masters. He is classified among the French impressionists.

Edouard Manet, "Boy with Fife" (detail)

manganese black — Pigment; a black oxide, obsolete

manganese blue — Pigment; a bright greenish blue, transparent and permanent

manganese brown — Pigment; a brown oxide, obsolete

manganese green — Pigment; a greenish manganese blue, obsolete

manganese violet — Pigment; a deep bluish purple, permanent

manieŕe criblée — See **criblée**

manifesto — A public declaration of the theories of an art movement

manikin, mannikin, mannequin — See **lay figure**

manila drawing paper — An inexpensive buff-colored paper used for sketches; a rough manila called *oatmeal* is also available

mannerism — A style of painting in Italy and France about 1525-1600, marked by emotional distortion, harsh coloring, and individualism, said to be a reaction to the art of the High Renaissance; major artists were El Greco and Tintoretto

Mannerism — **Jacopo Tintoretto**, "Christ at the Sea of Galilee"

maquette — In sculpture, a small, rough model, used as a guide for the larger piece; also called a *bozzetto*

marble dust — A crushed marble used as a texture in printmaking and pastels or mixed into plaster for frescoes

marble paper — A paper that imitates a marble pattern

marbling — 1. In painting, a mingling of colors that form an irregular pattern as found in marble. 2. A process for making a convoluting marble-like pattern for decorating books, etc., by floating colors in a gum solution, swirling them, and transferring the pattern to paper by contact

marigold yellow — Pigment; an orange close to cadmium yellow deep in gouache; permanent

marker pad — Paper in pad form made especially for felt-tip pens; colors flow easily with no bleeding

Marlite — Trade name for a plastic-covered Masonite

Maroger medium — A gel-like medium or megilp. *See* **megilp**

maroon — Pigment; a dark red

marouflage — The process of attaching a painted canvas to a wall with acrylic binders

marquetry — A decorative art in which small pieces of wood, ivory, metal, or other material are inlaid in furniture, usually forming floral or geometric patterns

Mars colors — Artificial earth colors

Maruyama school — An eighteenth-century Japanese school using a realistic approach to painting; started by the scholar Maruyama Okyo

mask — 1. White paint or paper used to cover or hide an area; 2. a film or resist used to cover and hold an area in silk screen and airbrush; 3. a mold of a human or animal face, used as a wall hanging; 4. a cover worn over the face, often weird and bizarre

masking film — A thin, plastic film coated with a thin, colored plastic emulsion, used for overlays for color separation and in silk-screen positives

masking tape — A paper-adhesive, pressure-sensitive tape that sticks tighter than *drafting tape*, but can be removed without damaging artwork

Maskoid — *See* **liquid mask**

Masonite — A trade name for a building material made from pressed wood. Untempered Masonite is used by artists as a painting surface or a mounting board

mass — 1. In artwork, a sizable area of a composition, as opposed to a line; 2. the bulk of an object

massicot — Pigment; yellow lead, toxic and fugitive, obsolete

mass tone — The surface color of a pigment

master — A knowledgeable artist, usually with extensive experience

masterpiece — A work of art of an excellence that has stood the test of time; originally an example of work presented to a guild to qualify for the rank of master

Master's brush cleaner — A commercial soap-like compound used to clean oil, acrylic, watercolor, varnish, etc., from brushes

mastic — A resin used with turpentine to make varnish; has a tendency to turn yellow with age

mastic varnish — Used as a final gloss varnish on oil paintings

mat — Heavy paper or cardboard surrounding a watercolor, photo, etc.; framed under glass, the mat separates the picture from the glass, protecting it from moisture and enhancing its appearance

mat board — The cardboard used to mat artwork or as a mounting board; available in many colors and white, and in various textures

mat cutter — A hand cutter for mats, giving a straight or a beveled edge; a large, automatic version is used by professionals

mat knife — A utility knife for cutting mats, cardboard, paper, etc.

matte — A dull, lusterless finish; sometimes spelled *mat* or *matt*

matte medium — An acrylic medium used with acrylic paints to reduce the gloss; can be used as a final matte finish

matte varnish — A nonglossy, flat varnish

matting wheel — A variant of the roulette, used in *crayon manner* or *chalk manner. See also* **roulette**

mattoir — *See* **mace-head**

mature style — An artist's individual style, method of paint application, composition, etc., usually developed after years of painting

mauve — Pigment; any of several shades of purple

McGuilp — *See* **megilp**

meander pattern — The Greek key pattern

mechanical — A working board made to guide the printer when making reproductions; consists of all the camera-ready components—type, illustration, etc.—in correct size and pasted up

mechanical perspective — Linear perspective with the use of tools

medallion — A circular or round design; a large medal

media — *See* **medium**

medieval art — Art produced in the Middle Ages in Europe, about A.D. 500-1500

medium (plural, mediums or media) — 1. The liquid used to thin paint; 2. material used to create art, such as pencil, pen, watercolor, oil color, gouache, pastel, alkyd, acrylic paint, wood, stone, and various found materials; 3. (usually **media**) channels for advertising, such as newspapers, magazines, and television

medium key — Using the middle value range as a picture's dominant tonality

megilp — A gel-like, quick-drying painting medium used in the nineteenth century that gave an enamel-like finish but had a tendency to darken and crack with age; also called *McGuilp* and *English varnish*

memento mori — (Latin, *remember death*) A skull as part of a painting or other artwork; may also be a clock or other symbol of the passing of life. Such a still life also called *vanitas*

memory picture — *See* **mind's eye**

men's wear — Designs pertaining to men's clothing

men's/women's wear — Designs pertaining to both men's and women's apparel

mermaid — A legendary creature with a woman's body and the tail of a fish, appearing as a design motif

Merz — A form of dada, started by Kurt Schwitters, an abstract artist. The name Merz originated from a collage he made which had MERZ in red capital letters (torn from a bank advertisement) in the composition

metacarpus — The five bones in the hand between the wrist and the fingers

metal-foil paper — Paper-backed foil, available in 20×26 inches size and in colors of gold, silver, red, green, and blue

metallic — Looking like metal, usually lustrous

metal modeling compound — Metal in paste form, used on sculpture; applied to the surface, dried and buffed; available in aluminum and bronze

metal point — A procedure in which a pointed metal rod is used as a drawing instrument on an abrasive, coated surface; the metal stylus may be of silver, lead, copper, or gold; much used by artists before the development of the graphite pencil in the sixteenth century

metamerism — An undesirable condition in which two areas of matching opaque color that have a reflective surface, as in an oil painting, appear to match in color under one kind of illumination and not under another form of light; usually caused by not using exactly the same pigments to paint both areas

metaphysical painting — Painting with a dreamlike quality combined with realism, created by de Chirico and others, where unusual perspective and color create a mysterious or unreal effect. *See* **magic realism**

metatarsus — The five bones between the tarsus and the toes

métier — The field or specialty in which an artist performs best, as painting or sculpture, or the subject field, as landscape, portraiture, or other

Mexican prints — Print designs associated with Mexico

mezzo fresco — A painting done on partially dry plaster; a line surrounds the forms because the paint sinks partially into the semidry plaster

mezzotint — (Italian, *halftone*) A relief print made on a metal plate; a rocker is used to roughen the whole surface, then the white ar-

Mezzotint by **Petrus Schenk**

eas (not to be printed) are burnished and smoothed below the surface; halftones are created by removing only part of the burr

Michelangelo Buonarroti — 1475-1564, Italian, a painter, sculptor, poet, and architect. Famous for his sculpture, *The Pieta,* among others, and his vast undertaking of frescoes on the ceiling of the Vatican's Sistine Chapel.

Michelangelo, "Ezechel" (detail)

middle ground — The middle area in a picture between the foreground and the background

middle key — Using the middle values on the value scale as the dominant tonality in a picture

migration — The bleeding or spreading of color outside the allotted area

mill blank — A white coated mounting board for photos and artwork

Milori blue — Pigment; a high-quality Prussian blue

mimosa yellow — Pigment; a yellow earth brighter than Naples yellow, permanent, gouache

minaret — A tall tower near a mosque from which the faithful are called to prayer; often used as a motif in Islamic design

mind's eye — The faculty of the mind to imagine or remember visual things

mineral black — Pigment; vine black; also a name for black iron oxide

mineral blue — Pigment; manganese blue, brilliant, transparent, and permanent

mineral brown — Pigment; burnt umber, permanent

mineral green — Pigment; Bremen green, toxic, obsolete

mineral spirits — A substitute for turpentine, used as a brush cleaner and a paint thinner, also called *petroleum spirits* and *white spirits*

mineral violet — Pigment; manganese violet, also ultramarine violet, obsolete

mineral white — Pigment; a native calcium sulphate, not recommended for oil paints

mineral yellow — Pigment; Turner's lead yellow, obsolete

minette — Pigment, ochre

mingling — The mixing of several colors right on the painting rather than on a palette; most often done in watercolors or gouache

miniature — Very small picture, usually about 4 × 4 inches or 5 × 7 inches

minimal art (ABC art) — A 1960s American movement related to the nonart theories of Duchamp, in which the artist's means are reduced to an apparent minimum; closely related are the bare surface paintings of Frank Stella, and the publicized wrapping of buildings and mountains by Christo

minium — A red lead popular in the Middle Ages

Minoan art — Art and culture of Crete about 3400 B.C.-1100 B.C.

mirror image — A design or picture in reverse as seen in a mirror

miskit — *See* **liquid mask**

mist — A hazy atmospheric effect

mistletoe green — Pigment; a light olive green, permanent, gouache

Minoan sculpture

MiTeintes pastel paper — Trade name for an imported paper especially made for pastels, crayon, casein, and gouache, available in many colors

miter box — A tool used with a saw to cut 45-degree angles for picture-frame corners

Mittis green — Pigment; a form of Vienna green, toxic, obsolete

Mittler's green — Pigment; a form of viridian, name obsolete

mixed media — Two or more media used in one picture, such as transparent watercolor and gouache, or pencil and ink wash

mixing cups — Small cups used for holding and mixing color, often with removable lids that fit over the "wells" to keep the pigments workable

mixing tray — Tray used as a palette and for mixing colors; available in numerous shapes

M O — Mold made, said of paper products

mobile — A sculpture with a delicately balanced arrangement of movable parts, suspended on thin wire and generally moved by air currents; the Chinese made wind chimes, which are mobiles, hundreds of years before Alexander Calder built his famous sculptures

mock-up — A three-dimensional model, full size, of a future structure

model — 1. A person posing for an art class; 2. a scaled-down representation; 3. in fashion, a mannequin

modeling — 1. In sculpture, the act of shaping and manipulating the clay or other material into desired forms; 2. in drawing or painting, the suggestion of three-dimensional forms through use of planes, values, and color

modeling board — In sculpture, a board on which the artist works with clay or other material

modeling clay, self-setting — A moist, ready-to-use clay that sets hard but does not have to be baked

modeling paste — A thick acrylic paste, used in reliefs or for any area that needs to be built up; easily modeled while wet, can be carved and sanded when dry

modeling stand — A turntable, usually about three feet high, on which a sculpture is formed

modeling tools — Various-shaped tools made from boxwood and wire, used in sculpture and ceramics

modello — (Italian, *model*) A sketch (often in paint) or a more finished model to show a patron the idea for an artwork

model's stand — A low table-like construction, sometimes on wheels, normally about 6 feet square, used for a life model to sit, stand, or recline

modern art — Generally indicative of the art of the twentieth century that is nonobjective or abstract in nature

modern folk art — In America, art that includes posters, baseball cards, car stickers, etc.

modified realism — Stylized representation of real and recognizable things

Modigliani, Amedeo — 1884-1920, Italian painter and sculptor who worked in France. His stylized figures with smooth, long oval forms are expressive and moody. His sculpture was influenced by African art and by Constantin Brancusi.

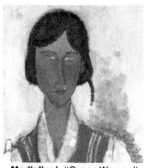

Modigliani, "Gypsy Woman" (detail)

modular colors — A line of acrylic colors already mixed to different values, put out under the trade name of Liquitex

moiré — A shifting, wavy pattern caused by superimposing a halftone screen over another one, an undesirable condition; in textile design, another name for *watered silk*

Moire

moist paper — In watercolor, the condition when the shine has disappeared from the surface of wet paper

mokkotsu — A traditional Japanese ink painting with color

mo-ku — (Chinese, *boneless style*) No lines are used; the picture is painted freely, with each brush stroke creating a form

mold — A hollow form used to cast or shape something, as a mold for a mask or a piece of pottery; sometimes spelled *mould* (usually British)

molding — Narrow strips of wood or metal used to make frames; available in simple or highly decorated styles

mold-made paper — Paper made by machine rather than by hand

Moderne Kunstkring — (Dutch, *modern art circle*) A group of painters who first exhibited together on Oct. 11, 1910; included were Cezanne, Mondrian, Toorop, Sluyters, Braque, Picasso, Derain, Dufy, Vlaminck, and Redon

Monastral blue — Trade name for a phthalocyanine blue

Monastral colors — A trade name for phthalocyanine colors

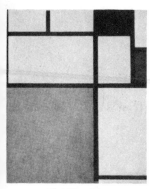

Piet Mondrian

Mondrian, Piet — 1872-1944, born in the Netherlands and known as a Neoplasticist. He is famous for his purely abstract compositions using the three primaries plus white, black, and gray. All lines are parallel to the sides and no obliques are used.

Monet, Claude — 1840-1926, French, one of the leaders of French impressionism. A *plein aire* painter who is noted for his series of paintings of the same subject, done at differing times of day.

Claude Monet, "Gare Saint-Lazare" (detail)

monochrome/monochromatic — Rendered in variations of one color

monogram — A design composed of one or more letters, for identification and decoration

Monogram signature of
Albrecht Dürer

Monolite yellow — Pigment; trade name for a Hansa yellow, close to cadmium yellow light on the color chart, transparent or semitransparent, permanent

monolith — A single standing stone or other material, carved or cast in one piece, sometimes used as a monument

monotype — 1. Process in which a one-of-a-kind original print is made by painting on a glass or smooth surface, then pulling a single print from the plate before the paint is dry; 2. (cap) trademark of a kind of hot lead typesetting machine similar to Linotype. Now largely replaced by computer typesetters

monotonous art — indicates an overall similarity in shapes, values, textures, colors, or lines

montage — A picture made by mounting other pictures, photos, etc., onto a flat surface; not three-dimensional as in *assemblage*

Montpellier green — Pigment; verdigris, fugitive, obsolete

Montpellier yellow — Pigment; Turner's lead yellow, now obsolete

mood — An emotional impression or feeling that may be created through visual means

Moon Mask — *See* **liquid mask**

mop — An oval-shaped watercolor brush used to lay washes

mordant — 1. An acid solution used in etching; 2. an adhesive film used in applying gold leaf; 3. any of a number of substances used in photography and fabric manufacture for dye-toning

morgue — *See* **clip file**

morphoplasticism — A word used to describe realistic, natural art which has form, color, etc., as opposed to *neoplasticism*

mortar and pestle — A bowl made of heavy glass, metal, or stoneware, and a tool of the same material, used to crush or grind dry materials; once commonly used by artists for the making of paints

mosaic — 1. An ancient process of decorative art using small colored pieces of tile, glass, or pebbles pressed into plaster or other ground; contemporary mosaics are made from tile, metal, beads, stone, etc.; 2. in photography, a term for photos pieced together from a number of separate exposures, often used in aerial surveying

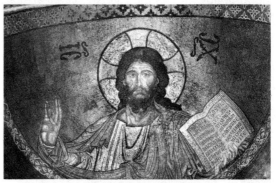

Twelfth century Byzantine *mosaic*

mosaic gold — A metallic gold-colored powder used as a substitute for real gold leaf or powder, obsolete

mosaic tesserae — *See* **tesserae**

moss green — Pigment; chrome green, fugitive, name obsolete

mother color — A touch of one color added to every color used in a picture; a dominant tint that results

mother-of-pearl — A hard, internal, iridescent layer in some shells, used in design and ornamentation

motif — A repeated design or pattern; the main idea or theme in a design

motion in art — 1. Movement suggested by the placement of compositional elements; 2. figures depicted as bending, walking, etc.

mottle — To make a variegated or spotty effect

mount — To place on top of, as to mount a photograph on a cardboard

mountant — A glue, paste, cement, or other adhesive for mounting

mountain blue — Pigment; dark azurite blue, obsolete

mountain green — Pigment;a form of Bremen blue, toxic, obsolete

mounting adhesive, dry — A sheet of adhesive that transfers to the back of the work to be mounted

mounting board — A heavy cardboard, usually white, used to mount photos and artwork

mounting tissue — *See* **dry mounting tissue**

mouse — *See* **pick-up**

movable type — Type of which each letter is separate so it can be moved and placed where desired; referred to as "hand set"

Mozarabic — A style produced by Spanish Christians using Moslem art and decoration during the Moorish domination of Spain

muddy — Said of colors in a painting that have lost their sparkle; usually caused by over-working or mixing too many colors together

mud-glyph — A coined word used to describe symbols, designs, and pictures inscribed in mud on cave walls

mulberry paper — A thin Japanese rice paper

muller — A tool used for grinding pigments

multicolor — Having many colors; polychromatic

multicolor print — A print made with a number of colors

multiliner tool — A scratchboard tool that makes several parallel lines with one stroke

multiple graver — A graver with two or more evenly spaced points, used to cut several lines with one stroke

mummy — Pigment; a brown ash color once made from Egyptian mummies; obsolete; the color apparently came from asphaltum, used in the embalming process

Munch, Edvard — 1863-1944, Norweigian, a painter, printmaker, and one of the leaders of expressionism. His mature work was simplified, stark, and often focusing on morbidity.

Edvard Munch, lithograph

Munich lake — Pigment; carmine, a fugitive lake, obsolete

Munich school — A group of nineteenth-century American painters who were influenced by their teachers at the Munich Academy; paintings tended to be dark in value and based on the works of Rembrandt, Hals, and Velásquez; prominent artists were Alexander, Bacher, Chase, Currier, Dielman, Duveneck, Fitz, Marr, Muhrman, Neal, Rosenthal, and Shirlaw

Munsell theory — A color system introduced in 1915 by Albert Munsell in which color has

three components to which the human eye responds: hue, value, and chroma; the method of color identification uses five hues: red, yellow, green, blue, and purple; based on visual mixture of color rather than pigments

mural — A wall or ceiling painting painted directly on the surface or permanently fixed in place, large in scale to match its setting

muscle — A tissue made up of fibers, capable of contracting and relaxing to effect bodily movement

museum — A building in which artistic or scientific works are preserved, housed, and displayed

museum mounting board — A high-quality mounting board used for artwork; has close to a neutral pH factor

Mycenaean art — Art and culture from Mycenae, a city on the Greek mainland about 1600 B.C.-1100 B.C.; characterized by rich artifacts, often of gold. *See also* **Aegean painting**

Mylar — Trade name for gum-backed coated paper used in graphics; a transparent, tough, dimensionally stable acetate used for overlays; also used in the offset printing process for stripping

myosotis blue — Pigment; a dark blue close to Prussian blue, fugitive, gouache

myrtle green — Pigment; chrome green, name obsolete

Mystic tape — Trade name for a strong waterproof cloth tape that sticks to almost any surface; available in different widths and in many colors

myth — A traditional fictitious story of gods and superbeings, often used as subject matter for paintings

Nabis, Les — (Hebrew, *the prophets*) In the 1890s, a group of French artists, including Bonnard, Vuillard, Denis, Roussel, and others, who were influenced by Gauguin and by naive painting, mysticism, and rebellion against artistic conventions

nacarat carmine — Pigment; carmine, fugitive lake, obsolete

Pierre Bonnard, self portrait
Les Nabis

Nagasaki school — Japanese eighteenth-century school of painting in a realistic style derived from traditional Chinese painting

Nangwa school — Japanese late seventeenth-to nineteenth-centuries school of painting noted for graceful brush strokes and the use of changing values throughout the painting

naphtha — A petroleum distillate used as a solvent for wax; toxic

naphthol crimson — Pigment; an acrylic color similar to alizarin crimson, permanent

Naples yellow — Pigment; a permanent pale yellow, a lead product; toxic

narrative art — Art that tells or suggests a story

National Academy of Design — A society of conservative American painters, sculptors, and engravers headquartered in New York City since 1826; associate members are entitled to

use A.N.A. after their name, and when elected to full membership, N.A. is used

native green — Pigment; native chromium oxide, obsolete

natural dyestuffs — Colors extracted from natural sources such as plants and animals, as opposed to synthetic material

naturalism — Realism in painting, not influenced by distortion, mysticism, etc., and not by romanticism

natural pigments — Pigments from animal, mineral, or vegetable sources

natural texture — Texture from natural sources such as stones, bark, etc.

nature morte — (French, *still life*) *See* **still life**

Nazarenes — Mocking name given to the Lukasbrüder, Order of St. Luke, a group of artists and writers founded in Vienna in 1809, and dedicated to encouraging art as a religious devotion; members included Friedrich Overbeck, Peter von Cornelius, Karl Begas, Julius Schnorr, and Franz Pforr

near complement — The color on either side of the direct complement; for example, a near complement of yellow is blue violet or red violet

near symmetry — A nearly equal visual balance of elements in a composition

needle — A pointed tool used in etching and other graphic arts

negative — A photographic image in which the darks of the original subject appear light and the lights dark; a tonal reverse of the original

negative space — The space in an artwork not occupied by subject matter but utilized by the artist as part of the design

negative tint — White dots or pattern against a dark background

negro pencils — Smooth, black, soft sketching pencils, made in sizes 1-5

neoclassical — Pertaining to a style, mainly in eighteenth-century Europe, influenced by classical Greece and Rome

Neo Dada — *See* **pop art**

neoexpressionist painting — Abstract painting stemming from the emotions or accidental happenings, as distinguished from planned, geometric forms

neoimpressionism — An art movement starting in France about 1880; also called chromoluminarism, pointillism, and divisionism; consists of applying tiny dots of pure color in such a manner that intermediate colors are created in the eye of the observer; prominent artists were Seurat and Signac, although the principle had been practiced by earlier artists including Watteau, DeCaerech, Turner, and others

Neopastel — Trade name for a pastel crayon that is good for shading and mixing as it does not leave dust

neoplasticism — *See* **De Stijl**

neoromanticism — A movement of escapism in painting in the late 1920s; the mood was dreamlike or mournful, similar to but more lyrical than surrealism; prominent artists were Berman and Bérard

net lines — In textile design, the "visible or not visible" lines of the network

Neue Gestaltung — *See* **Le Neo-plasticisme**

Neue Sachlichkeit — *See* **New Objectivity**

neuter figure — A manikin or comic figure that can be either male or female

neutrals — Pigments; beige, tan, putty, cream, khaki, etc.

neutralization — In lithography, the process that removes the hygroscopic film from the stone so the surface again becomes receptive to grease

neutralized color — Color that has been toned or grayed

neutral tint — Pigment; a watercolor made from alizarin crimson, lamp black, and phthalocyanine blue; durable

new blue — Pigment; a form of either cobalt blue or ultramarine blue

New English Art Club — A group including Augustus John, Walter Sickert, and James Whistler, established in 1886 in opposition to what they considered the sterile aesthetics of the Royal Academy

new objectivity or **Neue Sachlichkeit** — Painting that was a reaction to expressionism that developed in Germany in the 1920s; it was representational and exact in detail to the point of unreality; prominent artists were George Grosz and Otto Dix

new realism — *See* **pop art**

newsboard — *See* **chipboard**

newsprint — A cheap paper used for sketching, not durable, turns yellow with age, and tears easily

"Exploiters" by **George Grosz** (detail)

New York School,
Willem De Kooning

Newton's color wheel — The first color circle, developed by Sir Isaac Newton about 1666, using seven colors to correspond with the seven notes of the diatonic scale and the seven known planets; based on refracted light, they were red, orange, yellow, green, blue, indigo, and violet

New York school — A group of painters working in and around New York City after World War II; most are associated with abstract expressionism; among them were DeKooning, Gottlieb, and Pollock

nib — The metal point of a pen

nickle titanate yellow — Pigment; a pale lemon yellow, durable

nihilism — A philosophy denying the existence of any basis for truth. In art a revolt against established values and smugness. *See* **dada**

nimbus — *See* **aureole**

nitric acid — A mineral acid used as an oxidizing agent in etching

noboyka — Sixteenth- to eighteenth-century Russian designs crafted from wood blocks and printed on fabric, using florals and geometrics as repeat patterns

No-crawl — Trade name for a medium used with watercolors and retouch colors on plastic or glossy surfaces to prevent it from beading and crawling

nocturne — A painting of a night scene

noncontinuous-tone art — Artwork that has been screened, usually for reproduction

nondirectional — In textile design, a pattern in which direction is not conspicuous

nonfigurative — Without figures; sometimes not representational

nonglare glass or plastic — A matte finish, framing glass or plastic used to avoid glare

nonobjective art — Art arrived at without the influence of real or natural forms

nonrepresentational art — Art that does not represent real or natural things in any manner

nontoxic — Not poisonous

noodling — An artist's term for rendering intricate details; usually derogatory, implying overdone, over involved

Norwich school — A regional school founded in 1803 in England, devoted to landscape painting; Crome and Cotman were two leading artists

nouveau realisme — (French, *new realism*) Equivalent of American pop art

nude — 1. A live model without clothing; 2. a picture, sculpture, or photograph of a person without clothing; 3. a Caucasian skin color

Nupastels — A trade name for half-hard, smooth pastels in square sticks, used mainly for layouts and drawing, and in pastel painting

nylon brushes — Brushes made from nylon, a man-made fiber; used mostly for acrylic painting

oak tag — A tough stock paper used for stencils and mounting

oatmeal paper — *See* **manila paper**

objective art — The rendering of a subject as it appears; representational art

objet d'art — (French, *art object*) A work of art

objet trouvé — (French, *found object*) An object such as a piece of driftwood, a dried weed, a piece of machinery, that is seen as beautiful by an artist and exhibited as a piece of art

oblique — Diagonal; in type, a face that slants to the left

oblique perspective — *See* **two-point perspective**

oblique projection — Projection in which the object has two of its axes parallel to the picture plane. *See also* **axonometric projection**

occult balance — Same as **asymmetry**

ochre — Pigment; generally applies to the earth color yellow ochre

ochre de ru — Pigment;English red, an obsolete name

oeuvre — (French, *complete works*) The life's work of an artist

offset reproduction — A printing process in which the text and artwork are photographed and the negatives are used to make printing plates; on press, the ink is transferred (offset) from the printing plate to a rubber blanket, which in turn prints the paper

off-white — Pigment; a color that is not pure white; may lean in any color direction such as yellowish white, greenish white

ogee — In textile design, an ogival, or S-shaped, repeat

ogive — A Gothic arch or point in decorative design

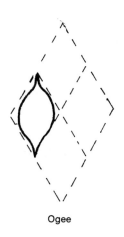

Ogee

oil black — Pigment; carbon lampblack, name obsolete

oil green — Pigment; a form of chrome green or Bremen green, obsolete

oiling out — A process of rubbing an oil medium into dry areas in an oil painting, then painting into the oil-wet surface with fresh color

oil of spike lavender — As essential oil often preferred by artists who object to the odor of turpentine

oil pastels — Oil colors in stick form used alone, dipped in turpentine, or with thinner and brushes; no fixative needed

oils — Usual term for oil-based artist's paints

oilstone — A grinding stone used to sharpen knives and tools

oil wash — An application of oil paint greatly diluted, usually with turpentine, and applied to the canvas or other support as an undercoating or as a glaze, sometimes used over an acrylic painting to add depth and character

Okyo school — *See* **Maruyama school**

old English — A style of lettering and type

old masters — Any of the accomplished European artists who lived from about 1500 to the early 1700s, whose work has stood the test of time; usually refers to painters

"old style" hand lettering — A style based on a structural and proportioning system using a broad pen at a natural writing slant

Caslon

old style typeface — A roman face such as Caslon O.S.

oleograph — A chromolithograph printed with oil-based inks on a textured board or canvas to suggest the appearance of an oil painting

oleopasto — A medium used with oils so they can be applied thickly without cracking

olive branch — In design, a branch from an olive tree, a symbol of peace

olive green — Pigment; yellow-green earth, permanent

one-man show — A showing for the public of one artist's work, usually provided by a gallery or museum

one-point perspective — Perspective in a drawing or painting, usually of a structure, having a single vanishing point

one-stroke brush — A square-tipped, flat brush used mostly for sign painting, lettering, and watercolor detail work; similar to a *flat* in shape

One point perspective drawing by **Carl Larsson**

opalescence — A cloudy iridescence. *See* **iridescence**

opal medium — A beeswax solution dissolved in turpentine, used as a matte medium for oils

opaque — Opposite of transparent; not allowing light to pass through

opaque projector — An instrument with a lens used to project an image of an opaque picture, copy, photograph, etc. *See also* **camera lucida**

opaque white — Pigment;a zinc white paint used with watercolors and gouache, or used to block out unwanted areas in a painting

op art — A term coined in the 1960s to denote a style of nonobjective art in which geometric designs and certain color combinations create an illusion of movement through visual vibrations

Op art, **Bridget Riley,**
"Fall 1963" (detail)

opening — The time set aside for invited guests to view an art show or exhibition prior to the public showing

open up — In lettering, to adjust the space between letters, words, or lines of words

open weave — In textile design, a loosely woven design

opposites — In color, the same as complements (opposites on the color wheel)

optical — Relating to vision; the means of seeing

optical balance — Elements that appear to balance in a composition. May be formal or informal balance

orange peel texture — A surface that has a pocked effect similar to that of an orange peel, occurring during the drying of some shellacs and varnishes

orange vermilion — Pigment; a form of pure vermilion

orbicular muscles — Muscles that open and close the mouth (oris) and the eyes (oculi)

Order of St. Luke — *See* **Nazarenes**

organdy — A cloth used to wipe plates in graphic arts

organic line — An unconsciously handled line in a drawing that flows in such a way as to take on a meaning of its own

organic pigments — Pigments that are compounds of carbon with sulphur, hydrogen, oxygen, etc.

oriental design — Chinese/Japanese/East Indian or other Eastern design

oriental perspective — An intellectual assumption that the top of the picture is the farthest away from the observer and the bottom of the picture is the nearest

orient yellow — Pigment; a deep cadmium yellow

original — 1. An authentic work of art conceived and produced solely by the artist; 2. in graphics, a print from a stone, plate, or block is considered an original since the print is the only manifestation of such work; 3. a printing plate used as a master plate

original print — A print pulled under the artist's control in graphic arts, such as etching, lithography, etc.; not a mechanical or photographic reproduction

ornamental — Decorative; having the purpose of embellishing an object or surface

ornate — Elaborately decorated

orphism or **orphic cubism** — A type of early twentieth-century cubism using overlapping

planes of brilliant color; also called *simultaneism, synchronism,* and *color orchestration*

orpiment — Pigment; a native King's yellow, toxic, obsolete

orthographic projection — A means of projection in which every side of an object is drawn on one flat plane

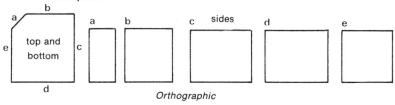

Orthographic

O.S. — Referring to typefaces meaning *old style*

Osmiroid — Trade name of a fountain pen for drawing; different tips are available, to be used with Artone fountain pen ink

Osnaburg — A lightweight cotton canvas, generally not as durable as duck, used as a painting support

ostrum — Pigment; Tyrian purple, an obsolete purple used by the Greeks and Romans

Ostwald system — The color system of Wilhelm Ostwald, a psychologist who, in 1916, based a color wheel on a visual mixture of colors, using red, yellow, sea green, and ultramarine blue

Ottonian Art — Art in Germany around 950-1060, named after the Ottonian emperors; a combination of the Carolingian, Early Christian, and Byzantine styles, notable in sculpture and manuscript illumination

outline — A drawing in which the outer limits are defined by lines, with no modeling of lights and darks

oval — egg-shaped, elliptical

oval wash brush — A brush made of various hairs (pony, goat, squirrel, etc.), used to lay washes; sometimes called a *sky brush*

overlapping joint — In textile design, a portion of one unit overlapping a portion of the next unit

overlays — 1. Transparent papers, clear or in color, used one over the other for changes, corrections, instructions, and for color separations in multicolor reproductions; 2. in textile design, a transparent sheet placed over a design which is then painted or copied in another color, directly on the transparent sheet

overpainting — Color applied on top of an underpainting or undercoat

overprinting — Printing colors or lines over a previously printed area

Owalin — A mixture of fine linseed oil and oil of spike lavender, used in restoring old oil paintings; sometimes called *Bell's medium*

ox gall liquid or paste — A wetting agent added to watercolors to allow painting on a glossy surface

ox hair brush — Brush made from hair of an ox ear; an imitation, without the spring of sable, and much less expensive

oyster shell white — Pigment; an off-white mixture

packaging — The design of packages for commercial purposes

pai-miao — *See* **kou le**

painted woven — In textile design, a painted design imitating a woven cloth

painterly — Appearing free in style or technique, with more use of mass than of line; having the effect of spontaneous, expert paint application

Painterly — detail of a painting
by **Ben Stahl**

painting knife — A flexible steel knife used to apply colors to a painting; different sizes and shapes are available

Paintsticks — Trade name for oils in stick form

paisley — In design, a stylized leaf or teardrop pattern, originated in India but later named after a city in Scotland

pale — Light in value or color

palette — 1. A flat support (wood, glass, plastic, metal) upon which colors are held and mixed, available in various sizes and shapes depending upon the medium used; 2. the colors that an artist chooses to work with, whether limited in number or consisting of many paints

palette cup — A small cup clipped to the palette, used to hold turpentine, thinner or other

Assorted *painting knives*

medium for painting; sometimes called a *dipper*

palette knife — A type of knife used to mix color on the palette, to clean the palette, to apply ground to a canvas, and sometimes as a painting tool

palette-knife painting — A painting rendered with the use of a palette knife, but more often with painting knifes

palette, limited — A restricted number of colors used to execute a painting

palmette pattern — A design made up of small palm shapes. *See also* **anthemion**

pamphlet — A booklet with a limited number of pages and with paper or cardboard covers

panel — 1. In painting, a section of wood, Masonite, plywood, or other hardboard, used in place of stretched canvas; 2. in cartooning, a sequence or several cartoons, also called a *strip*; or a single frame where the gag is complete with one drawing

Pannetier's green — Pigment; viridian green

panorama — A broad, extended scene suggesting an unlimited view of a landscape or seascape

pantograph — An instrument used to enlarge or reduce a drawing; the tracing arm activates a pencil point that reproduces the traced image at a desired size

pantomime — In cartooning, a panel or series of panels without words or captions

paperboard — A cardboard or composition board

paper cutter — A device with a large cutting blade designed to measure and cut paper and cardboard

Assorted *palette knives*

Pantograph

paperdolling — Using part of a drawing and pasting a new section over the artwork; for example, using the figure of a person and pasting a new costume over it; in photo retouching, combining elements from different photos

paper foil — A thin sheet of metal laminated to a piece of paper, available in gold, silver, bronze, red, green, and blue

paper mark — The name of a company pressed into a paper product

paper palette — *See* **disposable palette**

paper plate lithography — A procedure using a special paper plate (in place of a stone or zinc plate) that can be carried and used for outdoor sketching, then printed on a variety of presses

paper wipe — Wiping of inked plates with thin tissue paper

papier collé — (French, *stuck paper*) A form of collage using papers to build up three-dimensional forms

papier mâché — (French, *chewed paper*) Ground paper materials mixed with glue or paste, which can be molded when wet

Papoma — Trade name for a Winsor and Newton oil painting medium made from poppy oil, mastic varnish, and essential oils

paraffin wax — A white wax of lamino-crystalline structure, used in batik; may be bought in a food market (used to seal home-canned products such as jelly)

parallel lines — Straight lines that are equidistant from one another at all points

parallel perspective — *See* **one-point perspective**

Parallel rules

parallel rule — A mechanical drawing tool consisting of two rulers (straight edges) that are attached with movable arms so the rules always swing parallel to each other

para red — Pigment; a bright cherry red toner (paranitraniline)

parchment — A processed animal skin used for scrolls, illuminated writing, and painting, through the sixteenth century; occasionally used in modern times, but replaced by papers that resemble parchment. *See also* **vellum**

Paris black — Pigment; an inferior grade of ivory black, name obsolete

Paris blue — Pigment; Prussian blue, name obsolete

Pariscraft — Trade name of a sculpting product made of gauze and plaster of Paris; can be cut, wet, modeled, and painted; dries hard

Paris green — Pigment; emerald green; the pigment powder is also an insecticide; poisonous

Paris, school of — 1. Thirteenth-century manuscript illuminators of the time of St. Louis; 2. a term broadly used for any artists who were involved with modern painting in the 1920s and 1930s, mostly in Paris; included are such groups as: les Fauves, les Nabis, cubists, etc.

Paris yellow — Pigment; chrome yellow

parma violet — Pigment; a violet somewhat more blue than manganese violet on the color chart, fugitive, gouache

parquetry — Wood mosaic floor pattern; a design motif simulating a mosaic floor pattern

parting tool — A gouge used in woodcut or wood carving

passage — Term sometimes applied to a section, segment, or area of a painting

paste blue — Pigment; Prussian blue, name obsolete

pasteboard — Paperboard made of layers of paper pasted together

pastel — An inexact term suggesting a soft, pale, nonstrident hue. *See also* **pastels**

pastel chalk *See* **pastels**

pastel paper — A textured paper with a "tooth," used for pastels, crayon, and other media; a paper made especially for pastels, with a special surface

pastel pencil — A pencil-shaped drawing tool of which the inner material is a pastel pigment; made in assorted colors

pastels — Pigments pressed into stick form; permanent; available in many colors that are not limited to the common meaning of *pastel*; of soft or hard quality; like chalk, the sticks are broken into convenient sizes when used; can be overlaid with more color to obtain various effects; can be rubbed smooth or not. Art in pastels is classified as painting

pasteup form — In publishing, a bristol or other board printed with an appropriate grid of light blue (a color that does not reproduce when photographed with standard films), used to save time in pasting up standard page sizes of magazines, books, etc., to keep copy aligned

pasteups — pictures, type, etc. that are mounted onto a mechanical to form a page for a magazine, book, brochure, etc., to be printed

patchwork — In textile design, various patterns that imitate patchwork quilting

patent yellow — Pigment; Turner's lead yellow, now obsolete

patina — 1. A thin deposit of poisonous pigment, often greenish or brownish, caused by corrosion or age, that appears on copper or bronze artworks; 2. also the name given to a mellowing with age, and may be imitated in painting by glazing; also called *aerugo, aes ustum, verdigris*

patriotic colors — Colors pertaining to a country's flag, as red, white, and blue for the U.S.A.

patron — A person who supports or buys the work of an artist

pattern — 1. In textile design, a single motif or several repeated motifs; 2. a plan or diagram that is repeated, as in stenciling; 3. more abstractly, the colors, values, lines, or textures, regular or irregular, that form a configuration in a composition

Payne's gray — Pigment; a prepared blue gray, permanent

peacock blue — Pigment; bright to medium blue close to thalo blue on the color chart, fugitive, gouache

pectoral muscles — Muscles that cover the chest
 major — flexes, adducts, and rotates the arms
 minor — raises the ribs and draws down the scapula

pedestal — A support or base for sculptural work

peinture á l'essence — (French) A painting procedure in which oil paint is squeezed onto absorbent paper to remove the oil, then turpentine is used as a thinner; often applied in dry brush on pastel paper

peinture claire — (French) A procedure in which a bright, flat color is placed next to a dark, flat color to create form, in place of a gradual change from light to dark

pietra dura — A stone mosaic using semiprecious stones

pelvis — The skeletal structure that rests on the legs and supports the spinal column

pen and wash — A wash drawing including line work

pencil — A writing or drawing implement consisting of a thin rod of graphite or similar material encased in wood or held in a plastic or metal mechanical holder; commonly called a lead pencil

penholder — The part of the pen that holds the pen point

Pennsylvania Dutch patterns — Distinctive folk designs of the Pennsylvania Dutch, related to designs used in Europe during the eighteenth century; used on furniture and as household decorations; the colorful hex signs seen on barns are usually wheel-shaped

pen point — The part of a pen that fits into the holder; the writing or drawing part; the nib

pentimenti — lines drawn in searching for the correct movement or placement. A line is put down and if it is felt to be incorrect the artist adds another line he feels is more correct without removing the first line

Pentimenti — drawing by **Robert Fawcett**

pentimento — (Italian, *repentance*) The reappearance of a previous drawing or painting on the surface of an oil painting, caused by the tendency of the linseed oil used in the paint to become transparent with age; also called *ghost*

pepper-pot tints — In aquatint, a small jar covered with a fine screen (often an old nylon stocking) is used to sprinkle aquatint or bitumen on the plate

perception — The act of perceiving, understanding, and discerning

perforating wheel — *See* **pouncing**

periodicity — Rhythm

periwinkle blue — Pigment; a color close to cobalt blue on the color chart, permanent, gouache

Permalba — Pigment; a trade name for a white oil color

permanent — Lasting a considerable time and not deteriorating

permanent blue — Pigment; a color close to ultramarine blue, permanent

permanent carmine — Pigment; a synthetic red, permanent

permanent colors — Colors that will not fade or deteriorate

permanent green — Pigment; a bright opaque green, permanent, made in a light and a dark shade

permanent magenta — Pigment; a reddish purple, permanent

permanent rose — Pigment; pink or rose color close to thalo red rose on the color chart, transparent and permanent

permanent violet — Pigment; manganese violet, permanent

permanent white — Pigment; synonymous with titanium white

permanent yellow — Pigment; lemon yellow, permanent

Persian miniatures — Small, brightly decorated Persian art depicting hunting scenes, gardens, heroes and kings, animal illustrations, etc., often including calligraphy in the design

Persian orange — Pigment; a reddish orange, opaque orange lake, fugitive

Persian red — Pigment; English red, also a form of chrome red, name obsolete

perspective — A method of representing a subject that is in three-dimensional space on a two-dimensional surface

perspective chart — A prescaled grid chart used for accurate perspective drawing of architecture, interiors, package design, etc.

petit point — A small dot used in pointillist painting, from *petit point* embroidery, made of very small stitches

petroglyph — A line drawing or symbol incised on a cave wall or slab of stone as in prehistoric rock carvings

Petroglyph in New Mexico

petroleum spirits — *See* **mineral spirits**

phalanges — The short bones of the fingers and toes

phantom draw — 1. To mentally draw a subject, using a finger as a pencil, then draw the subject with a pencil; 2. to lightly sketch a subject and then redraw it, being more exact

photoengraving — A process for photographically recreating line or continuous-tone art on a chemically sensitive metal printing plate. A reproduction made by this method

photographic printing — In textile and other design processes, the method of transferring designs to the desired surface with photoengraved rollers; fine details and color effects are possible

photogravure — *See* **gravure**

photolithography — The transfer of art to a litho plate by the use of photography

photo-offset printing — *See* **offset reproduction**

photo oil color — Permanent, transparent oil color used specifically for coloring photographs

photo oil color pencils — Oil color pencils used to draw in highlights, shadows, and details in photographs

photorealism — The effect of a picture painted to resemble a photograph or having the realism of a photograph

photostat/stat — Copy produced by a photostat machine, using a camera that generates an opaque paper negative from which a positive print is made; good for line work reduction, enlargements, etc., relatively inexpensive

phthalocyanine blue (phthalo blue; thalo blue) — Pigment; an intense, permanent, transparent blue, close to Prussian blue. *See* **color chart**

phthalocyanine green (phthalo green; thalo green) — Pigment; an intense, transparent, permanent green

pica — A printer's unit of measurement equal to 12 points or 1/6 inch, used in page printing for line width, depth of columns, paragraphs, etc.

pica ruler — A ruler marked with agate and inches on one side and picas and inches on the other, used by printers and in commercial art

Pica rule

Picasso, Pablo — 1881-1973, born in Spain, settled in France, he had much influence on twentieth-century art. His early work was realistic. He then helped formulate cubism and later other modes of nonobjective art. He was a painter, sculptor, printmaker, and ceramist.

pick-up — A ball of dried rubber cement used to pick up excess dried rubber cement from paper or other surfaces; available in ready-made sheets or tapes; also called *goobungie; mouse*

pictograph — Picture writing, expressing an idea with picture symbols, as in primitive writing

Pablo Picasso —
"Weeping Woman"(detail)

picture frame — A molding or other border, usually wood or metal, that surrounds a picture

picture plane — The imaginary plane, like a sheet of glass, at right angles to the viewer's line of vision, on which the picture is projected

picture varnish — A final varnish used on oil paintings to protect them and give a uniform finish. *See* **damar**

piece mold — A rigid mold made in pieces, used for casting sculpture

pietà (Italian, *pity*) — A work of art showing Mary mourning the dead Christ, a recurring theme in devotional art

Michelangelo's *Pietà*

pigment — The dry, powdered coloring agent in a paint that is mixed with a medium to form tube colors or sticks

pigment yellow — Pigment; Hansa yellow, both transparent and opaque, permanent; close to cadmium yellow, pale on the color chart

piling — In printing, a buildup of ink on the plate, rollers, or blankets, causing a poor print

pine-soot black — Pigment; Chinese carbon lampblack, name obsolete

Pink Pearl eraser — Trade name for a good all-purpose eraser, pink in color

pin registration — The use of holes and special pins on copy, film, plates, and presses, for exact alignment

pinstripe — A very fine stripe, especially on a fabric

pinx — (Latin, *pinxit, he painted it*) Credit on a print after the name of the one who painted it; may also indicate *he designed it*

pitcher — In stone carving, a large, heavy implement similar to a chisel, used with a hammer to remove big pieces of stone in the early stages of carving

Pittura Metafisica — (Italian, *metaphysical picture*) An art style in Italy about 1918-1921. *See* **magic realism; metaphysical painting**

plaid — In textile design, a pattern in which lines and colors crisscross. *See* **tartan**

plane — A two-dimensional flat or level surface, as one surface of a cube

planographic printing — A printing procedure in which the printing surface attracts printing

ink and is on the same level as the nonprinting surface, unlike *intaglio* or *relief* procedures; lithography, callotype, and aquatone are included in this category of printing

plaque — An engraved, painted, or otherwise decorated piece of wood, metal, etc., for hanging on a wall

plaquette — A small version of a plaque

plasteline — A fine, smooth, gray-green, oil-base modeling clay for casting that remains soft, can be reused; trade names: *Plasticine; Plastilina*

plaster cast — A mold of plaster used for reproducing sculpture

plaster of Paris — A gypsum plaster that dries into a solid when mixed with water, used for casting sculpture and ceramics

plaster print — 1. A relief print made from an inked plaster plate; 2. a print made by casting plaster on an inked intaglio plate

plastic — A polymerized product; a nonmetallic, synthetic compound in various forms, capable of being shaped, made pliable, or hardened

plastic arts — Arts that use vision, space, and physical materials, such as painting, sculpture, ceramics, and architecture

plastic cutter — A cutting device used to score and cut plastic, lightweight copper foil, brass, and aluminum

plasticizer — An additive for paint, varnish, etc., to give it elasticity

plasticum — A plasteline which retains its smooth texture indefinitely. Does not crack or harden or stain the hands; used by sculptors

plate — 1. In graphics, a smooth surface applied to copper, zinc, or steel for etching, or to metal, plastic, or wood for printing; in photography, a prepared surface usually applied to glass; 2. a special illustration bound into a book

plate finish — A smooth finish

platemaker — In graphics, the person or machine that does the platemaking in a printing process

plate mark — In printmaking, the mark of the edges of the plate that are left on the paper

plate oil — A form of linseed oil, mixed with etching ink to make it more manageable

plein air/en plein air — (French, *open air*) Term applied since about 1850 to artists who paint scenes outdoors directly from observation

pleinairistes — A group of impressionists who painted *en plein air*; included are Monet, Pissaro, Renoir, Sisley, and others

Plessy's green — Pigment; a variety of chromium oxide green, name obsolete

Plexiglas — *See* **acrylic sheets**

plug — A piece of wood inserted in a woodcut in order to rework an area

plumbago — graphite

ply — Pertains to layers of paper, to indicate weight and thickness

pochoir — (French, *stencil*) The use of stencils to produce and color fine prints by hand

poetic — Emotional, sensitive, and imaginative; said of visual images that may be objective or nonobjective in character

point — 1. A unit of measurement of type, 1/72 inch; 2. in carving, a pointed tool, available in different sizes, used with a mallet to remove waste stone

point of entry — The likely place of eye entry into a picture; often varies from viewer to viewer

point of sight — *See* **center of vision**

point of station — *See* **station point**

pointillism — a painting procedure in which dots or spots of color are used to create colors and values by optical mixing; for example, dots of red and yellow used side by side blend optically to create orange, when viewed from a distance; closely linked with *impressionism*; also called *divisionism, simultaneous contrast, neoimpressionism,* and *chroma luminarism;* prominent artists involved included Seurat and Signac

polishing — In lithography, putting a fine grain on the stone with a grinding stone

political cartoon — A satirical or humorous drawing on a political subject often accompanied by abbreviated written material

polka dot — In textile design, a dotted pattern of either small or large dots

Pollock, Jackson — 1912-1956, an American who is considered an abstract expressionist. His works are known for their huge size and dripped and splattered paint. The work is nonobjective.

Jackson Pollock — engraving and drypoint

polyurethane brayer — In graphics, similar to a composition roller, but firmer

Pompeian blue — Pigment; Egyptian or cobalt blue

Pop Art — **Andy Warhol**

Pompeian red — Pigment; Tuscan red; a form of Indian red; a red oxide

pop art — Also called new realism and neo-dada; a movement of the 1950s utilizing as art such articles as soup cans, comic strips, and other mass-produced, found, or ready-made objects; this so-called "Coke culture" art rejects any distinction between good and bad taste; artists include Warhol, Rauschenberg, and Lichtenstein

pop colors — Bright chrome colors, high intensity colors

P.O.P. design — In commercial and advertising art, means *point of purchase;* an art display or construction located with a product at the retail level; may hold the product and/or simply advertise the product

poppy seed oil — A medium made from poppy seeds, used for thinning oil paints

portable easel — A lightweight, easily carried, folding easel

portfolio — 1. A portable case for carrying papers, drawings, etc.; 2. the drawings, paintings, or photos of artwork in a portfolio that are presented to interested parties for review in the course of seeking employment or school acceptance

portrait — A painting of a person's likeness, usually three-quarter or full length

portrait shape — A rectangular picture shape used in a vertical position, the most common picture shape for a portrait, although many successful portraits are in a horizontal shape

pose — 1. The stand or position a model assumes and holds while the artist works; 2. the position the artist gives a figure in a picture

positive space — The area containing the subject matter in a composition

positive tint or screen — Dots or texture pattern on a white background; a term usually used in commercial art

poster — Any illustration and/or lettering publicly displayed to advertise a service, product, or event

poster board — A smooth-finished paperboard used for signs and posters, available in several colors; also called *show card*

poster colors — Inexpensive opaque watercolor paints used for posters and commercial art; also called *show card colors*

poster design — 1. *See* **poster; 2. in textile design, a poster-type design used on pillows, sheets, rugs, etc., also called a *scenic***

postimpressionism — A term generally relating to the paintings of four artists, Cézanne, Van Gogh, Gauguin, and Seurat, from about 1875 to 1900; they accepted the impressionists' use of light with bright colors and conspicuous paint handling, but rejected the casual compositional structure of the impressionists

Post impressionists —
Georges Seurat

post modern art — 1980s art indicative of humanism and things of our visible world

pounce — 1. A fine powder of chalk or charcoal contained in a small bag and used in pouncing; 2. a powder used to condition a surface for inking. *See* **pouncing**

pouncing — 1. A means of transferring a drawing in which a perforating or tracing wheel or needle is used to prick small holes in the lines of a drawing, and a pouncing bag is tapped over the drawing; the powder goes through the holes and transfers the design; 2. when applying paint to a picture, a tapping motion with a brush, sponge, or cloth

pouncing bag — A cloth bag filled with pounce. *See also* **pouncing**

Pounce wheel

pounce wheel — A tracing or perforating wheel. *See also* **pouncing**

Poussinistes — Seventeenth- and eighteenth-century followers of Poussin, who felt drawing was superior in importance to color in painting; one of the leading advocates was Charles Lebrun. *See also* **Rubenism**

powder colors — Opaque watercolors available in powder form, to which water is added as the binder; available in a variety of nontoxic colors

powdered charcoal — Charcoal in powder form used for pouncing bags

powdered tempera colors — Tempera colors available in a powdered form to which water is added to make show card paint

Pozzuoli blue — Pigment; another name for Egyptian or cobalt blue

Pozzuoli red — Pigment; a red earth used in frescoes

Prang color wheel — A color wheel that deals with the mixing of colors; the three primaries of yellow, red, and blue are used, the secondaries are made from the primaries, and the intermediaries are derived from the colors on either side, as yellow and orange make the intermediary of yellow-orange. Researched by Louis Prang (1824-1909); *See* **color wheel**

pre-Columbian art — Early art from the Americas, prior to the landing of Columbus

prehistoric art — Anything relating to art earlier than about 3000 B.C. Some prehistoric art exists that was done more than 25,000 years ago, such as incised drawings preserved on cave walls

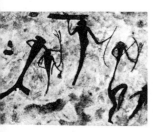

Pre-historic rock painting

presentation — A sketch or layout shown to a client to suggest a projected design or illustration plan

presentation portfolio — *See* **portfolio**

press printing — *See* **printing press**

press, block-printing — A hand press used for block printing

pressboard — A strong, durable, high-gloss paperboard, often used as a cover stock

press, dry-mounting — *See* **dry-mounting press**

press etching — A press made especially for intaglio printing, which includes etching, drypoint, aquatint, and engraving; the ink fills the incised lines below the surface of the plate and the pressure of the press forces the paper to contact the ink

Etching press

press, lithograph — A press made for printmaking from litho stones or plates

press type — *See* **pressure-sensitive letters**

pressure-sensitive letters — 1. Dry-transfer letters and symbols easily applied to paper by burnishing; available in different sizes, colors, and typefaces; 2. permanent vinyl plastic letters and symbols that are available for glass, metal, wood, leather, and outdoor use

presto-seal film — A self-sealing protective film for artwork, maps, and blueprints

"pretty picture" — A term used about artwork that is trite; implies a picture that relies on the subject matter for its appeal and has no lasting quality as a work of art

primary colors (artists') — Red, yellow, and blue

primary colors (printing inks) — Magenta, cyan, and yellow

213

prime — To prepare a canvas or panel for painting by covering it with a glue-like paint, such as gesso; the primer penetrates the surface and prepares the support so that paint does not seep through the backing

primed canvas — Canvas that has one or two coats of gesso or other primer

primer — The glue or size, such as gesso, used to prepare a canvas or panel

primitive art — 1. Native art of such cultures as African, Eskimo, American Indian, etc., usually associated with daily life or with religious rites; 2. works produced by an artist who has not received or absorbed professional art training or has not been influenced by others' work

primrose yellow — Pigment; a pale yellow close to cadmium yellow pale on the color chart

print — 1. An impression pulled from an original plate, stone, block, screen, or negative, prepared solely by the artist; in collagraphy, engraving, etching, dry point, aquatint, mezzotint, and silkscreen; 2. in textile design, a floral or geometric design as opposed to plaids or stripes; 3. a positive made from a photograph negative

printer's ink — Ink made and used specifically for printing presses

printer's proof — See **bon á tirer**

printing press — A hand- or power-operated machine that prints impressions on paper and other suitable materials. See **offset reproduction; press, block-printing; press, etching; press, lithographic**

print rack — a rack used to exhibit prints, drawings, watercolors and the like

prismatic color — *See* **iridescence**

Prismacolor pencils — Trade name for a type of colored pencils

process colors — 1. In commercial four-color printing, yellow, magenta (red), cyan (blue), and black; 2. standardized ink printing colors; 3. commercial silk-screen colors

process art — Art of the 1960s and 1970s, based on the idea that the artist's product is less important than the process that brought it into being; related to minimal art, performance art, and conceptual art

process color printing — Using yellow, magenta, cyan, and black, full-color representations are made of paintings or photos; each color is separated with camera filters and processed onto a separate printing plate

process plates — In reproduction, a set of plates made in halftone to produce different colors, usually black, yellow, magenta, and cyan

process white — Pigment; an opaque white paint used for corrections on artwork

production manager — At advertising agencies, publishers, etc., the person responsible for scheduling and ordering printing, paper, binding, etc.

profile — The side view of a subject

progressive proofs/progs — A set of separate proofs from each successive color run of a multicolor print for checking color

projection principle — The phenomenon whereby the imagination is able to create form from any amorphous element, such as clouds, ink blots, etc.

proof — In graphic arts, a preliminary print that is examined for perfection before final printing is done

prop — Anything used as a reference in creating a picture, such as an antique saddle or old boots in a Western painting

proportion — The mathematical relation of things to the whole, the harmonious relationship between the parts of a form

proportional dividers — An instrument for transferring measurements to make enlargements or reductions of an original drawing/illustration

prototype — The first of its kind; an original work of art, usually intended for reproduction or copying

protractor — A calibrated semicircular or circular instrument used to measure or construct angles

protrude — To jut out or extend beyond the borders

provenance — The history of a work of art, its origin and collectors; records kept to help assure authenticity and forestall forgery

Prussian blue — Pigment; intense, transparent blue, permanent

Prussian brown — Pigment; iron brown; Indian red in its unburned state; permanent but seldom used

Prussian green — Pigment; Brunswick green, a chrome green, fugitive

Prussian red — Pigment; a light red oxide, permanent

psychedelic art — Distortions of visual perception taking the form of exaggerated color and movement associated with hallucinogenic drugs; include swirls that resemble *art nouveau*

psychedelic colors — The bright fluorescent colors seen in psychedelic art

puce — Pigment; a purple color with a decided brown influence

puddle — 1. In watercolor, a small pool of water or color either on the palette or on the paper; 2. in tole painting, to add medium to paint to achieve the required consistency

puff ink — A type of ink used by printers that rises into a puffed pattern

pull — 1. In graphic arts, to make a print and "pull" from the press; 2. in a picture, the tension generated by the juxtaposition of lines, values, shapes, colors, in the composition

pull together — To unify elements in a picture to make the work more effective

pumice powder — A lightweight powdered porous volcanic rock used as an abrasive and as a polish

pure tube color — Pigment, straight from the tube

Purism — A 1918 protest against cubism by Amédé Ozenfant and Le Corbusier, who sought to restore representational construction by means of stressing purified outlines and machine-like qualities of forms

purist — 1. An artist who adheres to set principles; for example, one who does not mix mediums in the same picture, such as transparent watercolor and opaque watercolor; 2. followers of Purism

purple lake — Pigment; a purple somewhat bluer than manganese violet on the color chart, moderately permanent, gouache

purple madder (alizarin) — Pigment; a blend of alizarin lake and violet organic lake somewhat bluer than magenta, moderately durable

pusher blanket — In intaglio printing, the top or upper blanket on the press

Pushpin

pushpins/push points — 1. Tacks similar to thumbtacks, but with a longer point and a top-hat style head; 2. a metal device that is pushed into the back of a frame (the molding) to hold the glass, picture, and backing in place

push-pull technique — A method of drawing and painting in which parts of a form are left out and parts are pulled back in; also said of a "push-pull" type of brush or drawing stroke. *See also* **lost and found**

push-pull values — Seen in a decorative form of art in which the light source is not consistent; the artist strives for balance in values rather than realism. *See also* **shifting planes**

putto — In art, a male child as a cherub

put to bed — Said of a publication when all material is ready to be printed

putty color — Pigment; an off-tan, grayish mixture considered a neutral

putty eraser — A soft eraser similar to a kneaded eraser, but more flexible

putty rubber — A kneaded eraser

q-tip — A short, flexible stick with cotton wrapped around one or both ends, used in art for odd jobs such as cleaning a drawing, spreading graphite, charcoal, turpentine, sometimes for creating rub-out effects in a painting

quadrille paper — A graph paper on which all lines are of equal weight

quarter drop — In textile design, the motif dropped a quarter down from the first motif

quarter drop

quatrefoil (French, *quatre feuille, four-leaved*) — A motif made up of four leaves, seen in Gothic tracery

quenching — The method of hardening metal by plunging it into water or oil while it is red hot

quercitron lake — Pigment; a yellow lake, fugitive

Quatrafoil window design

quickies — Rapid little sketches done as exercises or to visualize picture concepts

quiet area — An area in a composition that is less busy in line, color, texture, etc., than other areas

quill — A large bird's feather cut to be used as a pen

quill pen *See* **crow quill pen**

quilted pattern — In textile design, a stitched design imitating quilting

quinacridone red — Pigment; a rosy red, durable, acrylic

quinacridone violet — Pigment; a red violet, durable, acrylic

quire — Twenty-five sheets of paper, or 1/20 of a ream

quoins — Little steel triangular wedges used to lock type and plates in chases for the press

R.A. — Royal Academician, a member of the Royal Academy of Arts, London

rabbitskin glue — Glue used as a size or binder; sold in solid form, granules, or sheets

radial balance — Accomplished by forms or elements designed as a wheel around a main subject

Radial balance

radiation lines — Lines that emit from a common point, but radiate in different directions. *See* **radial balance**

radius bone — A long bone parallel to the ulna bone in the forearm; it alone connects to the wrist

R.A.F.C.(Rembrandt Artists' Fluid Colors) — Trade name of liquid colors, packaged in small cans, that dry fast, can be used with acrylics and touched up with oils; its viscosity enables it to be used in many ways

rag — Paper made exclusively from cloth; if only partial, the percentage of rag is stated on the label

railroad board — A smooth six-ply board, available in many colors, that can be used on both sides for posters, lettering, and the like

rainbow printing — In graphics, rolling several colors simultaneously onto a plate or stone from a single roller, and blending the edges

Rainbow inking

Rasp

raising preparation — A nonflowing paste used for raised or embossed effects before gilt is applied; may become tacky in humid conditions but holds its form when dry

Rapidograph pen — Brand name for a technical drawing pen. *See* **technical pen**

rasp — A tool with a rough texture like a file, used for rough shaping wood, stone, plaster, and clay

raw color — Color straight from the tube, with no mixing or adulterations

raw sienna — Pigment; a natural earth, deeper than yellow ochre, permanent. *See* **color chart**

raw umber — Pigment; a natural earth, a cool brown, permanent. *See* **color chart**

rayonnism — (Called lutschism in Russia) A Russian offshoot of cubism, led by Mikhail Larionov (1881-1964), who was interested in the forms created when intersecting rays of light hit a subject

razor blade — A single-edge or double-edge cutting instrument frequently used by artists to scrape lightly over an unwanted color or line to make small corrections; also used to scratch lines in watercolor

ready-made — A found object used in collage, junk sculpture, etc. which is exhibited as is, as an aesthetic object

realgar — Pigment; a reddish-orange color, toxic, obsolete

realism — 1. A way of painting nature without distortion; 2. the philosophy of painting, led by Courbet, centered on unidealized, everyday subject matter

realistic — Said of a work of art striving to resemble reality or portray a likeness with a strong resemblance to the sitter

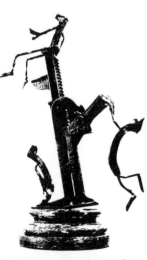

Ready made sculpture of railroad spikes and a jack by **Howard Munce**

ream — Five hundred sheets of paper

receding — Appearing to go back or away from the observer, as in an illusion of a space or line in a picture

receding colors — Cool colors—blue, green, and violet—that seem to move back, in comparison with warm colors of yellow, red, and orange that appear to come forward or advance

rectangle — A four-sided plane figure with four right angles

rectified petroleum — A good-quality petroleum spirit used to thin oils and clean brushes

rectified turpentine — A pure form of turpentine (double-distilled) used by artists to clean oil brushes, and as a medium for oil and alkyd paints

rectilinear — Made of straight lines

recto — Right-hand page. *See also* **verso**

red lead — Pigment; an opaque, heavy Indian red color used industrially

red ochre — Pigment; a form of Venetian red, originally a native earth. *See* **color chart**

red oxide — Pigment; a red earth color; Indian red made with a bluish or red undertone somewhat redder than Mars violet; opaque and permanent

red sable — *See* **sable/red sable brush**

reducer — In printmaking, a medium added primarily to dilute thick ink so it will print more easily

reducing glass — A double-concave lens used to see how artwork looks when reduced in size

Reducing glass

reduction printing — In printmaking, for registration purposes, the largest color areas are printed first, then the next sizes in sequence, and finally the smallest areas

reductivism — A procedure for reducing, diminishing or simplifying, with fewer lines, less color, etc.

reed pen — Now only the bamboo pen, usually sharpened at both ends and used for ink drawings

reference file — *See* **clip file**

reflected light — Light is "bent" or "thrown back" on something; for example, if you paint a silver pitcher which is placed on a red cloth, some red will probably be apparent in the pitcher. This red is called a reflected color

Portrait showing *reflected light* by **Douglas Graves**

reflex printing — A copy method in which a sensitized film or paper is placed face down on the material to be copied, light passes through the base of the sensitized film and is reflected from the light and dark portion of the original back to the emulsion

regionalism — Art pertaining to a region or section of the country, such as the Northwest or New England

registration marks — Marks that indicate where overlays or plates are to be aligned

Reichenau school — A German school of manuscript illuminators, about 965-1025, noted for its huge gold letters that often took up a whole page

Reims school — A French school of manuscript illuminators during the Carolingian era, eighth to eleventh centuries

relief — A variation of elevation in sculpture; a raised effect ranging from low (bas-relief or basso rilievo) to high (alto rilievo)

relief etching — A procedure in which large areas of a plate are etched away and the design is left standing so it can be surface-printed

relief printing — In printmaking, a means of printing design or type that stands above the surface of the printing block; woodcuts and rubber stamps print by relief methods

religious art — Art pertaining to religion, as the Buddha, Christ, the Virgin Mary, etc.

relining — In restoring an old painting, the process of mounting it on a new canvas support

Rembrandt, Harmensz, van Rijn — 1606-1669, Dutch, printmaker and painter. His works, which focus on landscapes, history, people, and portraits are well known for their chiaroscuro technique. A series of self-portraits covering a period of forty years show his deep concern for expression and control of values. Rembrandt is considered among the most important painters of all time.

Rembrandt — self portrait, etching (detail)

Renaissance art — Fourteenth-, fifteenth-, and sixteenth-century art in Western Europe characterized by the revival of classical design and concern for humanistic values; artists included Michelangelo, Raphael, da Vinci, and many more

Renaissance fold — In folded cloth, where all ends are rounded

render — 1. The process of drawing or painting a given subject. 2. To make a detailed drawing, usually enhanced with watercolor, of an architectural project

Renoir, Pierre Auguste — 1841-1919, French impressionist, known for his appealing figures, multiple figure compositions, portraits, flowers, and luminous landscapes.

Augustus Renoir, self portrait

repeat glass — An optical instrument used by textile designers, made of four lenses through which a design appears to be repeated four times

repeat pattern — A pattern occurring several times in a design

replica — A copy or reproduction of a work of art, especially when made by the same artist who created the original work

repoussé — In metalwork, a technique of hammering, scratching, or pressing metal on either side to create a design

representational art — Artwork that purports to represent what is seen; also called *objective art*

reproduction — A copy of an original work of art made by someone other than the artist, usually by mechanical means and most often for commercial use

reproduction proofs/repros — Clean, sharp proofs, usually of type, on a coated paper, used as copy for photographic reproduction

reproduction right — The right to maintain control of the reproduction of artwork or other copyrighted material

repro type — A high-quality reproduction type used for pasteups on mechanicals

rescale — To enlarge or reduce artwork so the material will fit into a given space in a page layout; usually figured in percentages, calibrated for the engraver's copying camera

research file — *See* **clip file**

resensitize — To treat and prepare a lithographic stone so it can be used again; to treat a metal plate so it can be worked again

resin ground — A ground used when making an aquatint by dusting it on the plate and heating the plate, causing the ground to stick to the surface; the covering acts as an acid resistant that is necessary in creating the tonal effects in the aquatint

resist — A substance (such as wax) which protects a surface from receiving dyes, inks or pigments

restoration/restoring — Bringing a work of art as nearly as possible to its original condition; includes cleaning, repairing, mending, remounting, restretching, and sometimes, retouching

restricted palette — *See* **limited palette**

retardant — An additive to a paint medium to delay the drying time, such as oil of cloves, oil of lavender, and others

rétirage — (French, *pulling again*) In graphics, the pulling of a second print without reinking the plate

retouch grays — A series of opaque watercolor paints, white through graduated grays to black, used to retouch photos and artwork

retouching — 1. Making corrections on artwork;2. eliminating or altering parts of a photograph

retouch varnish — A diluted liquid or spray varnish used between applications of oil paint to restore the wet look to matte colors for easier color matching; also utilized as a gloss coat on a finished painting until the final varnish is applied

retouch white — An opaque white paint used to cover unwanted areas in pictures and to make corrections

retrospective — A review of a large body of work produced during an artist's lifetime

retroussage — In printmaking, a method of leaving a trace of ink on the surface of an intaglio plate; the process makes the value of the incised lines richer

reverse — 1. In textile design, to flop over a design; 2. in commercial art, to change negative to positive or positive to negative, or to flop the picture to change its direction

reversed copy — White type on a dark background

reversed perspective — In opposition to mechanical perspective; objects in the front of a picture are smaller than those farther away

reverse etching — An etching procedure in which an intaglio plate is surface-inked and printed like a woodblock

reverse image — An image in which lines and areas normally black become white, and vice versa

reverse print — In textile design, a print in which the light areas are made dark and the dark areas light

rhodamine — A synthetic dyestuff used for making red lake pigments

rhomb/rhomboid/rhombus — A four-sided figure with all sides equal and opposite sides parallel, but two angles are acute and the other two angles are obtuse

rhythm — The regular repetition of any of the elements of a design, with or without periodic alteration

rib(s) — 1. A series of curved bones encasing the chest cavity in humans and animals, ex-

tending from the spine to or toward the breast-bone; 2. certain structural support members of ships, buildings, etc.

rib cage — The confined area made up of the ribs

rice paper (Japanese) — A lightweight paper made in different textures, sizes, weights, and colors; can be used for watercolors, inks, and printing

rich — Said of paint with intense color, strong values, and/or a thick application

riffler — A particular style of curved rasp. *See also* **rasp**

rigger — A long, pointed, usually sable brush used to paint long lines, branches on trees, and fine details

Rinman's green — Pigment; cobalt green

rocker — A textured tool used in mezzotint to prepare the surface on the plate; also called a *cradle*

Rococco figurine

rococo — A delicate eighteenth-century style of art and decoration with a concern for the trivial rather than the significant; colorful and capricious, closely linked historically with the fashionable reign of Louis XV of France; artists include Watteau, Boucher, Fragonard, and Tiepolo

Rodin, Auguste — 1840-1917, a French romantic sculptor who was influenced by the work of Michelangelo. One of the leading sculptors of the late nineteenth and early twentieth centuries. Two of his most famous works are *The Thinker* and *The Kiss.*

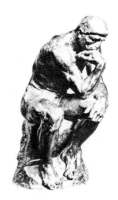

Augustus Rodin —
"The Thinker"

roller — *See* **brayer**

roller art — A means of painting with a roller/brayer technique that involves bouncing, twisting, scraping, or any other means of laying paint on a surface with a roller; unique effects can be created that are difficult to achieve by other means

roller printing — *See* **direct printing**

roll-up — The process of inking a plate or stone with a roller

roman — 1. A general term used to describe any typeface with serifs; 2. any upright typeface, as distinguished from the slanting italic

Romanesque — A transitional style of European art from the ninth to the twelfth centuries, preceding Gothic art; primarily for and of the church, its most notable art contributions were in architecture and stone-sculpture adornments

Romanesque — thirteenth century church, Nuremberg

Roman key — *See* **Greek key**

Roman ochre — Pigment; a variety of ochre, name obsolete

Roman stripes — In textile design, bright and usually wide vertical stripes

romanticism — An emotional, often idealized means of expression; romanticism in art, notable in the nineteenth century, is usually thought of as in basic opposition to the classical

Romayne medallions — Profile portraits used as design in Gothic art

rose carthame — Pigment; an orange red, moderately permanent, gouache

rose doré — Pigment; a variety of rose madder, inclined to scarlet in oils, in watercolors an organic quinacridone, durable

rose madder — Pigment; madder lake, a transparent red; similar to alizarin crimson but weaker; moderately durable

rosemahling — The painting of roses, usually in craft decoration

rose malmaison — Pigment; a reddish rose close to thalo red rose on the color chart, fugitive, gouache

Rosenstiehl's green — Pigment; manganese green, name obsolete

rose pink — Pigment; a weak pink made from brazilwood, fugitive

rose Tyrien — Pigment; a rose somewhat redder than magenta, fugitive, gouache

rosin — A brownish or yellowish resin derived from pine trees, used in aquatint

Ross board — Trade name of an illustration board with a variety of rough-textured surfaces; designed for line reproduction giving a halftone effect to crayon and ink brush strokes; highlight effects can be achieved by scratching away the coated surface, as with scratchboard

rotary press — A press with two cylinders, one of which rotates the paper while the other prints on it; large continuous rolls of paper are used

rotogravure — A photomechanical intaglio printing process with a velvety or soft quality that makes for excellent halftone effects

rotten lines — In etching, lines that are uneven or interrupted, caused by uneven needle pressure

rottenstone — A soft, decomposed limestone used in powder form for cleaning and polishing photographs for retouching

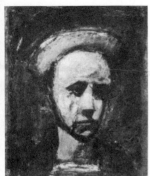

Rouault, Georges — 1871-1958, French painter and printmaker; the expressive dark lines and vivid colors in his paintings were developed from his experience in a stained-glass workshop. Rouault exhibited with the original fauves.

Rouault, self portrait

rough — A quick, incomplete sketch to express an idea

rough stipple — A heavy texture on reproduction board

roulette — A tool with a sharply pointed, revolving cylinder at the end of the handle, used to make dotted lines on a plate for intaglio printing

round — A pointed brush available in sable, synthetic, and bristle

roundel — In design, a semicircular recess, as a rounded window or niche

Roulette

Royal Academy of Arts — A fine arts society in London, founded in 1768

royal — *See* **watercolor paper sizes**

royal blue — Pigment; a color similar to cobalt blue

royal green — Pigment; chrome green, a mixture of Prussian blue and chrome yellow

royal red — Pigment; a bright red lake, fugitive

royal yellow — Pigment; King's yellow, an artificial arsenic trisulphide, toxic and obsolete

Rounds

royalty — A percentage paid to an artist by a publisher for each copy of the artist's work that is sold

rubber brayer — In graphics, a soft rubber roller used for inking in etching, block printing, etc. *See also* **brayer**

rubber cement — A paper-mounting compound that dries quickly; excess is easily removed by rubbing after it is dry; may stain surface in time and is not recommended for mounting art of permanent value

rubbing — A design or pattern transferred from a tombstone or other surface to a slightly damp paper laid on the surface; a flat piece of chalk, charcoal, or pencil is rubbed over the surface until the design is transferred

rubbing ink — In lithography, a rectangular cake of ink, applied by rubbing a finger across the ink and then onto the stone

"rub-down" — A transfer of an original design to another paper or surface

Rubenism/Rubenistes — Following the style of Rubens; the late seventeenth- and eighteenth-century artists involved felt color in painting to be more important than draftsmanship; Watteau was one of the leading artists. *See also* **Poussinistes**

Rubens brown — Pigment; a form of Vandyke brown

Rubens madder — Pigment; alizarin brown, obsolete

Rubens, Peter Paul — 1577-1640, a Flemish painter in the high baroque style. A superb draftsman, he is known for his luminous flesh tones and flamboyant compositions. Rubens was without doubt the outstanding painter of his day.

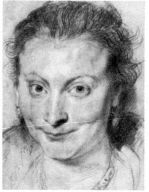
Rubens, portrait of Isabella Brant (detail)

Rub N' Buff — Trade name for colors that can be rubbed onto a surface with a finger or cloth; available in many colors, including me-

tallic and wood tones; used to touch up frames, etc.

rub-up — In lithography, the process of rubbing the stone with a sponge saturated with thinned litho ink and then with a sponge saturated with a gum solution and water, to bring up the drawing

rubylith — A transparent ruby-colored masking film used in making mechanicals and in film processes of photolithography

ruby masking film — A red light-safe masking film used in the preparation of artwork for photography, silk screen, etc.

rufous — Pigment; a rust color similar to a medium burnt sienna

ruling pen — A drawing instrument made of two parallel blades that are adjustable to regulate the size of the point and amount of ink

Ruling pen

rumpling — Bumps or wrinkles formed in paper, usually from too much moisture

run — The edition, or number of prints pulled in lithography, etching, etc.

run-around — A composition where the text is indented or formed to accommodate an illustration

running head — In a book or magazine, the heading repeated at the top of consecutive pages

running motif — A design repeated many times in a row

runs — Wet paints that drip or dribble; sometimes allowed purposely, for effect

rust — Pigment; a reddish burnt sienna color

R.W.S. — Royal Watercolour Society (British)

sabeline brush — A dyed ox-hair brush designed to serve as a substitute for sable; useful, relatively inexpensive, used mainly with waterbased paints

Sable/red sable brush — A brush made of kolinsky, which is a semiaquatic Siberian mink; the hairs hold their shape well and cling together when wet; the brush has good "spring" and comes to a fine point

sacred subject — Pertaining to religious art or symbols

sacrum — A triangular bone that forms the posterior section of the pelvis

safflower — Pigment; a red lake, fugitive and obsolete

saffron — Pigment; a bright yellow, fugitive and obsolete

S.A.G.A. — Society of American Graphic Artists

saibokuga — (Japanese) An ink painting using the traditional black with color

salamander — A restorative used on oil paintings

salmon — Pigment; a coral pink mixture, the color of salmon

salon — 1. Public exhibition of art in France,

for example, under the Académie des Beaux-Arts; 2. a regular social/philosophical meeting of artists, usually in the house of a patron

salt aquatint — Aquatint make by sprinkling salt on a hot, already grounded plate to create a different texture

sample — A picture shown to an art director as an example of the artist's proficiency

sampler — In textile design, various designs in small squares or rectangles, grouped together in one pattern

sand — 1. Very fine, gritty particles of rock used as an additive to paint to create texture; 2. pigment; a very light brown or tan color, considered a neutral

sandaraca — A varnish resin; term originally used indiscriminately for orpiment, realgar, cinnabar, lead oxide yellow, and the red earths

sandboard — A fine or rough sand-surface product used mainly to sharpen pencils and pastels

sandcasting — A method of laying mosaics. Also, a mold for a casting made with molten metal

sanded finish — 1. A finish obtained by the use of sandpaper to smooth usually relatively soft surfaces such as wood, gesso, etc.; 2. a paper (often pastel paper) with a rough finish like sandpaper

sand ground — 1. An aquatint ground preparation whereby sandpaper is placed face down on a printing plate which has a resist surface, then both are run through the press to produce a texture in the ground; 2. sand sprinkled on wet oil or acrylic paint as a texture; 3. sandpaper glued to a support for direct painting or pastel rendition

sand painting — (American Indian) 1. A picture composed on the ground with colored sands, usually for a ritual purpose, such as marriage or healing; 2. a facsimile of the same on canvas or panel

sandpaper — A heavy paper coated on one side with an abrasive, used to smooth or shape wood and other surfaces; used sometimes in artwork for a textural effect; available in textures from light to heavy

sandpaper aquatint — *See* **sand ground**

sandpaper block — A pad of small sandpaper sheets

sanguine — A reddish crayon long used for drawing and toning; often referred to as a conté crayon, from the French manufacturer's name

sans serif — Having no serifs, as in gothic type

san sui — (Chinese/Japanese) Mountain and water, meaning a landscape

sap green — Pigment; a transparent earth green, permanent

sapwood — The lighter, softer wood found between the bark and the heartwood, used in woodcarving

Saral paper — Trade name of a transfer paper that produces a grease-free line, easily erased

SASE — Self-addressed stamped envelope; enclosed in a mailing to assure the material submitted will be returned to the sender

satin finish — A moderately shiny finish, not as luminous as a gloss finish

saturated — Thoroughly wet so that no more liquid can be absorbed

Sans serif
Serif type

saturation — 1. The degree of vividness of a hue, from its concentration; used synonymously with *chroma* 2. In a solution, the material's limit of solubility

satyr — In design, a woodland god with ears, legs, and horns of a goat

scale — 1. The dimensions of an artwork relative to those of the original; 2. to enlarge or reduce (scale up or scale down) artwork or photographs for reproduction without changing the original proportions

scaleograph — An instrument used to scale photographs and illustrations

scale ruler — A ruler with different scales printed on the sides, available in divisions of tenths and of twelfths

scamp — A basic rough or sketch

scan — 1. To check or quickly study something, as to scan a blueprint; 2. a computer method of making color separations to be used in printing

scapula — A shoulder blade; a large, flattish, triangular bone forming the back part of the shoulder

scarlet — Pigment; a strong, vivid red color

scarlet lake — Pigment; a bright orangish red lake, permanent

scarlet vermilion — Pigment; an orange red, permanent

scenics — Designs on fabrics and rugs that depict landscapes or seascapes

schablone — The use of a stencil to color prints

Scheele's green — Pigment; same as emerald green, toxic, obsolete

Schnitzer's green — Pigment; a form of chromium oxide green, name obsolete

school of Paris — *See* **Paris, school of**

schrottblatt — *See* **criblée**

Schweinfurt green — Pigment; emerald green, toxic, obsolete

Scintilla — *See* **fiberglass paper**

score — 1. To mark or lightly cut a line, not cutting all the way through; 2. a printing term meaning a blank impression on the inside fold of a signature, made with a blank hard tool, to locate the fold and prevent surface damage to certain heavy stocks

scotchstone — A fine abrasive used to wear away a surface

scraper — In printmaking, a tool with a sharp blade, used to remove the burr and to smooth areas

Scraper

scrap file — *See* **clip file**

scraping down — A technique for oils and acrylics in which a palette knife is drawn across the wet paint, pressing the paint into the canvas and at the same time softening the hard edges; on dry paint a slightly different effect is accomplished

scratchboard — An ink drawing method using a cardboard sheet that is coated with a clay finish and covered with drawing ink; special cutting tools are used to scratch in the drawing, which resembles wood engraving; makes excellent reproductions

Scratchboard — Three stages of a scratchboard drawing by **Fritz Henning**

Multiple line *scratchboard* tool

scratchboard tools — Small knives about the size of pen tips are used as cutting or scratching tools, some with multiple points for drawing several parallel lines at once, as for cros-shatching

scratch foam board — A foam-coated board on which a drawing is pressed or scratched, which then can be used as a printing plate with either oil- or water-based printing inks

screen — 1. In textile design, a color separation device; for instance, in three separations on white, screen no. 1 is the white and screens 2, 3, and 4 are the colors; 2. various textured adhesive-backed shading sheets used in design, usually for art to be reproduced

screen opener — For silk screen, a spray used to open a screen that has dried ink

Silk *screen printer*

screen printing (hand and machine) — In textile design, hand screen printing is known as silk screen; machine screen printing is about the same process, but performed mechanically. *See also* **silk screen**

scribble — Lines interwoven or intermixed in a fast, unplanned manner

scribble drawing — A quick-gesture drawing in which the pencil does not leave the surface of the paper

scriber — A pointed tool for marking wood, metal, and other surfaces

scrim — In intaglio, a heavy, coarse cloth used to wipe the plate

scrimshaw — An early American folk art originated by sailors on long voyages, using whale's teeth and bones or walrus tusks to carve trinkets, often with intricate design

script — Lettering that imitates handwriting; also, the handwriting style called cursive (flowing)

script brush — A brush with extra-long red sable hairs that come to a fine point, used for script lettering, scroll work in design, and for fine details

scrive — A hollow burin with a "V" shape, used in sculpture

scroll — (Japanese) *See* **makimono; kakemono**

scroll pattern — In design, a rolling design resembling the beginning of a spiral, almost immediately reversed

scrubbing — A means of applying paint with a brush in a scrubbing motion

scruffing — 1. Drawing or blocking in a quick, loose drawing; 2. roughing up a surface area in a painting, usually with brush strokes; 3. dry-brushing color over a rough surface, allowing the underneath color to show through

Sculpmetal — Trade name for a product that is formed like clay and hardens into metal; also can be applied to a preshaped armature; can be carved, filed, and sanded, then brushed to an aluminum patina

sculpture — The art of three-dimensional or relief carving and modeling

sculptured design — In textile design, a pattern indicating two or more levels in the pile, for carpeting or fabric; the pile is actually cut long and short or the design is painted to resemble that effect

sculpture in the round — Free-standing sculpture, completed on all sides

scum — In lithography, the grease on nonimage areas of the stone or plate; a film of ink printing where it should not print

scumble — To lay a light, semitransparent color on a surface already painted with another

color, to unify or soften the area and create a textural quality; usually accomplished with a dry-brush or with a rag or finger

S curve — Design in the shape of an S

seal — (oriental) A stamp on an artwork of the artist's given name, a family name, the name of his home or household, the date of his birth, a poetic phrase, or a pictorial symbol; also, a collector may stamp his seal on the artwork; sometimes called a *chop mark*

seal print — A blind-embossed print

search lines — *See* **pentimenti**

seascape — A view of the ocean and/or the surroundings as composed in a picture

secco — (Italian, *dry*) A mural painting procedure using colors ground in a binder such as casein, and applied to dried lime paster; less permanent than fresco, which is applied to wet plaster

secondary colors — Orange, green, and violet, made from mixing the primaries: red and yellow make orange, blue and yellow make green, and red and blue make violet

section d'or — (French, *golden mean/golden section*) *See* **golden mean/golden section**

semiabstract art — Art that depicts a subject in a stylized or partially abstract manner

separation — *See* **color separation**

sepia — A brown-colored pigment originally made from cuttlefish, also a sepia ink; now a mixture of burnt sienna and lamp black, permanent

sequence — In cartooning, a series of panels that relate to each other, to tell a story or series of events

serifs — The small cross-lines or embellishments at the termination of the main stems of roman letter forms

serigraphy — *See* **silk screen**

serrated — Having toothlike or notched projections

set-in — In woodcarving, to outline the design with stop-cuts prior to removing unwanted wood. *See* **stop-cut**

set palette — A limited palette

setup — Articles arranged in a still life

Seurat, Georges — 1859-1891, a prominent French neoimpressionist who is considered the founder of pointillism—a manner of painting with small dots of pure color that are blended optically in the eyes of the viewer.

Georges Seurat's drawing of his mother

sfumato — (Italian, *smoke*) An imperceptible transition of gradual change in color or value

sgraffito — Decoration made by scratching through a layer to reveal a different color underneath; now applied to pottery, was a Renaissance procedure using stucco and stained glass

shade — A degree of color obtained by adding black to a hue

shading — suggesting various shadow values in a drawing or painting by gradation of tone

shading film — *See* **shading sheets**

shading sheets — In commercial art, transparent acetate sheets with an imprinted pattern or dots, used by overlaying wherever a tone or texture is desired

243

shadow — The darkest area of a subject; that area that is away from direct illumination. *See also* **cast shadow**

shape — Configuration, form

shaping claw — In stone carving, a chisel with teeth that produce serrated gouges, used in the early shaping stages of a sculpture

sharpening stone — A Carborundum stone used to sharpen cutting and carving tools

sheet-fed — Describes a printing press that prints on flat sheets of paper rather than rolls

sheeting — A light cotton canvas used as a painting support

shellac — A thin varnish made from flake shellac (resin) and denatured alcohol, used as a size over rabbitskin glue ground, but must be completely covered with pigment for best results; also used as a blockout for silk screen

shifting planes — Images drawn or painted on various planes other than what are observable from a single station point; cubist art is often based on shifting planes

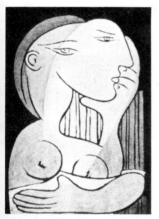

Shifting planes, "Seated Woman," by **Picasso**

ship curve, adjustable — *See* **curve ruler**

Shivair — Trade name for colors already formulated for the airbrush; no mixing necessary; nonclogging, opaque, and transparent available

Shivarsol — Trade name of a water-soluble, crystal-clear liquid used for airbrush between layers of color to prevent bleeding as well as to enhance color

shocking pink — Pigment; a brilliant pink, a mixture of a bright red and a touch of white

short ink — Buttery thick ink that does not flow well

shoulder blade — *See* **scapula**

show cards — Indoor posters for temporary announcements

show-card board — A smooth, dull-finished cardboard used for posters; takes many mediums and available in a variety of colors

show-card brush — A lettering brush, square-tipped (usually sable), available in many sizes

Show card brushes

show-card colors — *See* **poster colors**

shuan kou — (Chinese, *double outline*) *See* **kou le**

Siberian charcoal — Compressed charcoal

siccative — *See* **drier**

Sienese school — Fourteenth-century Italian artists located at Siena, painting in the Byzantine and Gothic styles; Duccio and Simone were the prominent artists

sienna — Pigment; *See* **burnt sienna; raw sienna**

sighting — A means of seeing and mentally measuring the relationships of angles, shapes, spaces, etc., and applying them to a drawing or painting

sight line — In a picture, an imaginary line from the eye of a figure, indicating the direction of his glance

signage — The making of signs which usually includes designing, inking, and/or painting

signature — 1. The artist's name or initial on artwork; 2. in printing and binding, the grouping of pages according to the folding of the paper as it comes from the press; usually printing signatures consist of 16 or 32 pages

sign cloth — A specially primed cloth used for signs and display art, available in sizes to 50 inches by 48 yards

signet1. A small seal used as a design, as on a signet ring; 2. an official seal or stamp

sil — Pigment; ochre, an obsolete Roman name

silhouette — A flat shape in profile, usually in one value

silhouette paper — A smooth paper, dull black on one side and white on the other, used for making silhouettes

Silhouetted photo ready for reproduction

silhouetting — In commercial art, a means of separating an element from the rest of the picture for printing by painting a white area around the subject to isolate it from other areas (usually in a photograph); the film stripper can then more easily produce the plates necessary for the desired effect

silicoil brush washer — A jar containing silicone with a wire coil at the bottom, to facilitate cleaning oil paint from brushes

silk screen (serigraphy) — A stencil-printing process where paint or ink is forced with a squeegee through a silk, organdy, or other screen onto the paper or textile below, the area not to be painted being previously stopped out

silk-screen frame — In the silk-screen process, a wooden frame that has silk or other material stretched over it and is hinged for pulling proofs

silver leaf — Silver used like gold leaf in medieval paintings; tarnishes easily

silverpoint — A method of drawing with a silver point on a specially prepared paper, leav-

ing a delicate gray line that becomes darker and warmer with age. *See also* **metal point**

silverpoint tool — A tool that holds a rod of silver used to draw on silverpoint paper

silver white — Pigment; synonymous with flake white. *See* **white**

simplify — To make a design or picture less complicated

simultaneism — *See* **orphism**

Silverpoint (metal point) by **Leonardo** (detail)

simultaneous contrast — *See* **pointillism**

simultaneous representation — In a picture, the depiction of a person or thing in more than one view; some pictures incorporate two or more eye levels. *See also* **universal perspective**

simultaneous submissions — Artwork, such as cartoons, submitted to more than one prospective buyer at a time

singe — To lightly burn the edges of paper or board; to lightly burn the fibers that are loose and sticking up on a stretched raw canvas to prevent the absorption of moisture

singeries — Designs of monkeys and apes

single-panel cartoon — A single-picture cartoon, often with caption or balloon-enclosed comment

single-primed — Having one application of gesso

single-stroke brush — *See* **one-stroke brush**

sinopia/sinope/sinoper — 1. The Roman name for red iron oxide; 2. in fresco painting, a red ochre underpainting

sirens — Mythological sea nymphs whose singing lured mariners to destruction on the rocks of their islands; may appear in artwork, especially fountain sculpture

sitter — The subject of a portrait

sitting — The period of time the model poses for the artist who is painting a portrait

size/sizing — A gelatinous substance used as a glaze or filler on canvas, panels, and paper

sizing catcher — In intaglio, the thin bottom blanket next to the dampened paper, used to absorb the sizing

sketch — A quick drawing or painting, freely done, often purely suggestive and incomplete

sketchbook or sketch pad — A book or pad of paper especially for sketching, available in various shapes, styles, and sizes

sketch box — Any box that carries sketching equipment

sketching easel — *See* **easel**

skew — To twist on an oblique angle; to distort

Skew chisel

skew chisel — A chisel used in woodcarving

sky blue — Pigment; a bright blue close to cerulean

sky brush *See* **oval wash brush**

slab — A heavy piece of marble, porcelain, or plate glass used for grinding pigments or for other studio purposes

slant tiles — On a watercolor palette, color containers that are on a slight slant so the watercolor paint stays within its wells

Slant Palette

slate black — Pigment; powdered slate of a grayish color with poor opacity

sleeve — A container or cover; a plastic pocket designed to hold items such as transparencies or negatives

slick — Very smooth; said of paintings that are handled deftly or where the paint quality has the look of creamy consistency

slick stock — Paper with a fine, smooth finish

slipsheet — Blank sheet of paper used to separate newly printed pages while drying, or wherever one thing is to be isolated from another in stacking

slipsheet mounting method — Used when mounting paper, tissue, photos, etc. Use rubber cement on both papers to be mounted together. Let dry. Place a tracing paper over the base paper, leaving about one inch of the cement showing at the top. Mount the top paper on the one inch of rubber cement, lining up all corners. Then slip the tracing paper out from the bottom. Press the top paper down, working out any air bubbles

slip sheet alternative method — Use rubber cement on both papers that are to be mounted together. Let them dry. Place two tracing papers (one overlapping the other at the middle) onto the bottom paper which has rubber cement on it. Place the artwork on top exactly where you want it, then pull the bottom tracing paper out a little at a time, pressing the artwork down at the middle while working out the air bubbles. Then remove the other tracing paper the same way

slugs — In typesetting, leads that are more than six points high, used for spacing

small caps — Capital letters the size of lower-case letters in a given point size

STYLE represents

smaragd green — Pigment; viridian, hydrated chromium hydroxide, name obsolete

smock — A long, jacket-type covering worn to protect an artist's clothing when working

smoking — In etching, the use of a candle to darken or smoke a hard ground on a plate

snake slip — An abrasive in stick form used to clean scraper marks off litho plates around the margins

snapline — A piece of string coated with chalk, which is extended between two points, pulled back, and snapped against a surface, marking a straight chalk line; sometimes used in mural painting

snow white — Pigment; zinc oxide, an obsolete name

soaking the paper — In watercolor, placing the paper in a tray or tub of water for a period of time as a preliminary step for stretching or as a wash-off procedure

soapstone — In sculpture, a soft, easy-to-carve stone, available in a few different colors

socialist realism — Official style of art in the Soviet Union, socialist in theme and realist in form, not to be confused with *social realism*

social realism — A twentieth-century movement in painting dealing directly and critically with social, political, and economic issues; some nineteenth-century painters, such as Daumier and Courbet, were forerunners of this movement

soft ground — An etching ground that is part tallow, is tacky and greasy

soft-ground etching — An etching technique using soft ground, producing a soft quality to

the lines similar to a crayon effect; when a paper or textile is laid on the plate and a pencil or stylus is used to copy the design, various effects can be achieved by the ground adhering to the paper under the strokes and by the impression of the paper or textile on the ground

solder — A fusible alloy, such as tin and lead, used to join metal pieces

solferino — Pigment; a reddish mauve lake bluer than cobalt violet, fugitive, obsolete

solids — Forms having three-dimensional mass in any shape and volume; not liquids or gases

Solomon's Seal — Two equilaterial triangles overlapping, indicating the union of body and soul; the Star of David

Soft-ground etching by
William Strang

solvent — A substance capable of dissolving another substance, as benzine, kerosene, turpentine, alcohol, etc.

solvent-resistant tape — In silk screen, a tape used inside a frame to eliminate seepage

sotto in sù (Italian, *from below upwards*) — A realistic painting style of illusionism used on ceilings of churches and public buildings; also called *frog perspective*

space — 1. The unoccupied area in a painting; 2. the interval within a boundary as positive or negative space; 3. two-dimensional space is the picture plane; 4. three-dimensional space possesses height, width, and depth

space arts — *See* **plastic arts**

spacing — In lettering, adjusting the letters so they flow together properly and aesthetically

Spanish black — Pigment; charcoal made from cork; obsolete

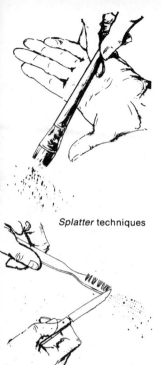

Spanish brown — Pigment; burnt umber, name obsolete

Spanish red — Pigment; a bluish shade of native iron oxide, comparable to Indian red, permanent

Spanish white — Pigment; bismuth white, obsolete

Splatter techniques

spatter — A painting technique in which a finger or comb is used with a stiff brush (toothbrush) that has pigment on it, creating an uneven spotted pattern; or, a loaded brush is struck on the hand or a ruler; may also be achieved with an airbrush

spectrum — 1. A band of colors, as seen in a rainbow or through a prism; 2. a broad range of colors

spectrum red — Pigment; a color close to cadmium red medium on the color wheel, gouache

spectrum violet — Pigment; a blue violet close to Prussian blue, fugitive, gouache

spectrum yellow — Pigment; a color close to cadmium yellow medium on the color chart, permanent, gouache

Speedball pen — Trade name of a penholder and many different-sized nibs, used for hand lettering and for drawing

speed lines — *See* **action lines**

Speedball pens

sphere — A globular form in which all points on the surface are equidistant from the center; one of the basic forms used in construction drawing

sphinx — From ancient Egypt, a stone image of a reclining lion with a human head

spire gothic — *See* **gothic type**

spine — 1. The backbone; the column of vertebrae extending from the cranium to the coccyx; 2. The backbone of a bound book

spit bite — Saliva applied to a plate to define an area and keep the acid from running

spitsticker — *See* **elliptic graver**

splash print — In textile design, color splashed or dropped in such a way that a fairly large design is created

splay — The opening or spreading outward of a brush

split complement — The use of the colors on each side of a complementary color

split planes — *See* **fractured planes**

sponge technique — 1. To moisten a sponge with water and color and lay a wash; 2. to daub a sponge in color and then on paper or canvas, creating a texture

spot design — A design used as a single motif

spot drawing — A single small drawing used for illustration

spotlight — A portable studio light used to light models, still life, etc; designed to concentrate a spot of light in a small area

Spotright — Trade name of a red sable brush used for retouching, spotting, and cleaning up artwork and photography

spray gun — *See* **airbrush**

spread — 1. A layout design that covers an entire page; 2. a two-page spread that encompasses two facing pages

spring — The bounce or maneuverability of the hairs in a brush

spring clamp — A device used to grip paper to a board or other surface; also called a *spring clip*

springwood — In woodcarving, the softer wood layers in the tree ring pattern; the growth during the spring season

squared up — Said of a corner being checked for a 90° angle

squeegee — In silk screening, the tool used to force the ink or paint through the screen; usually consists of a rubber blade mounted in a wooden handle, similar to that used to wash windows

squiggles — Any curlicues, scrolls, or embellishments added to a design

S/S — (same size) In printing, a mark for the printer indicating the reproduction is to be the same size as the original

S-scroll — A design in the shape of an S

stabile — Sculpture that is stationary, does not move like a mobile

stabilizer — Ingredient in artist's pigments to make them easy to brush and keep the oil from separating

staff artist — An employee of an agency, store, business, or publisher, who works on salary as an artist

stain — 1. A dye that has no bulk, dissolves completely; 2. to put a thin color over a canvas or panel; 3. in oils, color plus turpentine, and in water media, color plus water

stained glass — Colored glass used to make picture windows, usually for public buildings and churches; also popular for home decoration in windows, wall plaques, lamps, etc.

stand oil — *See* **linseed oil**

staple gun — A tool used to hold and dispense staples, useful when stretching canvas

Star of David — *See* **Solomon's seal**

stat — *See* **photostat**

static — Said of certain artwork, meaning fixed, conservative, without aesthetic energy

Solomon's seal

station point — In perspective, the point of the artist's eye at which sight lines begin in relation to the picture plane; the point at which the artist views the scene in creating the picture

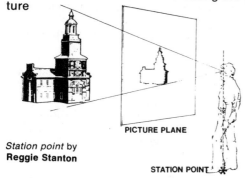

PICTURE PLANE

Station point by
Reggie Stanton

STATION POINT

statue — A carved or modeled figure of a person, animal, or thing, in any size

steel brush — A flexible brush (pen) used for lettering, made of steel

steel facing — In printing, an added steel layer deposited on the surface of a copper plate, allowing a greater number of prints to be pulled from the plate

stele — An upright pillar or slab of stone with a design and/or inscription

stencil — Any material that is cut out to mask certain areas and allow a coloring medium to be applied to the open areas

Stencil brush

stencil brush — A round brush with short, square-cut bristles that is used for stencil work

stencil paper — A heavy, often oiled, paper that will withstand rough treatment and can easily be cut to a clean edge

stencil printing — Making copies of a design from a stencil by silk screen or other stencil method

stereotype — A metal printing plate cast from a papier-mâché matrix or mat that has been made from a page of metal type

sternomastoid — A muscle originating behind each ear, moving forward and down each side of the neck, forming a *V* shape in the front of the neck

sternum — The breastbone, a bone that is between the cartilages of the upper seven ribs

stet (Latin, *let it stand*) — A proofreader's mark meaning "do not change as marked," used on corrected work that has been countermanded

stick figures — Stick-like lines drawn into simplistic figures

Stijl, De — *See* **De Stijl**

stil-de-grain — Pigment; Dutch pink

still — In animated cartoons, a single cartoon as opposed to a series of cartoons making action; also, a "still" photo from a movie film

still life — Inanimate objects such as flowers and fruit, arranged as a model for a composition to be painted, photographed, etc.; also, the finished work

stipple — A texture made up of tiny dots; to fleck or speckle an area of a painting usually with a contrasting color

stipple engraving — Using fine dots as part of an engraving

stipple print — *See* **stipple engraving**

stock — The paper used for a printing, specified by the production manager or art director

stone carving — Engraving or cutting into stone or cutting away stone to create sculpture

stone green — Pigment; green earth, an obsolete name

stop-cut — In woodcarving, a vertical cut into a surface to outline and to prevent accidental splitting while removing excess wood

stop-out — 1. In intaglio printing, a substance that prevents the plate from being bitten, or etched; 2. a substance used in silk screen to prevent the paint from penetrating any nonprinting areas not blocked out by the stencil

story boards — Small sketches, diagrams, or photographs made in panels to suggest the sequence of action and dialogue for movies, TV ads, etc.

story man — In animated cartooning, one who draws a series of sketches pertaining to the story or tale

St. Plate — A light-sensitive plate used in photolithography and photointaglio printing

straightedge — A ruler or T-square; any straight bar used for ruling, cutting, etc.

straight on — Directly in front; directly at eye level

strapwork — Designs made up of intertwined straplike lines. *See* **arabesque**

Strathmore Aquarius — *See* **fiberglass paper**

straw — Pigment; a neutral mixture resembling the color of straw

street art — Murals on buildings, outdoor sculpture, street displays, public art happenings

street furniture — Anything pertaining to a street, such as lampposts, signs, benches, etc.

strength — In art, 1. the saturation of a color; 2. the impact of a work of art

stretched canvas — Canvas that is fastened to stretcher strips and ready to prepare for a painting

Stretcher pliers

stretcher pliers — A pincer-type tool with wide gripping jaws used to tighten and stretch canvas when fixing it to stretcher strips

stretcher strips — The strips on which the canvas is stretched; commonly made of wood and available in a variety of lengths; the interchangeable slotted ends make for easy assembly

strie — (French, *groove*) In textile design, fabric that has a fine, irregular streak or stripe made by a slight variance in color of the warp

strike — In chip carving, to make stop-cuts

strike-off — In textile design, a sample of cloth showing the design and colors, used by decorators

string-and-wire art — String and wire stretched on a frame, making a design or picture

strip — 1. Cartoon drawings in a series of panels suggesting a story sequence, usually with captions; 2. to remove the varnish from an oil painting

strip-in — A piece of artwork, film, type, or the like, which has been removed from one surface and taped in place on another; usually relates to the plate-making process in printing

stripe — In textile design, a long band of color that may or may not contain a pattern; can be straight or wavy, horizontal, vertical, or oblique

strip frame — A narrow border frame made of strips of wood or metal attached to the edge of the canvas stretchers or other support; quick and inexpensive, available in a variety of sizes

striping tool — A tool that draws straight or curved lines in any color; has a glass fountain for poster paint, japan colors, lacquer, etc.

stripping — 1. Removal of photo emulsion from its backing, so it can be assembled on another support; 2. artwork that has been taken off or stripped from a heavier support

strobe light — An electronic flash or speed light used in photography

strong — In art, said of work that has an impact, is not weak or trite

strong color — 1. Intense color or high chroma; 2. In watercolor, a pigment that is hard to remove from the paper once it is painted, such as Prussian blue

strontium white — Pigment; strontium sulfate, replaced with *blanc fixe*

strontium yellow — Pigment; a lemon yellow, permanent

struck off — Pulled or printed—said of an edition of prints

student-grade — Grade of artist's colors and other materials, not of the finest quality, but serviceable for most purposes

studio — A room or building in which the artist works and keeps his equipment

studio easel — *See* **easel**

study — A drawing or painting of a section or of a whole composition, usually detailed more carefully than a sketch

stump — A cigar-shaped roll of heavy paper with a point on each end, used to refine pencil, charcoal, and pastel drawings

style — The artist's individual manner of working; the identifying characteristics of a particular period, group, or movement

styles, current — The latest fashions

stylist — In textile design, one who develops and advises on style; one who assembles the "line" that a manufacturing house is offering

stylize — To modify natural forms and make a representation in a preset style or manner

stylus — 1. A pointed instrument used to work on scratchboard and other coated surfaces; 2. a tool for engraving

subhead — A secondary headline or title

subject — The most important figure, object, or area in a composition

subjective — Originating within the artist, rather than a reporting of what is seen (objective)

subjective color — Color the artist chooses without regard for the real or original color of an observed object

subject matter — What the artist renders, such as still life, landscape or seascape, figures, portraits, etc.

subordinate element — Anything of lesser importance than the primary element in an artwork

subtractive color mixing — Mixing colors in paint in such a way as to reduce the total light rays reflected. *See* **color additive mixing; complementary color**

sugar bite — *See* **lift-ground etching**

sugar paper — A British term referring to a plain wrapping paper sometimes used for drawing

suiboku — (Japanese) A traditional ink painting on silk or paper

"suicide" — In graphic arts, a reduction and stencil method using only one block for the entire print; one color is cut and printed and then cut away, preparing the block for the next color; there is no second chance, thus the term "suicide"

suite — A group of original prints, usually related in subject matter, often used in portfolio form, with a colophon

sulphur tint — In intaglio, made by oil spread on a plate and sulphur dusted over it, creating a lightly bitten or washed-tone effect.

sumi — Japanese brush painting with ink and/or watercolors

sumi-e — (Japanese, *black ink picture*) A black-ink picture

sumi ink — A mixture of carbon and glue pressed into a block; pieces ground off are mixed with a little water to make "ink"

Fourteenth century Japanese *sumi* drawing

summerwood — In woodcarving, the hard-wooded layers in the tree ring pattern; growth during summer and dry seasons

Sunday painter — A term applied to amateur artists who pursue painting for pleasure

sun-thickened oil — *See* **linseed oil**

supercalendering — A machine process that produces a glossy surface on paper

superrealism — *See* **magic realism; surrealism**

support — 1. The foundation upon which a painting is made, such as canvas, panel, metal, wood, etc.; 2. the "backing" on which paper is mounted

suprematism — A Russian movement, founded by Kazimir Malevich about 1913, that was derived from cubism; encompassed nonobjective, geometric forms, using simple color combinations such as white on white or variations of black and white; had much effect on the following generation of artists

surface paper — A frisk used for corrections on pen and ink and technical drawings; a scalpel is used to scrape away unwanted areas, then it is redrawn

surface printing — A type of printmaking in which ink or color is applied directly to the plate, then the paper laid onto it and rolled or daubed

surface-rolled — A plate inked on the surface rather than in the grooves or cut-out areas

sur le motif — A term that refers to working in front of the subject, indoors and outdoors

surprint — A combination of line and halftone from two separate negatives, merged to produce one printing plate

surrealism — A movement in art that purports to be a way of life as well as a style; seeks to

broaden reality by dealing with the subconscious, the result often taking on the form of fantasy, dreams, symbols, or the grotesque; prominent artists include Miró, Ernst, and Dali

Surrealism —
engraving by **Max Ernst**

suzuri — (Japanese) An ink grinding stone used to grind pieces from a sumi ink block to make sumi ink

swash — A flourish or extended serif on a Roman letter

Swash letters

"sweat box" — In animated cartooning, the projection room

Swedish green — Pigment; cobalt green, a bluish green, opaque, not commonly used

sweetener — *See* **badger blender**

swing — The movement of the body or clothing on the body

swipe file — *See* **clip file**

symbol — A sign, figure, design, pattern, motif, signet, or color used to represent something or somebody by association

symbolism — The art of depicting a hidden meaning, using symbols

symbolist painting — An attitude more than an art movement around 1890, when artists such as Redon, Moreau, and others promoted the idea of using symbolic, enigmatic dream fantasies to represent the emotions, such as love, hate, fear, etc.

symmetrical — Formal in balance, with elements of equal or near-equal weight on either side of a real or implied center fulcrum

Syn — (Greek, *together*) A group of German artists formed in 1964 to reveal art beyond hard-edge painting or action painting; artists involved included Bernd Berner and Rolf-Gunter Dienst

synchronism — *See* **orphism**

synthetic — Artificially produced

synthetic brushes — Brushes made from materials other than hair and bristle, such as nylon, polyester, etc., used mostly with acrylics

synthetic canvas — Artificial fibers made into a canvas for painting

synthétism — Same as **cloisonnisme**

tableau painting — (French) A painting which is produced in an unexpected or dramatic way; example: a layered glass painting; three, four, or five layers of glass with a portion of a picture painted on each glass, placed one on top of the other, creating a three-dimensional picture

table easel — *See* **easel**

tabouret — A stand to hold an artist's palette, paints, and accessories; drawers and compartments are underneath for supplies

taches — Effective touches of impasto paint

tachisme — (French, *tacher,* to *stain* or *blot* (An offshoot in the 1950s of abstract expressionism, closely associated with activism; an unplanned pattern of splotches and dabs of paint, the emotional impact of which results from the outburst of the artist's spirit while working; exponents of this approach: Jean Atlan, Camille Bryen, Alfred Wols, Georges Mathieu, and others

tacking iron — A tool heated by electricity, used to tack pictures, photographs, or papers to cardboard by a dry mounting procedure

tackle box — A box that fishermen carry their supplies in, sometimes used by artists for supplies

tacky — Sticky, neither really wet nor dry; in graphics, describes the stickiness of ink or the pull of the ink against a surface

Tabouret

tagboard — Cardboard used for posters, tickets, flash cards, etc.; available in white and colors

tailpiece — An illustration used at the end of a page or end of a book

talc — A fine-grained mineral used as a filler, sometimes called *French chalk*

talent — A natural gift or ability of superior quality

tan — Pigment; a very light brown mixture, considered a neutral

tangent — Touching or meeting, as of lines or forms

tanka — (Tibetan) A religious painting mounted on brocade cloth, used as a processional banner

t'ao-t'tieh — In design, a heraldic animal mask. *See* **devil's mask**

tapestry — In textile design, 1. a scenic fabric wall hanging, originally used for insulation and warmth as well as decoration; 2. a colorful, durable fabric

tarlatan — A strong, white absorbent cloth used for wiping inked plates

tarsus — The broad portion of the foot including the ankle, heel, and instep

tartan — In textile design, a plaid pattern, worn especially by Scots; each clan having its own pattern and colors

taste — Discrimination; in art, often relates to the artist's choice of colors, values, subjects, etc.

Tatlinism — A constructivist art style named for one of the earliest constructivists. *See* **constructivism**

Tattersall — In textile design, a large plaid design at one time used on blankets worn by horses at the auction rooms in London, where the auction market was owned by a man named Tattersall

tau — *See* **tree of life**

taupe — A brownish gray mixture, considered a neutral

teardrop — A motif in the shape of a teardrop

teardrop brush stroke — A drop-shaped brush stroke

tear sheet — A published page showing an artist's illustrations, designs, photographs, or other artwork, or a copy of that page

teaser — *See* **flap**

technical pen — A drawing pen with a fine point and an ink supply cartridge; available in different point sizes; brand names include Rapidograph, Mars, Faber-Castelli, Martin/Stano, K&E, and Unitech

technique — The method of using a medium or tool by an artist, or the particular method of an artist; closely linked to style

tectiform — A term applied to certain abstract forms/signs which accompany paleolithic wall engravings

tectonic — In sculptural forms, relating to the simple mass rather than extended shapes and forms

tempera — Originally a pigment ground with egg emulsion, properly called egg tempera, that dries hard and quickly and is very permanent; while egg tempera is still used, in general, the term refers to gouache, poster colors, and other opaque watercolors

temperature — In color, the relative "warmth" or "coolness," warm colors being in the red-yellow range and cool colors in the green-violet range

template — A plastic or metal guide for drawing circles, squares, triangles, and other shapes and symbols

Ten, the — Ten American artists who exhibited together in 1898 and thereafter—Frank W. Benson, Joseph R. DeCamp, Thomas W. Dewing, Childe Hassam, Willard L. Metcalf, Robert Reid, Edward Simmons, Edward C. Tarbell, John H. Twachtman, and J. Alden Weir; after Twachtman died in 1902, William M. Chase became a member; all were influenced by French impressionism

ten chi jim — (Chinese, *heaven, earth, and man*) A Buddhist concept in all art; in a painting, refers to the three elements: main subject, complementary addition, and auxiliary details

tenebrism — (Italian, *tenebroso, dark* and *gloomy*) The emphasis is on chiaroscuro to achieve dark, dramatic effects, the picture often being illuminated by a streak of light; the approach is reminiscent of the style made famous by Caravaggio; Georges de LaTour is often referred to as the great French tenebrist

tension — In composition, the visual feeling of strain or pull, the dynamic relationship between any of the elements

tension points — In fashion design, any point where there is stress on cloth: the elbow, knee, thigh, crotch, etc.

tent stripe — In design, an obvious wide stripe

terra cotta — Pigment; a reddish color that imitates red clay

terra merita — 1. Pigment; a yellow lake, fugitive and obsolete; 2. In sculpture and pottery a hard, fired, unglazed clay

Tenebrisimo — **Francisco Zurbaran** painting of St. Francis (detail)

terra ombre — Pigment; raw umber, name obsolete

terra rosa — Pigment; a native earth tinctured with sesquioxide of iron somewhat close to burnt sienna, permanent

terra verte — Pigment; a green earth, permanent

tertiary colors — In contemporary usage, the intermediate colors are considered tertiaries: yellow orange, red orange, red violet, blue violet, blue green, and yellow green; in early color theory, the mixture of the secondary colors created a tertiary, as green mixed with orange, orange mixed with violet, and violet mixed with green

tesserae — The tiles, glass, pebbles, etc. used to make a mosaic

tetrads — Color harmonics based on four colors; using every fourth color; the tetrads on the Prang color wheel: yellow orange, red, blue violet and green; orange, red violet, blue and yellow green; red orange, violet, blue green and yellow

text — A typeface group, also referred to as *old English* and *black letter*

textile colors — Permanent colors made especially for painting directly on textiles

texture — In artworks, the quality of a surface or the representation of a surface such as smooth, rough, jagged, etc.

textured design — In textile design, 1. texture actually woven into fabric or 2. a painted design simulating texture

thalo blue — Pigment; a trade name for phthalocyanine blue

thalo green — Pigment; a trade name for phthalocyanine green; same as Phthalo green on the color chart

thalo red rose — Pigment; a trade name for a synthetic quinacridone red, permanent

theme — The most important idea or subject in a composition; the subject for a work of art, sometimes with a number of phases or variations; for example, Cézanne used La Montagne Sainte-Victoire as a theme for many of his paintings

Thenard's blue — Pigment; a true cobalt blue, name obsolete

theorem painting — An early American decorative art using stencils and oil paint on velvet cloth

theory — 1. A statement of accepted principles; 2. an hypothesis yet to be proved

thermography — Process for making raised printing used for business cards, letterheads, etc.; made with ordinary type, but while the ink is still wet a special resinous powder is sprinkled on it, it is then heated, and the fused resin rises to produce the raised lettering, giving a general appearance of engraving

thick and thin — 1. The weight of a line, its graphic quality; 2. the weight of the paint, thick paint as opposed to thin paint

thigh — The part of the leg between the hip and the knee

thin — Oil color diluted with turpentine rather than an oil medium; it creates a matte finish; also called "lean"

thinner — A liquid used to reduce the thickness of a pigment, as water for watercolors, gouache, acrylics, and casein, and turpentine for oils

Thick and thin — detail by
Joseph Clement Cole

thio violet — Pigment; thioindigo, an intense purple with a red undertone close to manganese violet, permanent

thirsty brush — A watercolor term meaning a brush that has been wet and then squeezed dry; if then touched into a wet area, it will pick up moisture

thorax — The chest; the area between the arms, below the neck, and above the diaphragm

three-dimensional — Showing height, width, and depth

three-point perspective — Representations drawn in perspective so as to show height, width, and depth; necessary when the scene is seen either from a "bird's-eye view" or a "worm's-eye view"

thumbnail sketch — A rough, very small sketch

tibia — A long bone occupying the front and inner side of the lower leg

"tickling up" — Making small, fussy adjustments on artwork

tie, a — In stencil printing, the bar or bridge that holds an island to the remainder of the stencil

tie in — To pull elements together so they make more design unity

tight — Said of a drawing or rendering that is exact, carefully detailed through the use of small brushes or other precise tools

tight hand — The ability to draw or paint with precision

Three point perspective

tile — A slab of fired clay with a smooth finish, used in mosaics and in covering floors and walls; designs are often painted on large tiles, which are then glazed

tin leaf — Used in the Middle Ages in place of silver leaf because it did not tarnish; also used with yellow color or yellow varnish as a top coat, to imitate gold leaf

tinsel painting — The craft of painting on glass with transparent oil paints backed with aluminum foil; sometimes called *crystal painting*

tint — White or another light color with a small amount of another hue added

tintype — In photography, the process of developing a direct positive image on a lightweight metal plate, popular until the late nineteenth century; also called *ferrotype*

tip-in — 1. An illustration printed separately and inserted into a book by using paste at the top of the illustration, the rest hanging free; 2. the insertion of a full-page illustration or plate, printed separately on smoother or heavier stock than the rest of the book

tissue overlay — A transparent paper used to keep artwork clean, for instructions, and for making corrections

tissue paper — A thin translucent paper used in different colors for crafts and decorations

titanium white — *See* **white**

tjanting needle — A tool used to apply liquid wax to cloth for batik

toile de Jouy — In textile design, a one-color design depicting scenes pertinent to the eighteenth century or oriental scenes

tole — Painted tinware; a decorative folk art of painting on tin trays, lamps, and other household items with designs, borders, etc.

toluidine red — A red synthetic toner

tonalists — A term applied to some artists in the period from 1880-1910, who tried to capture realistic qualities in nature; Inness, La-Farge, and Whistler were among the artists in this group

tonality — The emphasis of values in a picture; tonality can also incorporate color and how it is considered; for instance, all earth colors in a low key would be a subdued tonality; likewise a bright tonality could be the whole range of values, colors, and intensities

tondo — A painting in circular form, or a sculptured medallion

tone — The relative lightness or darkness in a picture; its value quality either in color or black and white; it's predominant value suggesting the key

toned ground — 1. A glaze or wash of thinned, transparent color laid over a canvas, panel, or paper to prepare it for painting; turpentine is used with oils for thinning and water with water-base paints; 2. color mixed into the gesso when preparing a gesso ground

toner — 1. In silkscreen, a concentrated ink mixed with a color to make it transparent; not to be used alone; 2. a synthetic organic color in a highly concentrated form that is stronger than a lake

tonking — A process of using blotting paper to remove excess oil paint from an area while still leaving pigment in the hollows of the canvas; name derived from Henry Tonker, a professor at the Slade Art School in England

tooth — The texture of a paper, canvas, or other ground, that helps to hold the paint

top tone — *See* **mass tone**

tormented — Said of artwork that has been overworked

torso — The trunk of the body made up of the chest and shoulders, the waist, and the pelvis area

Tortillons

tortillon — A rolled heavy paper stump, pointed on one end, used to soften and tone pencil, charcoal, and pastel drawings. Similar to a stump

Tosa school — Japanese school of painting in the fifteenth to late seventeenth centuries, started by Tosa Motomitsu; the main subjects were court scenes, nobles, and ceremonies of the court

totem — In design, an animal, plant, or natural object used as an emblem for a clan

totem pole — A carved pole made up of totemic symbols, telling a story of the tribe; usually relates to Indians of the Northwest

totentanz — Same as **dance of death**

touch — A term sometimes applied to the quality of a work, including the brush strokes, color, etc.; some paintings are said to have a soft, hard, airy touch, etc.

toxic — poisonous

tracery — In design, curved and/or foliated design, common in Gothic art

Gothic tracery

tracing box — A box with a glass top, having a light inside, used for tracing

tracing cloth — A thin, sturdy, starched, transparent cotton cloth that is used for ink tracing; available in rolls

tracing paper — Transparent paper used over a drawing in order to copy (trace) it; also used for layout and planning work

tracing wheel — *See* **pouncing**

traditional — Conforming to established procedures and principles handed down from the past

trail/traile/trayle — A running carved design of a continuous vine

transfer — The conveying of a drawing from one paper to another

Trail

transfer paper — A carbon-, graphite-, or pastel-coated paper used under an original picture to transfer the picture to its surface by pencil or other pressure

transfer type — *See* **pressure-sensitive letters**

translucence — A quality of paper or other material that allows light to pass through, but is not transparent enough to see through clearly

transparency — A photographic positive film such as a color slide; or, sheet or roll film used by commercial photographers

transparent — Able to be seen through; glasslike

transparent base — In silk screen, an extender that reduces the opaque paint to transparency; improves the screening and does not change the color or viscosity

transparent brown — Pigment; burnt green earth

transparentizing fluid — Any of several types of fluids that can be used to make papers more transparent; often used when painting from old drawings; available through drafting supply stores

transparent oxide of chromium — Pigment; viridian, a transparent dark green, permanent

trapezius muscles — Muscles that shape the shoulders, continue up the back of the neck, draw the head back and to the side, and rotate the scapula

"trash" paper — A very thin, transparent sketch paper used by architects; it is possible to see through several layers

tree of life — A symbol in the shape of a tree, usually with fruit or leaves; the Greek letter tau, a *T* is also considered the tree of life

trefoil — (Latin, *three-leaved*) A motif with three leaves, often found in Gothic ornamental work

trial proofs — In graphic arts, proofs that are pulled to work out the requirements for the choice of paper, color, pressure, etc.

triangle — A three-sided drafting tool, made in several sizes and with different angles; standard are 90°/60°/30° and 90°/45°/45°

triceps — A large muscle running along the back of the upper arm, extending the forearm and arm

trimetal plate — Plate made with three layers of metal—chromium on top of copper, on a base of aluminum or stainless steel

trim size — The size a final printed piece will measure; the measurement to which the printed sheet will be cut

Tripoli — A cutting compound used to remove tiny scratches on metal

triptych — A panel painting in three parts, a middle section with two wings; often used for altarpieces

trite — Said of artwork that is ordinary, has little meaning, lacks interest and originality

triton — In design, a creature with the body of a man and a dolphin's tail

trois crayons, à — (French, *with three chalk crayons*) A drawing on toned paper, usually with black, red, and white crayons or chalk

trompe l'oeil — (French, *deception of the eye*) Painting rendered with photographic realism, so realistic it can fool the viewer into thinking the subjects are real rather than painted; also called *illusionism*

Trompe L'oeil by **Victor Dubreuil**

trucage — A painting forgery; a fake

truck — In newspaper printing, each page of type, illustrations, etc., put together on a small movable table called a *truck,* each truck holding just one page; the system is now obsolete

truqueur — An art forger

"try-outs" — In animated cartooning, a series of rough animated drawings that are photographed on a film strip, then analyzed or criticized

T-square — A drawing tool shaped like a *T* with exact 90° angles at the crossbar; used to draw accurate lines and to check squareness of art and copy, often in conjunction with a triangle

tsuketate — A traditional Japanese ink painting in which sumi or color is used for the masses; no outlines are employed

tube colors — 1. Pigments packaged in tubes, as opposed to pans or cakes; 2. color straight from the tube, without additions or alterations

tube sizes (for paints) —

no. 2 = 5 ml.	no. 14 = 37 ml.
no. 3 = 8 ml.	no. 20 = 60 ml. (2 oz.)
no. 5 = 14 ml.	no. 40 = 120 ml.
no. 8 = 21 ml.	

No. 20

No. 10

No. 9

No. 6

One half actual size of common tube sizes

Tudor rose

tube wringer — A tool to help squeeze all the paint from a tube

Tudor rose — In design, five open petals in a rose shape

Turkey brown — Pigment; raw umber, name obsolete

Turkey red — Pigment; native red oxide, name obsolete

Turkey umber — Pigment; raw umber, name obsolete

Turk's Florentine medium — Trade name for an oil medium used on textiles

"turn around" — In textile design, same as rotate

"turn over" — In textile design, to flip a design

Turner, Joseph Mallord William — 1775-1851, British painter, known for his atmospheric land and seascapes which sometimes bordered on abstraction. He was a major influence on impressionism.

Turner's yellow — Pigment; an obsolete lead yellow

Turner's "Snow Storm"

turnsole — A blue or violet dye used in medieval manuscripts

turntable — A revolving stand, used by sculptors

Turpenoid — Trade name of an odorless turpentine product used in place of turpentine

turpentine — A natural solvent distilled from pine trees, used as a thinner with oils and alkyds and for cleaning brushes

turquoise — Pigment; a greenish blue or bluish green color

278

turquoise blue — Pigment; a blue with a green undertone, moderately permanent, gouache

Tuscan red — Pigment; a red oxide plus alizarin crimson, used industrially

tusche — A fluid used to paint the design in lithography and silk screening

T.V. story-board pad — A white visual paper with a slight transparency for sketching story-board presentations; made of little T.V. screens (about 5 × 3 inches) with a panel below for comments. *See also* **story boards**

tweed — In textile design, a weave of two or three colors which produce a mottled color effect, as in tweed coats or rugs

tweezers — A tool used to grip, move, and lift type or small papers and pictures, particularly when mounting and pasting up mechanicals

Twenty, the — *See* **Vingt, les**

twill — In textile design, a fabric woven with heavy diagonal ribbed lines; also called *Scotch twill*

Twinstick — Trade name for a tape that is sticky on both sides

two-dimensional — Flat, having only two dimensions—height and width

two-point perspective — The type of perspective in which objects in a picture viewed on an angle will have two vanishing points, with verticals remaining parallel to the sides of the picture plane; also called *angular perspective*

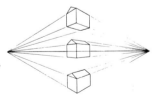

tympan — 1. In lithography, a greased fiberboard or zinc sheet used to protect the paper and allow the scraper bar to move easily; 2. in architecture, the space between the arch and the lintel of a portal

type — A mechanical means of reproducing letters, such as typewriters, Linotype machines, computers, etc.

typeface — The style of a type letter form—italic, roman, gothic, or script; a named type style such as Caslon, Goudy, etc.

Type high

type high — The height of letterpress type, .918 of an inch in the U.S.; also, the height of the photoengraving when blocked for printing on letterpress

typography — The study, practice, and art of using or designing with movable type

Tyrian purple — Pigment; an obsolete purple used by the Greeks and Romans

U-gouge — A woodcutting tool, scoop-shaped like the letter *U*

U-gouge

Ukiyo-e — (Japanese, *floating world*) Eighteenth-century and after, art featuring woodblock prints depicting everyday customs and habits; inexpensive prints that attracted the attention of Europeans and sold well in Europe as well as Japan

ulna — The inner parallel bone to the radius bone in the forearm, placed slightly behind the radius

ultramarine blue — Pigment; a deep blue, transparent and permanent

ultramarine green — Pigment; a pale green, semitransparent, permanent

ultramarine red — Pigment; a pale red, semitransparent, permanent

ultramarine violet — Pigment; a pale violet, semitransparent, permanent

ultramarine yellow — Pigment; a pale yellow, semitransparent, permanent

umber — Pigment. *See* **burnt umber; raw umber**

umbra — (Latin, *shade* or *shadow*) The darkest part of a shadow on a curved surface

Umbrian school — Artists working in central Italy in the fifteenth and sixteenth centuries;

Ink drawing by **Raphael**

Diagram of a **Cèzanne** painting having several eye levels.

important artists were Perugino, Pintoricchio, and Raphael

undercut — In woodcarving, to cut back and beneath an exposed edge

undercutting — When acid gives a side-bitten effect, it is undercut

underpainting — The first paint applied to a picture surface, to be overpainted with other layers or glazes of paint; also called *abbozzo*

underpainting white — A quick-drying white oil paint used in underpainting

undertint — A transparent undercoat or veil, over a white ground

undertone — The underneath or less noticeable part of a color, as the bluish undertone of alizarin red

uninked intaglio — Blind embossing from an intaglio plate

universal perspective — Perspective from different eye levels in the same picture

universal quality — In art, a quality that is not limited or dated, but creates the feeling of agelessness

unprimed canvas — Raw canvas or support that has no primer on it

unsized — Without any sizing or filler

uppercase letters — Capital letters

urn — A vase or a vase shape

Utrecht school — An early seventeenth-century Dutch school emulating the style of Caravaggio; the most important artists were Baburen, Honthorst, and Terbrugghen; influenced Hals and Rembrandt

value patch — An area in a painting that has a specific value

value scale — The range from light to dark, including white, grays, and black; colors can be evaluated on this scale. Values are often numbered on scales of 0 to 10. In one system 0 = black and 10 = white; another system reverses the designations and has 0 for white and 10 for black. Generally, high values are considered to be light, and low values dark

Vandyke brown — Pigment; a dark earth brown close to burnt umber, moderately permanent

Vandyke red — Pigment; shades of brownish red, brown, and reddish violet; an obsolete, toxic color

Van Eyck green — Pigment; verdigris, hydrated copper acetate, obsolete

Van Gogh, Vincent William — 1853-1890, Dutch postimpressionist who spent much of his adult life in France. His work is known for its powerful emotional impact of direct painting with vibrant colors. He was an influence on the fauve/expressionist movements.

Van Gogh ink drawing

vanishing point(s) — In perspective, a point or points on the horizon at which parallel lines converge

vanitas — *See* **memento mori**

vantage point — An advantageous point from which to view something; the position from which you view a scene

varnish — A protective liquid or spray coating used as a finish coat on oil paints. *See also* **retouch varnish**

Vasarely, Victor — a Hungarian who migrated to Paris in 1930 and devoted himself to advertising. He became an innovator of op art/vibration art, working with geometric shapes and color combinations for optical effect.

veduta — A painting attempting to faithfully represent a portion of a town or city

veduta ideata — An imaginary view of a place, realistically rendered

vehicle 1. A word often used in place of *medium;* 2. the liquid that is ground with dry pigments

veil — *See* **undertint**

veining tool — A *V*-shaped tool used in wood carving to cut a broad channel

vellum — Originally a writing and painting surface, made from young animal hides; a fine parchment; name now given to a heavy, smooth paper used as fine stationery and a semismooth drawing paper, also called *kid finish*

vellum cloth — A fine cotton cloth made into a transparent tracing film

velour paper — A heavy paper that looks and feels like velvet, good for pastels; available in different colors

velox — A term designating a screened photographic print of a continuous-tone photo, or a piece of art that can be printed in line, without halftone screening

velvet brown — Pigment; an obsolete name for fawn brown, which is also obsolete

Venetian red — Pigment; a reddish earth color, permanent, different from burnt sienna or Indian red

Venetian school — Initially the workshops of St. Mark's, under the influence of Paolo Veneziano in the fourteenth century; later, more of an attitude of place than a school; in the sixteenth century it was dominated by great Venetian artists including Bellini, Canaletto, Gorgione, Guardi, Tintoretto, and Titian

Venetian School — "Venus and Adonis" by **Titian** (detail)
The Metropolitan Museum of Art, New York

Venice red — Pigment; Venetian red

verdaccio — A neutral or brownish green color similar to raw umber, used as an outline, shading, or undercoating by Italian painters in the fourteenth century

Verderame — Pigment; verdigris, hydrated copper acetate, obsolete

verdetta — Pigment; green earth, name obsolete

verdigris — Pigment; a light bluish green made from hydrated copper acetate, obsolete. *See also* **patina**

vermilion — A bright orange red comparable to cadmium red light; considered permanent, but if exposed to the sun for a length of time, it turns dark

Vernet green — Pigment; Bremen green, a form of Bremen blue which is a combination of copper hydroxide and copper carbonate; toxic and obsolete

Verona brown — Pigment; burnt green earth, name obsolete

Verona green — Pigment; green earth, name obsolete

Veronese green — Pigment; a pale viridian, name obsolete

verso — Left-hand page. *See also* **recto**

vertebrae — The thirty-three bones or cartilaginous segments forming the spinal column

vert emeraude — Pigment; viridian, a transparent green, permanent

vertical — Up and down, at right angles to a base line

Vestorian blue — Pigment; Egyptian or colbalt blue

vibration art — An optical sensation, partly manipulated by design and partly by color. *See also* **op art**

Victorian art — Nineteenth-century style in Britain at the time of Queen Victoria; tends to be romantic, ornamental, and massive

Vidalon — Trade name of a good-quality tracing paper made in medium, heavy, and super heavy weights

video art — Video technology used as a means of expression to be seen on a television screen; Andy Warhol, among others, has recorded such images

Vienna blue — Pigment; an obsolete name for cobalt blue

Vienna green — Pigment; copper arsenate, toxic, obsolete

Vienna lake — Pigment; carmine, a fugitive lake

viewfinder — A small (about 4 × 5 inches) cardboard frame used to isolate or frame a scene in order to locate a desired composition to be painted or sketched

viewpoint — *See* **station point**

vignette — 1. An irregular shape to a picture without square edges to frame it. 2. a photograph that is prepared (usually with airbrush) so the edges fade gradually to white

vine black — Pigment; an inferior carbon black with a bluish undertone

Vignette by
Alfred Chadbourn

Vingt, les — (French, *the Twenty*) A group of twenty avant-garde painters, active from 1884-1894 in Brussels, who promoted and exhibited new and unconventional art; a few of their exhibitors were Cézanne, Gauguin, Monet, Pissaro, Renoir, Seurat, and Van Gogh

vinyl inks — Inks used in silk screen for printing on vinyl, usually commercial; opaque but can be thinned with a special base to become transparent; toxic and flammable

violent — Said of strong, hard, and/or harsh artwork

violet — Pigment; a light purple color

violet carmine — Pigment; a clear reddish violet, transparent and fugitive

violet madder lake — Pigment; alizarin violet, a clear transparent lake, fugitive

violet ultramarine — Pigment; ultramarine violet, pale, transparent, and permanent

viridi aeris — Pigment; a bluish green, hydrated copper acetate, obsolete

viridian — Pigment; a transparent dark green, permanent

viscosity — The degree of thickness in paint or ink

viscosity printing — The process of printing with two or more viscosities of ink, which may

also be different colors; one roll-up will use an oily ink and the second will be drier, thus producing different textures and colors all from one plate

visual — In commercial art, a layout of a proposed artwork

visual arts — Graphics, painting, sculpture, and architecture, as opposed to the performing arts of the theater, music, dance, opera, and writing

visualizing paper — A transparent paper used mostly for layouts and design work

visual pad — A pad of paper that has removable sheets of transparent paper

visual weight — The ability of a picture element to attract attention and thus assume its part in establishing visual balance

vogue — The prevailing style or fashion of the time

void — 1. An area where there is nothing happening, emptiness which needs to be filled; 2. a hole in a picture

volume — Bulk; mass; space occupied

volute — In design, a spiral form; a scroll-like ornament

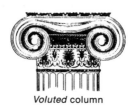
Voluted column

vorticism — An art movement in England, 1912-1915, an offshoot of cubism and futurism, led by Wyndham Lewis; simplified forms into angular, machine-like representation, abstract and often nonobjective; prominent in the movement were Jacob Epstein, Henri Gaudier-Brzeska, William Roberts, Edward Wadsworth, and C.R. Nevinson

Voussoir

voussoir — In architecture, one of the wedge-shaped stones forming a stone arch

waffle — *See* **honeycomb**

walk-off — In graphic printing, the impairment or deterioration of part of an image on the plate during the printing process

wall of Troy — *See* **Greek key**

wall painting — *See* **mural**

walling wax — *See* **bordering wax**

warm colors — Colors in which red, orange, and yellow predominate

warming the ink — In printmaking, the act of softening the ink on a hard surface

warp — 1. The bend that develops in stretcher strips, frames, paper boards and Masonite boards, usually due to unseasoned wood or to moisture; 2. in textile design, the lengthwise or vertical yarn in weaving

wash — A thin, liquid application of paint in any medium, brushed on in a free-flowing manner; in oil colors, when applied over dry underpainting, it is a *glaze*

wash out — 1. In lithography, to wash the stone with a sponge and turpentine just before inking; 2. in water-based painting, to remove a painted area of a picture by applying water and washing out the color as much as possible with brush or sponge

Watercolors

watercolor — Paint that uses water as the medium; categories are: traditional watercolors—transparent; gouache—opaque; casein—a casein glue pigment, opaque; acrylics—used as watercolor, transparent or opaque

watercolor block — A number of watercolor papers, bound on all four sides to lie flat, designed so the top sheet may be painted on, then removed singly, leaving the next sheet ready for use

watercolor mediums — Mainly water; two special types are available from Winsor and Newton: watercolor medium No. 1 encourages smooth application and No. 2 enriches the colors; also called *wetting agents*

watercolor pad — Sheets of watercolor paper bound into tablet form

watercolor paper — Paper made specifically for watercolors; hot pressed (HP)—smooth; cold pressed (CP)—medium texture; and not pressed (NP)—or rough (R)—heavier, rougher texture; 100 percent rag content is a superior paper

watercolor paper sizes — Demi, 15 × 20 inches; medium, 17 × 22 inches; royal, 19 × 24 inches; imperial, 22 × 30 inches; elephant, 23 × 28 inches; double elephant, 26½ × 40 inches; and antiquarian 31 × 53 inches; imperial is the most common in single sheets; Rolls of paper are also available

watercolor paper weights — 72 lb.—lightweight; 90 lb.—lightweight; 140 lb.—medium weight; 250 lb. medium weight; 300 lb.—heavyweight; 400 lb.—heavyweight; 555 lb.—extra-heavy weight; 1114 lb.—extra, extra-heavy weight; 72 lb., 140 lb., and 300 lb. are most popular

watercolor pencils — Pencils made in various colors of watercolor pigments, used for drawing, or dipped in water to create smooth color

application when a wet brush is pulled across the colored line a wash effect is generated

waterleaf paper — unsized paper

watermark — A translucent name or design molded into paper during the manufacturing process; more visible when held to a light

water mask — In silkscreen, a block-out used as a stencil filler; it dries fast and is removed with water

water matte gold size — A stiff paste sizing used for illumination where gilt is applied; can become moist and tacky to accept gilt when it is warmed by breathing on it

water-of-Ayr stone — *See* **snake slip**

waterscape — A picture in which a body of water is a primary compositional element; surrounding land area, trees, boats, shacks, etc., may also be included

wave scroll — A running design that suggests a breaking wave

wax coater — A tool that applies an even coat of wax to paper, plastic, film, cardboard, etc., so it is pressure-sensitive for mounting pasteups; one type is large and stationary and another is a hand-held roller-like tool

waxed Masa — A waxed Japanese rice paper, used mostly by textile designers; soft but strong and translucent

wax medium — A concentrated wax used for encaustic painting and for preserving wood carvings, paintings, art objects, etc.

wax painting — *See* **encaustic**

wax proofing — A method of pulling a rough print from a paper covered with melted wax

wax varnish — A paste varnish made from beeswax and petroleum spirit; can be thinned with rectified petroleum, applied with a cloth or brush

weak artwork — Artwork that lacks character or strength, has no impact, is bland; often refers to timid use of values or color in painting or to unsure drawing

weaving — In textile design, the process of forming a fabric on a loom by interlacing the warp and woof

weft — *See* **woof**

weight — The visual feeling of mass or heaviness in a composition; the heaviness of line, shape, size, value, color, or texture

weld — A natural yellow dyestuff, practically obsolete

welding — Joining metal parts in metal sculpture

wet-into-wet — Painting additional color into an already wet area, creating a soft, flowing effect; usually applies only to water-based mediums

wet palette — A palette of colors that are still loose and workable; the paint is not dry and hard

wetting agent — *See* **watercolor mediums**

Whatman board — Trade name for a quality 185-pound English paper mounted on a heavy cardboard, suitable for many media

wheat — Pigment; an off-white mixture, usually with a yellow undertone

wheel, color — *See* **color wheel**

whiplash line — A line prominent in art nouveau

Whistler, James Abbott McNeill — 1834-1903, born in America, a painter, etcher, and portraitist who spent most of his life abroad.

Whistler's — "The White Girl" (detail)

white — Pigment: Chinese white—zinc white; Cremnitz, Krems, or Kremnitz white—a white lead paint, toxic; flake white—gives good coverage, excellent drier, flexible film, has a tendency to yellow or turn dark, toxic; lead white—flake and Cremnitz; zinc white—brilliant, cold white, brittle, slow-drying, permanent and nontoxic; Permalba—a trade name for titanium white; titanium white—opaque, gives good coverage, nondiscoloring and nontoxic

white-on-white — An embossed print made with an uninked plate; some avant-garde artists have dealt with white-on-white paintings. *See* Suprematisin

whiteout — To use an opaque white paint to block out unwanted areas

white sable brush — A brush made from a combination of synthetic fibers; can be used with any medium, but usually with oil or acrylics

white spirits — *See* **mineral spirits**

whiting — A type of chalk, a natural calcium carbonate, used as a filler in gesso and in cheaper paints

Whitney rotary — Trade name for a tool made of two watercolor brushes, one on each end of one handle, designed for a quick change or lift

Wiener Werkstätte — A Viennese organization of designers and craftsmen started in 1903, dedicated to certain aesthetic principles; their style is related to art nouveau

Williamsburg collection — In textile design, designs pertinent to America in the 1700s,

based on the research of the Williamsburg, Virginia restoration

willow stick — Vine charcoal. *See* **charcoal**

wind chimes — Pieces of bamboo, wood, metal, or glass, hanging from a string or wire, so the air currents can move them to make sounds. *See* **mobile**

Win-gel — Trade name for a clear medium for oils and alkyd, to increase the gloss and transparency

Winsor blue — Trade name for a pigment; blue that is close to phthalocyanine blue, transparent and permanent

Winsor emerald — Trade name for a pigment; in oil, a mixture of arylamide yellow and chlorinated copper phthalocyanine, and in watercolor, zinc oxide is added; permanent

Winsor green — Trade name for a pigment; a permanent dark to medium green; similar to phthalocyanine green, transparent

Winsor lemon — Trade name for a pigment; a light yellow, permanent

Winsor orange — Trade name for a pigment; a bright orange, permanent

Winsor red — Trade name for a pigment; a bright red, permanent

Winsor violet — Trade name for a pigment; a blue violet, transparent and permanent

Winsor yellow — Trade name for a pigment; a cool yellow, permanent

Winton picture cleaner — Trade name of a product used to clean soiled oil paintings, an emulsified mixture of copaiba balsam, Dipentene, and pine oil with ammonia

wipe-on plate — In photolithography, a light-sensitive plate

wire-end modeling tools — Tools with many different-shaped wire ends, used to model clay, plaster, etc.

woad — A blue dye used in the Middle Ages

Wolf's carbon pencils — Trade name for pencils made with pressed carbon, marked with degrees of hardness

wood-burning tool — An electric tool with a point or interchangeable points, used to burn or incise a design on wood, leather, and other materials and sometimes to create a wormwood effect on frames

woodcut — In graphic arts, a relief print obtained when knives and tools are used to cut a design with the grain into wood, and the surface not cut away is printed

wood engraving — A process in which the design is cut on the end grain of a wood block; usually only very hard, even-grained wood such as cherry, pear, or boxwood is used; when printed, the lines are usually white against a dark ground

Wood, Grant — 1892-1942, American, a metal craftsman turned painter who became famous for his realistic but stilted style.

woodless drawing pencil — A solid stick of graphite, lacquer-coated; can be sharpened to a drawing point; available in a variety of weights

woof — In textile design, the filling threads, running horizontally in weaving; also called the *weft*

word spacing — Increasing or decreasing the space between words in copy or lettering

Fifteenth century *Woodcut* of St. Dorothy

Detail of wood engraving after painting by **Gilbert Stuart**

Caslon Bold with Italic
Caslon Bold with Italic

workable eraser — *See* **kneaded eraser**

working proof — In graphics, a trial proof on which corrections and additions are indicated

worm's-eye view — A picture in oblique perspective from an extremely low eye level, with the horizon at the bottom of the picture or below it

wove paper — Paper with a smooth, uniform surface, unlined in texture

wrapping — A so-called art form mainly associated with the Bulgarian, Christo, consisting of wrapping buildings, mountains, and other forms with material such as plastic sheeting; this procedure is called *empaquetage*

Wrico pen — Trade name of a pen similar to a ruling pen, used for lines and lettering

writing brush — *See* **calligraphy brush**

Lettering quill

X-Acto knife — Trade name for a small, sharp knife used to cut paper, friskets, cardboard, mats, etc., having different handles and shapes of blades for a variety of jobs

X-acto knife blades

x-height — The height of lowercase letters; various typefaces have different x-heights for the same point size

x-height of several 48 point typefaces

xylography — Woodprint engraving or wood-cutting to produce a woodblock print

Yamato-e — The traditional painting style of Japan

Yamato school — A Japanese ninth century school that lasted five centuries; the famous Kose Kanaoka painted landscapes and portraits in a pure Japanese style

yeast black — Pigment; a form of vine black, carbon, name obsolete

Yellow Book style — *See* **art nouveau**

yellow carmine — Pigment; a yellow lake, transparent and fugitive

yellowing — Discoloration of paint or paper that becomes darker from age or poor quality of product

yellow ochre — Pigment; a yellow earth, opaque and permanent

yellow oxide of iron — Pigment; a brilliant artificial yellow earth, permanent

yellow ultramarine — Pigment; an obsolete name for barium yellow

Z

Zen calligraphy — Calligraphy executed by the Zen monks; the strokes are of a bold and pure nature

zensho — Zen calligraphy

Zec — Trade name of a quick-drying medium used with oils as an underpainting and to achieve texture

zinc chrome — Pigment; zinc yellow

zinc green — Pigment; cobalt green

zincography — A lithographic process using zinc plates in place of stone

zinc oxide — Pigment; zinc white

zinc white — Pigment; *See* **white**

zinc yellow — Pigment; color close to cadmium yellow pale on the color chart, semiopaque, toxic, and permanent

zinnober — Pigment; vermilion, obsolete

Zipatone — Trade name for press-on halftone or shading sheets. *See also* **halftone**

zoomorphic design — Designs, symbols, or ornaments based on animal forms

Zen calligraphy — an ancient oriental saying: Whether for life or for death, depends on what's in the spoon.

Noteworthy Artists of the Western World

This list in chronological order identifies artists who have made a telling contribution to Western art in the past 800 years. Many of the names are household words, known throughout the world as the giants of our culture. However, not all those listed are of equally lofty stature. Some artists are included because their approach is helpful in defining periods and establishing guideposts for schools, styles, and trends that followed.

The country or region following the artist's name is his place of origin, or the area with which he was closely associated through most of his career. The dates shown are the years of the artist's birth and death, or if unknown, when he was active in his career.

Code:

c. (circa) Approximate time; exact dates unknown

a. The period when the artist is known to have been active; even approximate vital dates are unknown

f. Indicates the artist was the *father* of one or more of the listed artists

s. The *son* of another listed artist

b. The brother of one or more of the listed artists

sc. The artist is chiefly known as a sculptor

[Brackets] indicate the name by which the artist is usually known

Many fine examples of Western art predate the thirteenth century; however, relatively few such works can be traced to specific individuals. Many earlier masterpieces were either created by an unknown artist, or by artists working as a team, usually anonymously.

Thirteenth century

Nicola Pisano (Pisa, a. 1258-1278) f., sc.
Guido (Siena, a. 1260-1285)
Giovanni Pisano (Pisa, a. 1265-1314) s., sc.
Giotto (Florence, c. 1267-1337)
Cimabue (Florence, a. 1272-1302)
Cavallini (central Italy, a. 1273-1330)
Duccio (Siena, a. 1278-1318)
Simone Martini (Siena, c. 1285-1344)
Tino di Camaino (Siena, c. 1285-1337) sc.

Fourteenth century

Gaddi (Florence, c. 1300-1366)
Ambrogio Lorenzetti (Siena, a. 1319-1348) b.
Pietro Lorenzetti (Siena, a. 1320-1348) b.
Altichiero (northern Italy, c. 1330-1395)
Orcagna (Florence, a. 1344-1368)
Gentile Da Fabriano (central Italy, c. 1360-1427)

Hubert Van Eyck (Flanders, c. 1366-1426) b.
Bertram (Germany, a. 1367-1387)
Campin (Flanders, 1375-1444)
Jan Van Eyck (Flanders, c. 1390-1440) b.
Masolino (Florence, c. 1383-1447)
Donatello (Florence, 1386-1466) sc.
Lorenzo Monaco (Florence, a. 1388-1422)
Sassetta (Siena, c. 1392-1450)
Pisanello (northern Italy, c. 1395-1455)
Uccello (Florence, 1397-1475)
Malonel (France, a. 1396-1419)
Van der Weyden (Flanders, c. 1399-1464)

Fifteenth century

Fra Angelico (Florence, c. 1400-1455)
Jacopo Bellini (Venice, c. 1400-1470) f.
Multscher (Germany, c. 1400-1467)

Tommaso Dimone [Masaccio] (Florence, c. 1401-1428)
Pol de Limbourg (France, a. 1402-1416)
Giovanni Di Paolo (Siena, c. 1403-1482)
K. Von Soest (Germany, a. 1405-1422)
Fra Flippo Lippi (Florence, 1406-1469)
Petrus Christus (Flanders, c. 1410-1472)
Lochner (Germany, a. 1410-1451)
Castagno (Florence, c. 1410-1457)
Domenico Veneziano (Florence, c. 1410-1461)
Vecchietta (Siena, 1412-1480)
Antonio Vivarini (Venice, c. 1415-1484)
Piero Della Francesca (central Italy, c. 1416-1492)
Fouquet (French, c. 1420-1481)
Dirck Bouts (Flanders, c. 1420-1475)
Benozzo Gozzoli (Florence, c. 1420-1497)
Andrea Bregno (central Italy, 1421-1506) sc.
Gentile Bellini (Venice, c. 1429-1507) s., b.
Francke (Germany, a. 1424-1435)
Baldovinetti (Florence, 1425-1499)
Matteo Di Giovanni (Siena, c. 1430-1495)
Giovanni Bellini (Venice, c. 1430-1516) s., b.
Antonello Da Messina (Venice, c. 1430-1479)
Cosimo Tura (northern Italy, 1430-1495)
Memling (Flanders, c. 1430-1494)
Schongauer (Germany, c. 1430-1491)
Pollaiuolo, A. (Florence, c. 1431-1498)
Mantegna (northern Italy, 1431-1506)
Lucas Moser (Germany, a. 1431-1440)
Pietro Lombardo (Italy, 1433-1515) sc.
Konard Witz (Swiss, a. 1433-1447)
Pacher (Germany, c. 1435-1498)
Cossa (northern Italy, c. 1435-1498)
Crivelli (Venice, c. 1435-1495)
Verrocchio (Florence, 1435-1488)
Martorell (Spain, a. 1433-1453)
Melozzo da Forli (central Italy, 1438-1494)
Francesco Di Giorgio (Siena, 1439-1502)
Nan der Goes (Flanders, c. 1440-1482)
Signorelli (central Italy, c. 1441-1523)
Botticelli (Florence, c. 1444-1510)
Neroccio Di Landi (Siena, 1447-1500)
Pietro Perugino (central Italy, 1445-1523)
Hieronymus Bosch (Flanders, c. 1450-1516)
Gerald David (Flanders, c. 1450-1523)
Chirlandaio (Florence, 1449-1494)
Veit Stoss (Germany, 1450-1533) sc.
Froment (France, a. 1450-1490)
Leonardo da Vinci (Florence, 1452-1519)
Pinturicchio (northern Italy, 1454-1513)
Carpaccio (Venice, c. 1455-1526)
Filippino Lippi (Florence, 1457-1504)
Mathias Grünewald (Germany, c. 1460-1528)
Hans Holbein, The Elder (Germany, 1460-1524) f.
Massye (Flanders, c. 1466-1530)
Albrecht Dürer (Germany, 1471-1528)
Lucas Cranach (Germany, 1472-1553)
Fra Bartholommeo (Florence, 1472-1517)
Bermejo (Spain, a. 1474-1495)
Jean Clouet (France, c. 1475-1547)

Michelangelo (Florence, 1475-1564)
Sodoma (Siena, 1477-1549)
Jan Gossaert [Mabuse] (Flanders, c. 1478-1533)
Joachim Patenier [Patinir] (Flanders, c. 1478-1524)
Giorgione (Venice, 1478-1510)
Dosso Dossi (northern Italy, c. 1479-1542)
Altdorfer (Germany, c. 1480-1538)
Hans Baldung [Grien] (Germany, 1480-1545)
Palma Vecchio (Venice, 1480-1528)
Lorenzo Lotto (Venice, 1480-1556)
Raphael (central Italy, 1483-1520)
Sebastiano Del Piombo (Venice, 1485-1547)
Giulio Romano (central Italy, 1492-1546)
Andrea Del Sarto (Florence, 1486-1531)
Beccafumi (Siena, c. 1486-1551)
Titian (Venice, 1487-1576)
Rosso Fiorentino (Florence, 1494-1540)
Correggio (northern Italy, 1494-1534)
Pontormo (Florence, c. 1494-1557)
Lucas Van Leyden (Holland, 1494-1533)
Jan Van Scorel (Flanders, 1495-1562)
Hans Holbein, The Younger (Germany, 1497-1543) s.
Moretto (northern Italy, c. 1498-1555)
Maerten Van Heemskerck (Holland, 1498-1574)

Sixteenth century

Benvenuto Cellini (Florence, 1500-1571) sc.
Bronzino (Florence, c. 1503-1572)
Parmigianino (northern Italy, 1503-1540)
Aertsen (Holland, 1508-1575)
Morales (Spain, 1509-1586)
Jean Goujon (France, 1510-1568) sc.
Jacopo Bassano (Venice, 1510-1592)
Coello (Spain, 1515-1590)
Antonis Mor [Moro] (Holland, c. 1519-1576)
Tintoretto (Venice, 1518-1594)
Moroni (northern Italy, c. 1525-1578)
Pieter Bruegel, The Elder (Flanders, c. 1525-1569) f.
Veronese (Venice, 1528-1588)
Giovanni Bologna (Italy, 1529-1608) sc.
Domenikos Theotocopoulos [El Greco] (Spain, c. 1542-1614)
Nichols Hillard (England, c. 1547-1619)
Annibale Carracci (Italy, 1560-1609)
Pietro Bernini (Italy, 1562-1629) f., sc.
Caravaggio (Italy, c. 1565-1609)
Gentileschi (Italy, 1565-1647)
Pieter Brueghel (Flanders, 1564-1638) s.b.
Jan Brueghel (Flanders, 1568-1625) s.b.
Guido Reni (Italy, 1575-1642)
Pietro Tacca (Florence, 1577-1640) sc.
Peter Paul Rubens (Flanders, 1577-1640)
Elsheimer (Germany, c. 1578-1610)
Frans Hals (Holland, 1580-1666)
Strozzi (Italy, 1581-1644)
Terbrugghen (Holland, c. 1588-1629)

Ribera (Spain, 1588-1652)
Antoine LeNain (France, c. 1588-1648) b.
Seghers (Holland, c. 1589-1638)
Honthorst (Holland, 1590-1656)
Guercino (Italy, 1591-1666)
Maurice LaTour (France, 1593-1652)
Jacob Jordaens (Flanders, 1593-1678)
Louis LeNain (France, 1593-1648) b.
Nicolas Poussin (France, 1594-1665)
Hubert LeSueur (France, c. 1595-1650) sc.
Pietro Da Cortona (Italy, 1596-1669)
Jan Van Goyen (Holland, 1596-1656)
Pieter Saenredam (Holland, 1597-1665)
Zurbaran (Spain, 1598-1664)
Gianlorenzo Bernini (Italy, 1598-1680) s., sc.
Van Dyck (Flanders, 1599-1641)
Velasquez (Spain, 1599-1660)

Seventeenth century

Claude Lorrain (France 1600-1682)
Champaigne (France, 1602-1674)
Brouwer (Flanders, 1605-1638)
Rembrandt (Holland, 1606-1669)
Mathieu LeNain (France, 1607-1677) b.
David Teniers (Flanders, 1610-1690)
Van Ostade (Holland, 1610-1684)
Salvatore Rosa (Italy, 1615-1673)
Emanuel De Witte (Holland, 1617-1692)
Gerald Ter Borch (Holland, 1617-1681)
Murillo (Spain, 1617-1682)
Peter Lely (England, 1618-1680)
Charles Lebrun (France, 1619-1690)
Cuyp (Holland, 1620-1691)
Fabritus (Holland, c. 1622-1654)
Jan Steen (Holland, 1626-1679)
Francois Girardon (France, 1628-1715) sc.
Jacob Van Ruidael (Holland, c. 1628-1682)
Pieter De Hoogh (Holland, 1629-1683)
Jan Vermeer van Delft (Holland, 1632-1675)
Hobbema (Holland, 1638-1709)
Jose de Mora (Spain, 1642-1724) sc.
Kneller (England, 1646-1723)
Rigaud (France, 1659-1743)
Magnasco (Italy, 1677-1749)
Van Huysum (Holland, 1682-1749)
Watteau (France, 1684-1721)
Nattier (France, 1685-1766)
John Smibert (U.S.A., 1688-1751)
Tiepolo (Italy, 1696-1770)
Canaletto (Italy, 1697-1768)
Hogarth (England, 1697-1764)
Chardin (France, 1699-1779)
Bouchardon (France, 1698-1762) sc.

Eighteenth century

Liotard (Swiss, 1702-1789)
Pietro Longli (Italy, 1702-1785)
François Boucher (France, 1703-1770)
Robert Feke (U.S.A., c. 1705-1750)
Guardi (Italy, 1712-1793)
Richard Wilson (England, 1714-1792)
Joshua Reynolds (England, 1723-1792)
Greuze (France, 1725-1805)
Thomas Gainsborough (England, 1727-1788)
Anton Mengs (Germany, 1728-1779)
Fragonard (France, 1732-1806)
George Romney (England, 1734-1802)
John Singleton Copley (U.S.A., 1737-1815)
Benjamin West (U.S.A., 1738-1820)
Jean-Antoine Houdon (France, 1741-1828) sc.
Charles Wilson Peale (U.S.A., 1741-1827) f.
Goya (Spain, 1746-1828)
Jacques-Louis David (France, 1748-1825)
Gilbert Stuart (U.S.A., 1755-1828)
John Trumbull (U.S.A., 1756-1843)
Henry Raeburn (England, 1756-1823)
Thomas Rowlandson (England, 1756-1827)
Antonio Canova (Italy, 1757-1822) sc.
William Blake (England, 1757-1827)
Prud'hon (France, 1758-1823)
Georges Michel (France, 1763-1843)
John Crome (England, 1768-1821)
Bertel Thorwaldsen (Denmark, 1768-1844) sc.
Thomas Lawrence (England, 1769-1830)
Gros (France, 1771-1835)
Caspar Friedrich (Germany, 1774-1840)
Phillip Otto Runge (Germany, 1777-1810)
Raphaelle Peale (U.S.A., 1774-1825) s., b.
Thomas Girtin (England, 1775-1802)
J.M.W. Turner (England, 1775-1851)
Rembrandt Peale (U.S.A., 1778-1860)s., b.
John Constable (England, 1776-1817)
Washington Allston (U.S.A., 1779-1843)
Jean Auguste Ingres (France, 1780-1867)
John Sell Cotman (England, 1782-1842)
Thomas Scully (U.S.A., 1785-1851)
John James Audubon (U.S.A., 1785-1851)
Gericault (France, 1791-1824)
Jean-Baptiste Corot (France, 1796-1875)
Eugene Delacroix (France, 1798-1863)

Nineteenth century

Richard Bonnington (England, 1801-1828)
Thomas Cole (U.S.A., 1801-1848)
Narcisse-Vergile Diaz (France, 1807-1876)
Honoré Daumier (France, 1810-1879)
George Caleb Bingham (U.S.A., 1811-1879)
Theodore Rousseau (France, 1812-1867)
Jean Francois Millet (France, 1814-1875)
Adolf Menzel (Germany, 1815-1905)
Alfred Stevens (England, 1818-1875) sc.
Gustave Courbet (France, 1819-1877)
Johan Jongkind (Holland, 1819-1891)
Rosa Bonheur (French, 1822-1899)
Puvis De Chavannes (France, 1824-1898)
George Inness (U.S.A., 1825-1894)
William A. Bougureau (France, 1825-1905)
Frederic E. Church (U.S.A., 1826-1900)
W.H. Hunt (England, 1827-1910)
Jean-Baptiste Carpeaux (France, 1827-1875) sc.
Arnold Boecklin (Swiss, 1827-1901)
Dante G. Rossetti (England, 1828-1882)
John E. Millais (England, 1829-1896)
Albert Bierstadt (U.S.A., 1830-1902)
Camille Pissarro (French, 1830-1903)
Edouard Manet (French, 1832-1883)
Eduard Burne-Jones (England, 1833-1898)
Edgar Degas (French, 1834-1917)
James McNeill Whistler (U.S.A., 1834-1903)
John La Farge (U.S.A., 1835-1910)
Winslow Homer (U.S.A., 1836-1910)
Marees (Germany, 1837-1887)
Paul Cézanne (French, 1839-1906)
Odilon Redon (French, 1840-1916)
Claude Monet (French, 1840-1926)
Auguste Rodin (French, 1840-1917) sc.
Pierre A. Renoir (French, 1841-1919)
Berthe Morisot (French, 1841-1895)
Henri Rousseau (French, 1844-1910)
Thomas Eakins (U.S.A., 1844-1916)
Wilhelm Leibel (Germany, 1844-1900)
Mary Cassatt (U.S.A., 1845-1926)
Albert Ryder (U.S.A., 1847-1917)
Augustus Saint-Gaudens (U.S.A.,1848-1907)sc.
Paul Gauguin (French, 1848-1903)
William M. Harnett (U.S.A., 1848-1892)
William Merritt Chase (U.S.A., 1849-1916)
Christian Rohlfs (Germany, 1849-1938)
Edwin Austin Abbey (U.S.A., 1852-1911)
Howard Pyle (U.S.A., 1853-1911)
Vincent van Gogh (Holland, 1853-1890)
Ferdinand Holder (Swiss, 1853-1918)
Charles Niehaus (U.S.A., 1855-1935) sc.
John Singer Sargent (U.S.A., 1856-1925)
Thomas Dewing (U.S.A., 1857-1938)
Lovis Corinth (Germany, 1858-1925)
Childe Hassam (U.S.A., 1859-1935)
Maurice Prendergast (U.S.A., 1859-1924)
Georges Seurat (France, 1859-1891)
James Ensor (Belgium, 1860-1949)

Anders Zorn (Sweden, 1860-1920)
Aristide Maillot (French, 1861-1944) sc.
Anna Moses [Grandma Moses] (U.S.A., 1860-1961)
Frederic Remington (U.S.A., 1861-1909)
Arthur Davies (U.S.A., 1862-1928)
Frank W. Benson (U.S.A., 1862-1951)
Gustav Klimt (Austria, 1862-1918)
Paul Signac (French, 1863-1935)
Edvard Munch (Norway, 1863-1944)
Joaquin Sorolla (Spain, 1863-1923)
Charles M. Russell (U.S.A., 1864-1926)
Henri de Toulouse-Lautrec (French, 1864-1901)
Robert Henri (U.S.A., 1865-1929)
Pavel Trubetskoy (Russia, 1866-1938) sc.
Wassily Kandinsky (Russia, 1866-1944)
Charles Dana Gibson (U.S.A., 1867-1944)
Pierre Bonnard (France, 1867-1947)
George Luks (U.S.A., 1867-1933)
Emil Nolde (Germany, 1867-1956)
Frank Brangwyn (England, 1867-1956)
Edouard Vuillard (France, 1868-1940)
Henri Matisse (France, 1869-1954)
John Marin (U.S.A., 1870-1953)
Maxfield Parrish (U.S.A., 1870-1966)
William Glackens (U.S.A., 1870-1938)
Ignacio Zuloaga (Spain, 1870-1945)
John Sloan (U.S.A., 1871-1951)
Lyonel Feinnger (U.S.A., 1871-1956)
Georges Ronault (France, 1871-1958)
Kupka (Czech., 1871-1957)
Giacomo Balla (Italy, 1871-1958)
Aubrey Beardsley (England, 1872-1898)
Piet Mondrian (Holland, 1872-1944)
Howard Chandler Christy (U.S.A., 1873-1952)
Ernest Lawson (U.S.A., 1873-1939)
Joseph Christian Leyendecker (U.S.A., 1874-1951)
Constantin Brancusi (Rumania, 1876-1957) sc.
Vlamick (France, 1876-1958)
Boardman Robinson (U.S.A., 1876-1952)
Everett Shin (U.S.A., 1876-1953)
Anna Hyatt Huntington (U.S.A., 1876-1973) sc.
Marsden Hartley (U.S.A., 1877-1943)
Dufy (France, 1877-1953)
Augustus John (England, 1878-1961)
Kasimir Malevich (Russia, 1878-1935)
Paul Klee (Swiss, 1879-1940)
Hans Hoffman (Germany, 1880-1966)
Franz Marc (Germany, 1880-1916)
Ernst Kirchner (Germany, 1880-1938)
Andre Derain (France, 1880-1954)
Russell Flint (England, 1880-1969)
Wilhelm, Lehmbruck (Germany, 1881-1919) sc.
Fernand Léger (France, 1881-1955)
Pablo Picasso (Spain, 1881-1973)
Nicolai Fechin (Russia, 1881-1955)
Max Weber (U.S.A., 1881-1961)
Umberto Boccioni (Italy, 1882-1916)
Elie Nadelman (U.S.A., 1882-1940) sc.

George Bellows (U.S.A., 1882-1925)
Rockwell Kent (U.S.A., 1882-1971)
N.C. Wyeth (U.S.A., 1882-1945) f.
Georges Braque (France, 1882-1963)
Edward Hopper (U.S.A., 1882-1967)
Maurice Utrillo (France, 1883-1955)
Charles Demuth (U.S.A., 1883-1935)
Jo Davidson (U.S.A., 1883-1952) sc.
Charles Sheeler (U.S.A., 1883-1965)
Max Beckmann (Germany, 1884-1950)
Guy Pène Du Bois (U.S.A., 1884-1958)
Van Doesburg (Holland, 1883-1931)
José Orozco (Mexico, 1883-1949)
Harvey Dunn (U.S.A., 1884-1952)
Amedeo Modigliani (Italy, 1884-1920—
Wyndham Lewis (England, 1884-1957)
Robert Delunay (France, 1885-1941)
Paul Manship (U.S.A., 1885-1966) sc.
Milton Avery (U.S.A., 1885-1965)
Oshar Kokoschka (Germany, 1886-1980)
Diego Rivera (Mexico, 1886-1957)
Lajos Kassak (Hungary, 1887-1967)
Juan Gris (Spain, 1887-1927)
Jean Arp (France, 1887-1976) sc.
Marcel Duchamp (France, 1887-1968)
Marc Chagall (Russian, 1887-1981)
Georgia O'Keeffe (U.S.A., 1887-)
Giorgio De Chirico (Italy, 1888-1978)
John Taylor Arms (U.S.A., 1887-1953)
Thomas Hart Benton (U.S.A., 1889-1975)
Giorgio Morandi (Italy, 1890-1964)
Mark Tobey (U.S.A., 1890-)
Max Ernst (Germany, 1891-1976)
Edwin Dickinson (U.S.A., 1891-)
Jacques Lipschitz (Lithuania, 1891-1973) sc.
Dean Cornwell (U.S.A., 1892-1960)
Grant Wood (U.S.A., 1892-1941)
Harold Von Schmidt (U.S.A., 1892-1982)
Charles Burchfield (U.S.A., 1893-1967)
Peter Helck (U.S.A., 1893-)
Joan Miro (Spain, 1893-)
George Grosz (Germany, 1893-1959)
Stuart Davis (U.S.A., 1894-1964)
Chaim Soutine (Lithuania, 1894-1943)
Norman Rockwell (U.S.A., 1894-1978)
John Steuart Curry (U.S.A., 1897-1946)
Reginald Marsh (U.S.A., 1898-1954)
Henry Moore (England, 1898-) sc.
Ben Shahn (U.S.A., 1898-1969)
Alexander Calder (U.S.A., 1898-) sc.
Rufino Tamayo (Mexico, 1899-)
Raphael Soyer (U.S.A., 1899-)

Twentieth century

Rico Lebrun (U.S.A., 1900-1964)
Louise Nevelson (U.S.A., 1900-) sc.
Alberto Giacometti (Swiss, 1901-1966) sc.
Jean Dubuffet (France, 1901-)
Philip Evergood (U.S.A., 1901-1973)
Barbara Helpworth (England, 1903-) sc.
Graham Southerland (England, 1903-)
Robert Fawcett (U.S.A., 1903-1967)
Mark Rothko (U.S.A., 1903-1970)
Adolph Gottlieb (U.S.A., 1903-)
William De Kooning (U.S.A., 1904-)
Peter Hurd (U.S.A., 1904-)
Clyfford Still (U.S.A., 1904-)
Salvador Dali (Spain, 1904-)
Isamu Noguchi (U.S.A., 1904-) sc.
Arshile Gorky (U.S.A., 1905-1948)
Al Parker (U.S.A., 1906-)
David Smith (U.S.A., 1906-1965) sc.
Fairfield Porter (U.S.A., 1907-)
John Clymer (U.S.A., 1907-)
Millard Sheets (U.S.A., 1907-)
Feliks Topolski (England, 1907-)
Joseph Hirsch (U.S.A., 1910-1981)
Ben Stahl (U.S.A., 1910-)
Francis Bacon (England, 1910-)
Franz Kline (U.S.A., 1910-1962)
Will Barnet (U.S.A., 1911-)
Matta Echaurren (Chile, 1912-)
Jackson Pollock (U.S.A., 1912-1956)
Ad Reinhardt (U.S.A., 1913-1967)
Lynn Chadwick (England, 1914-) sc.
Robert Motherwell (U.S.A., 1915-)
Jack Levine (U.S.A., 1915-)
Andrew Wyeth (U.S.A., 1917-) s.f.
Antonio Frasconi (Uruguay, 1919-)
Richard Diebenkorn (U.S.A., 1922-)
Leonard Baskin (U.S.A., 1922-)
Larry Rivers (U.S.A., 1923-)
Roy Lichtenstein (U.S.A., 1923-)
Philip Pearlstein (U.S.A., 1924-)
George Segal (U.S.A., 1924-) sc.
Robert Rauchenberg (U.S.A., 1925-)
Robert Vickery (U.S.A., 1926-)
Robert Indiana (U.S.A., 1928-)
Robert Peak (U.S.A., 1928-)
Andy Warhol (U.S.A., 1930-)
Jasper Johns (U.S.A., 1930-)
Bernard Fuchs (U.S.A., 1932-)
Mark English (U.S.A., 1933-)
Frank Stella (U.S.A., 1936-)
Ned Jacob (U.S.A., 1938-)
Larry Bell (U.S.A., 1939-) sc.
James Wyeth (U.S.A., 1946-) s.

Bibliography

Aida, Kohei. *Japanese Brush Painting.* Tokyo: Japan Publications, Inc., 1973

American Heritage Dictionary, The. New York: Dell Publishing Co., Inc., 1969

Art Mart Catalogue. Plainfield, New Jersey: 1976 and 1977

Artist's Manual, The. New York: Mayflower Books, 1980

Artnews. New York: Artnews Associates, 1983

Banister, Manly. *Lithographic Prints from Stone and Plate.* New York: Sterling Publishing Co., 1972

Barron, John N. *The Language of Painting.* New York: The World Publishing Co., 1967

Bergan Arts and Crafts Catalogue. Salem, Massachusetts

Boger, Louise Ade. *The Complete Guide to Furniture Styles.* New York: Charles Scribner's Sons, 1969

Bowie, Henry P. *On the Laws of Japanese Painting.* New York: Dover Publications, Inc., 1952

Britannica World Language. New York: Funk and Wagnalls Co., 1954

Brown and Bro. Inc., Arthur. Catalogue. New York: 1981

Cardamone, Tom. *Advertising Agency and Studio Skills.* New York: Watson-Guptill Publications, 1959

Cherry, David. *Preparing Artwork for Reproduction.* New York: Crown Publishers, Inc., 1976

Clifford, Martin. *Basic Drafting.* Blue Ridge Summit, Pennsylvania: Tab Books, Inc., 1980

Craftint Catalogue. Woodbridge, New Jersey: 1968

Davis, Sally Ann, ed. *Artist's Market.* Cincinnati: Writer's Digest Books, 1983

Dilly, Romilda. *Fundamental Fashion Drawing.* New York: Sterling Publishing Co., Inc., 1967

Edwards, Betty. *Drawing on the Right Side of the Brain.* Los Angeles: J.P. Tarcher, Inc., 1979

Elspass, Margy Lee. *Tips and Notes for the Artist.* Seven Lakes, West End, North Carolina: RaMar Press, 1980

Encyclopedia of Painting. New York: Crown Publishers, Inc., 1963

Fell, Barry. *America B.C.* New York: Quadrangle, The N.Y. Times Book Co., 1976

Field, Robert D. *The Art of Walt Disney.* London and Glasgow: Collins, 1947

Flax Catalogue, Sam. New York: 1976

Fredrix Canvas Materials Catalogue. Atlanta, Georgia: 1974 and 1977

Fredrix Catalogue. Lawrenceville, Georgia: 1983

Gates, David. *Type.* New York: Watson-Guptill Publications, 1973

Gettens, Rutherford J., and Stout, George L. *Painting Materials, A Short Encyclopedia.* New York: Dover Publications, 1942

Greene, Daniel E. *Pastel.* Edited by Joe Singer. New York: Watson-Guptill Publications, 1974

Grumbacher Catalogue, M. New York

Haggar, Reginald G. *A Dictionary of Art Terms.* New York: Hawthorne Books, Inc., 1962

Heller, Jules. *Printmaking Today.* New York: Holt, Rinehart and Winston, Inc., 1972

Henning, Fritz. *Concept and Composition.* Cincinnati: North Light Publishers, 1983

Huntly, Moira. *Imaginative Still Life.* New York: Van Nostrand-Reinhold Co., 1983

International Paper Co. *Pocket Pal, A Graphic Arts Production Handbook.* New York: 12th edition, 1979

Jacobs, Jay. *The Color Encyclopedia of World Art.* New York: Crown Publishers, Inc., 1975

Jerry's Catalogue, The, No. 8A. Bellerose, New York: Spring 1983

Johnstone, James B., and the Sunset Editorial Staff. *Woodcarving Techniques and Projects.* Menlo Park, California: Lane Books, 7th printing, 1975

Justema, Wm. *The Pleasures of Pattern.* New York: Reinhold Book Corp., 1968

Kan, Diana. *The How and Why of Chinese Painting.* New York: Van Nostrand Reinhold Co., 1974

Larousse Illustrated International Encyclopedia and Dictionary. New York: World Publishers, Times Mirror, 1972

Larousse's French-English, English-French Dictionary. New York: Washington Square Press, Inc., 1964

Loche, Renee. *Lithography.* New York: Van Nostrand Reinhold Co., 1971

Lovoos, Janice, and Felice Paramore. *Modern Mosaic Techniques.* New York: Watson-Guptill Publishers

McDowell, Jack, and Takahiko Mikami. *The Art of Japanese Brush Painting.* New York: Crown Publishers, Inc., 1961

Maurello, S. Ralph. *Commercial Art Techniques.* New York: Tudor Publishing Co., 1952

Mayer, Ralph. *A Dictionary of Art Terms and Techniques.* New York: Thomas Y. Crowell Co., 1969

Metropolitan Museum of Art Miniatures, The. *Great European Portraits.* Album, Long Island, New York: 1953

Muench, John. *The Painter's Guide to Lithography.* Cincinnati, Ohio: North Light Publishers, 1983

Murray, Peter and Linda. *A Dictionary of Art and Artists.* Baltimore: Penguin Books, 1972

Naz Dar Screen Printing Catalogue. Chicago: 1968

New York Central Catalogue. New York: 1976 and 1977

North Light Magazine. Westport, Connecticut: Fletcher Art Services, Inc., Sept. 1983

Palette Talk, Editors of. *Are You a One-Brush Painter* and *How Grumbacher Brushes Are Made.* New York: M. Grumbacher, Inc.

Peterdi, Gabor. *Printmaking.* New York: Macmillan Co., 1971

Peters, Harry T. *Currier and Ives.* Garden City, New York: Doubleday, Doran and Co., Inc., 1942

Pocket Dictionary of Art Terms. New York: New York Graphic Society, 1979

Proctor, Richard M. *The Principles of Pattern for Craftsmen and Designers.* New York: Van Nostrand Reinhold Co., 1969

Pyramid Artists Materials Catalog. Urbana, Illinois: 1983

Quick, John. *Artists' and Illustrators' Encyclopedia.* New York: McGraw Hill Book Co., 1971

Richardson, Annie. *Tole Orange.* Salt Lake City: Color Craft Publishing, 1978

Ross, John, and Romano, Clair. *The Complete Screenprint and Lithograph.* New York: The Free Press, 1972

Russ, Stephen, ed. *A Complete Guide to Printmaking.* New York: Viking Press, 1975

Sanden, John Howard, with Sanden, Elizabeth R. *Successful Portrait Painting.* New York: Watson-Guptill Publications, 1981

Schlemmer, Richard M. *Handbook of Advertising Art Productions.* Englewood Cliffs, New Jersey: Prentice Hall, 1966

Sloane, E. *Illustrating Fashion.* New York: Harper and Row Publishers, 1968

Stevens, John. *Sacred Calligraphy of the East.* Boulder, Colorado: Shambhala Publications, Inc., 1981

Stoltenberg, Donald. *Collagraph Printmaking.* Worcester, Massachusetts: Davis Publications, Inc., 1975

Tabor's Cyclopedic Medical Dictionary. Philadelphia: F.A. Davis Co., 1965

Wenniger, Mary Ann. *Collagraph Printmaking: The Technique of Printing from Collage-Type Plates.* New York: Watson-Guptill Publications, 1975

Winsor and Newton Catalogue. Secaucus, New Jersey: 1972 and 1983

Zigrosser, Carl. *Prints and Their Creators.* New York: Crown Publishers, Inc., second revised edition, 1974

Other Fine Art Books from North Light

Watercolor
Basic Watercolor Painting, by Judith Campbell-Reed $14.95 (paper)
Capturing Mood in Watercolor, by Phil Austin, $21.95 (paper)
Controlled Watercolor Painting, by Leo Stoutsenberger $15.95 (paper), $22.50 (cloth)
Croney on Watercolor, by Charles Movalli and Claude Croney $14.95 (paper)
Opaque Watercolor, by Wallace Turner $19.95 (cloth)
Painting in Watercolors, edited by Yvonne Deutsch $18.95 (cloth)
Variations in Watercolor, by Naomi Brotherton and Lois Marshall $14.95 (paper)
Watercolor for All Seasons, by Elaine and Murray Wentworth $21.95 (cloth)
Watercolor Painting on Location, by El Meyer $19.95 (paper)
Watercolor—The Creative Experience, by Barbara Nechis $14.95 (paper)
Watercolor Workbook, by Bud Biggs and Lois Marshall $22.50 (cloth)

Mixed Media
American Realist, by Stevan Dohanos $22.50 (cloth)
The Animal Art of Bob Kuhn, by Bob Kuhn $15.95 (paper)
A Basic Course in Design, by Ray Prohaska $12.95 (paper)
The Basis of Successful Art: Concept and Composition, by Fritz Henning $16.95 (paper)
Catching Light in Your Paintings, by Charles Sovek $22.50 (cloth)
Drawing and Painting Animals, by Fritz Henning $14.95 (paper)
Drawing and Painting Buildings, by Reggie Stanton $19.95 (cloth)
Drawing for Pleasure, edited by Peter D. Johnson $15.95 (cloth)
Encyclopaedia of Drawing, by Clive Ashwin $22.50 (cloth)
The Eye of the Artist, by Jack Clifton $14.95 (cloth)
The Figure, edited by Walt Reed $14.95 (paper)
The Mastery of Alla Prima Painting, by Frederic Taubes $14.95 (cloth)
On Drawing and Painting, by Paul Landry $15.95 (cloth)
The Painter's Guide to Lithography, by John Muench $14.95 (paper)
Painting Floral Still Lifes, by Joyce Pike $19.95 (paper)
Painting a Likeness, by Douglas Graves $19.95 (paper)
Painting with Pastels, edited by Peter D. Johnson $16.95 (cloth)
The Pleasure of Painting, by Franklin Jones $13.95 (paper)
The Roller Art Book, by Sig Purwin $11.95 (paper)
6 Artists Paint a Landscape, edited by Charles Daugherty $14.95 (paper)
6 Artists Paint a Still Life, edited by Charles Daugherty $14.95 (paper)

Oil Color/Art Appreciation

An Approach to Figure Painting for the Beginner, by Howard Forsberg $17.95 (cloth)

Encyclopaedia of Oil Painting, by Frederick Palmer $22.50 (cloth)

Controlled Painting, by Frank Covino $14.95 (paper), $22.50 (cloth)

The Immortal Eight, by Bennard B. Perlman $24.95 (cloth)

Painting in Oils, edited by Michael Bowers $18.95 (cloth)

Commercial Art/Business of Art

The Art & Craft of Greeting Cards, by Susan Evarts $13.95 (paper)

An Artist's Guide to Living By Your Brush Alone, by Edna Wagner Piersol $9.95 (paper)

1985 Artist's Market, edited by Sally Ann Davis $15.95 (cloth)

Graphics Handbook, by Howard Munce $11.95 (paper)

North Light Dictionary of Art Terms, by Margy Lee Elspass $9.95 (paper)

To order directly from the publisher, include $1.50 postage and handling for one book, 50¢ for each additional book. Allow 30 days for delivery.

North Light Books
9933 Alliance Road, Cincinnati OH 45242
Prices subject to change without notice.